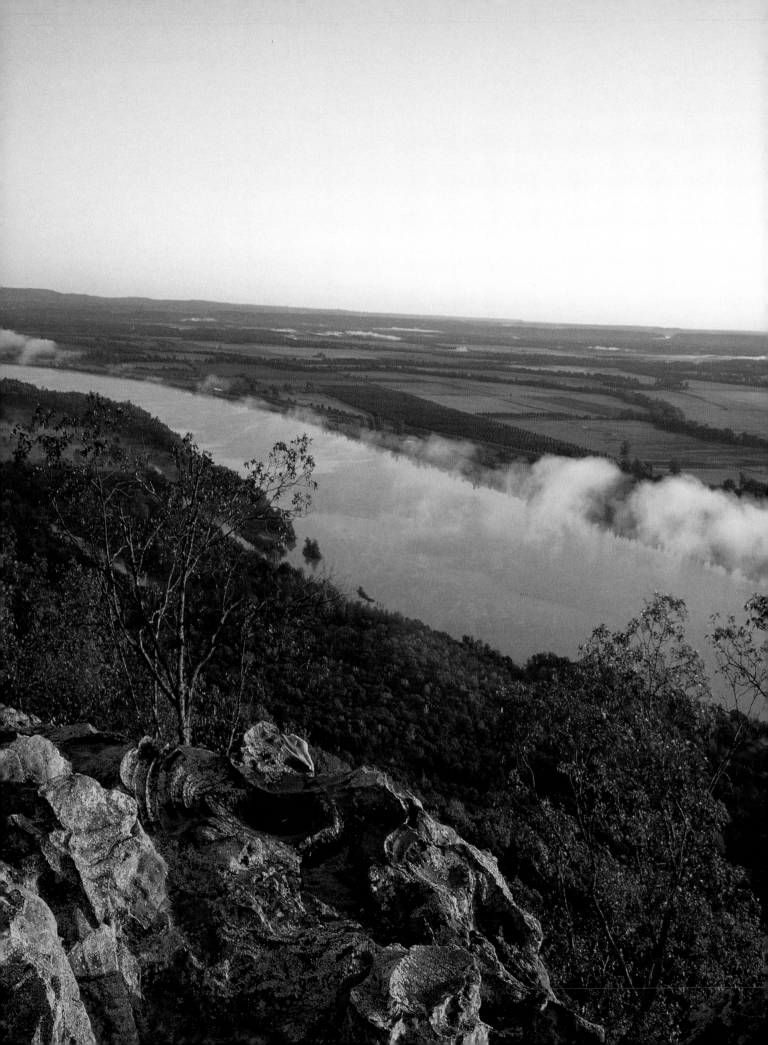

THE CHEROKEE TRAIL OF TEARS

PHOTOGRAPHY **DAVID G. FITZGERALD**

TEXT **DUANE H. KING**

GRAPHIC ARTS BOOKS

To the memory of Howard Meredith—one who loved,
and who was loved by, the Cherokee.
—D. K.

Graphic Arts Books
An imprint of Graphic Arts Center Publishing Company
P.O. Box 10306, Portland, Oregon 97296-0306
503/226-2402 • www.gacpc.com

Library of Congress Cataloging-in-Publication Data
Fitzgerald, David, 1935-
 The Cherokee Trail of Tears / photography by David Fitzgerald ; text by Duane H. King ; foreword by Chadwick Smith
 p. cm.
Includes index.
 ISBN-10 1-55868-905-2 ISBN-13 978-1-55868-905-3 (hardbound)
 1. Trail of Tears, 1838—Pictorial works. 2. Cherokee Indians—Pictorial works. I. King, Duane H. II. Title.
 E99.C5F584 2005
 975.004'97557—dc22 2005019201

President: Charles M. Hopkins
Associate Publisher: Douglas A. Pfeiffer
Editorial Staff: Timothy W. Frew, Kathy Howard, Jean Bond-Slaughter
Design: Vicki Knapton and Jean Andrews
Production Coordinator: Vicki Knapton

Printed in the United States of America

◁◁ Two of the four water routes (Drew Detachment and Deas Detachment) passed by this point on the Arkansas River in 1838 en route to Indian Territory. Here, the river is seen from Stout's Point in Petit Jean State Park, Morrilton, Arkansas.

▷ In 1937, Major Ridge's family settled in present-day Delaware County, Oklahoma, just west of Honey Creek after making the trip to Indian Territory.

Contents

Map .. 6

Acknowledgments ... 7

Foreword ... 8

Introduction .. 11

I Cherokee Homeland .. 13

II The Treaty of New Echota and Preparation for Removal 29

III The Water Route Detachments .. 35

IV The Bell Route .. 41

V The Northern Route .. 61

VI The Benge Route ... 89

VII The Drew Detachment and Life in the Indian Territory 105

Conclusion .. 112

Appendix

 A. Departures and Arrivals of the Seventeen Detachments 114

 B. Numerical Statistics of the Ross Detachments 116

 C. Comparison of Detachments under the Direction of John Ross ... 117

Endnotes ... 123

Index .. 125

Major Routes of the Trail of Tears

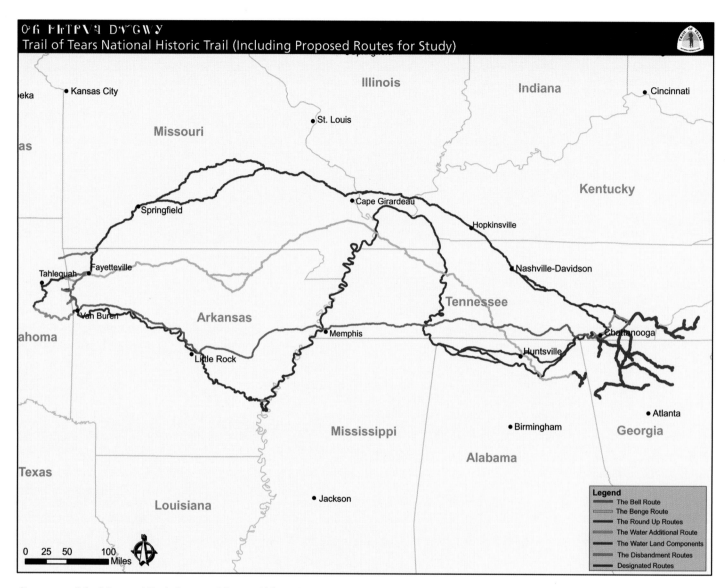

Courtesy of the National Park Service, National Trails System—Santa Fe.

Acknowledgments

I want to express my appreciation to the following:

Doug Pfeiffer, whose vision and determination brought this book to fruition; the editorial team of Tim Frew, Kathy Howard, and Jean Bond-Slaughter, for their patience, professionalism, and dedication to detail; Vicki Knapton and Jean Andrews, for outstanding design.

Principal Chief Chad Smith, Tahlequah, Oklahoma, for his Preface and project support.

Dr. Duane King, for his historical expertise and vast Cherokee knowledge.

Jack Baker (Oklahoma City, Oklahoma), President of the (national) Trail of Tears Association, for his assistance with many key sites in Oklahoma and Tennessee; Trail of Tears Association, Little Rock, Arkansas; Curtis Rohr, Claremore, Oklahoma, President of Oklahoma Chapter Trail of Tears Association; Bill and Michelle Chambers A'Neal, Tulsa, Oklahoma; Mark Christ, Arkansas Historic Preservation, Little Rock, Arkansas; Big Buck Resort in Hornsby, Tennessee: Tina Hodge and Robert Hensley; Phillip Hodge, Hornsby, Tennessee; Monita Carlin, Hardeman County, Tennessee, Chamber of Commerce; John Ross, Savannah, Tennessee;

Museum of the Cherokee Indian, Cherokee, North Carolina: Bo Taylor and Barbara Duncan, Ph.D.; Richard Sheridan, Sheffield, Alabama; Mayor Stewart Nelson, Morrilton, Arkansas; Zoe Butler, Conway County Library, Morrilton, Arkansas; Dennis Peterson; Spiro Mounds Archaeological Park, Spiro, Oklahoma; Jackie Marteney, Mariee Wallace Museum, Jay, Oklahoma; Mildred McCormick, Golconda, Illinois; Suzann Tweedy, Imboden, Arkansas; Charles Jarrett, Pocahontas, Arkansas; Hurst Fishing Service, Cotter, Arkansas; Ernest Crawford Jr., Marion, Arkansas; Steven North Adams, Sexton, Mt. Holly Cemetery, Little Rock, Arkansas;

Historic Arkansas Museum in Little Rock: Bobby Heffington, Bill Worthen, and Bill Branch; Steve and Shelton Meriwether, Guthrie, Kentucky; Bess Neil, Bradley County, Tennessee; Joan Loope Franks, Chattanooga, Tennessee; Zach Wamp, Sarah Bryan, Paulina Medaris,

and Susan Haigler, Chattanooga, Tennessee; John Housch, Chickamauga-Chattanooga N.M.P., National Park Service; Roberta Sloan Carter, Tulsa, Oklahoma;

Dr. Mary Jane Warde, Oklahoma Historical Society, Oklahoma City, Oklahoma; Roger Harris, Oklahoma Historical Society, Oklahoma City, Oklahoma; Shirley Pettengill, Murrell Home Site Manager, Oklahoma Historical Society, Tahlequah, Oklahoma

Cherokee Heritage Center, Tahlequah, Oklahoma: Tom Mooney and Mickel Yantz

Andy Montebello, Strafford, Missouri; Dollywood's Valley Carriage Works' wagon makers, Pigeon Forge, Tennessee; Foxfire Museum & Center in Mountain City, Georgia

—D. G. F.

This book is the result of the efforts, encouragement, and help of many people. I am especially grateful to the National Park Service and the Arkansas Historic Preservation Office for support of my research on Cherokee Removal routes. I am also grateful to the Trail of Tears Association for the opportunity to report frequently on the findings of my research. I am grateful to those who have offered encouragement including Jere Krakow, John Conoboy, Aaron Mahr, Mark Christ, Bobbie Heffington, Paul Austin, Jack Baker, and Jerra Quinton. I am greatly indebted to Ken Blankenship, Director of the Museum of the Cherokee Indian, and Chad Smith, Principal Chief, Cherokee Nation, for supporting museum exhibits based on this book.

David Fitzgerald's creative photography has brought to life the information in this book. I am grateful to those who helped with the editing, in particular Anne Rogers and Barbara Duncan. Bo Taylor provided the historic images from the Museum of the Cherokee Indian and Brooke Taralli adapted the National Park Service map, for which I am appreciative. Most importantly, I want to thank Angela, Travis, and Lee for allowing me the time to do the research and writing for this book and always making sure that my work is balanced by family time.

—D. K.

Foreword

BY PRINCIPAL CHIEF CHADWICK SMITH,

CHEROKEE NATION

In 1825, the governor of Georgia encouraged Georgians to acknowledge the treaties between the Cherokees and the United States and to keep peace. In fact, he admonished his own people for inciting difficulties with the Cherokee people. "I have therefore thought proper to issue this my proclamation, warning all persons, citizens of Georgia or others, against trespassing or intruding upon lands occupied by the Indians, within the limits of Georgia, either for the purpose of settlement or otherwise, as every such act will be in direct violation of the provisions of the treaty aforesaid, and will expose the aggressors to the most certain and summary punishment, by the authorities of the state, and the United States.... All good citizens, therefore, pursuing the dictates of good faith, will unite in enforcing the obligations of the treaty, as the supreme law."

Yet within a decade, one of the most horrific and cruel episodes of American history occurred—an episode wherein tens of thousands of people were forcibly ripped from homes that had been theirs beyond the memory of man, driven into prisons, and then forced upon a tragic, 850-mile march to an unknown and hostile land. The Cherokees called it the Trail of Tears, or the place where they cried, because 4,000 of the 16,000 people who were forced upon that march from their homeland to Indian Territory died. It was those who were weakest and the most frail who perished; the very young and very old, the infirm and the helpless.

Societies, governments, and a familiar way of life can turn upside down within a decade. So it happened with the Cherokees. Within a decade of the Georgia governor's admonishment to Georgians to honor Cherokee treaties, the Cherokees' homes were taken.

This often-overlooked lesson of history is critical for this country's survival, because the Trail of Tears was a stark violation of the fundamental principles this country was purport-

edly based on: fairness, justice, equality. In fact, this episode of history should be studied because it was a culmination of two sins that had plagued humankind since the beginning of time: simple greed and simple lust for power. Cherokees have seen that lesson of history repeat itself time and time again. In this case, the first turning point was in 1828 when a low-grade gold was found at Dahlonega, Georgia. This was inside the Cherokee Nation and outside the territory of Georgia. The lust for gold and belief that it belonged to the good citizens of Georgia, not the Indians, created such a fervor and greed in Georgians that it spawned Georgia's confiscation of those gold mines and wrongful assertion of jurisdiction over the Cherokee Nation lands, people, and government.

The second event was when the Cherokees took to heart the admonition of Thomas Jefferson in 1802 and memorialized a regular set of laws by passing a constitution. Although it was not an act of defiance, Georgia took it as such because there was some erosion of their power. In the words of one writer, "Georgia was very galled. It was bad enough to have to harbor this tribe of savages at all—worse to reflect that a large part of northern Georgia seemed destined to become a permanent Indian reservation—but worst of all to have a foreign nation try to set itself up within her boundaries! This superb effrontery—as Georgia naturally regarded it—really marked the turning-point in the state's Indian problem ..."

Of course, racism played a strong role in the tragedy of the Trail of Tears. Cherokees with sophisticated farms were portrayed as savages, and the treatment of Cherokees only became worse with the discovery of gold and the Cherokee Nation's assertion of constitutional power. The analysis of this episode of history certainly must be reviewed through the various disciplines—socially, economically, politically, legally, anthropologically, and psychologically. If every discipline and set of words we can think of in the English language were to

review this lesson of history, then we can evaluate cause and causation and the resulting impact of the Trail of Tears, not only on individuals, Cherokee and non-Cherokee, but on our institutions, our families, our communities, our political structures, and our societal beliefs. Under every analysis, the events leading up to and during the Trail of Tears have to be some of the most ugly, unforgivable events in American history. It's an event that is undeniable in its contrast of what was right and wrong.

In 1838, 16,000 Cherokee citizens affixed their names, the vast majority in the Cherokee language, to a petition presented to the U.S. Senate to nullify the fraudulent Treaty of New Echota. The Treaty of New Echota had passed by only one vote in the Senate. The petition was merely tabled and was not given the slightest consideration. Ninety-nine percent of the Cherokee people protested the taking of their homelands.

The photographs in this book depict the places that our people passed on the Trail of Tears from our homeland to the Indian Territory. Each of those places saw the heartbreak, the trials, the tribulations, the death and pain of the Cherokee people. As we look at those photographs, we know if geography could speak, the stories told would be disturbing. How do we ever prevent the greed and lust for power from causing another Trail of Tears? How do we encourage the generations of people who are not familiar with the story of the Trail of Tears to learn and not forget?

Among the Cherokees who now live in the Cherokee Nation, it takes no words, no pictures, and no reminders to experience the emotional and spiritual impact of our removal from our homeland. When we go back to that homeland, in the Appalachians, without question a melancholy and penetrating feeling arises in our hearts when we enter the Smoky Mountains. We know without words, this is the homeland.

This is where our ancestors are buried. And this homeland was wrongfully taken from us by a political mob mentality that belied logic, law, and humanity.

People should understand that the Trail of Tears is not an episode of defeat and that the strength, character, and the power of the story of the Trail of Tears is that it evidences in very real and graphic terms the great Cherokee legacy: We are a people who have faced adversity, survived, adapted, and who now prosper and excel.

After that Trail of Tears, in Indian Territory, we soon rebuilt a sophisticated society and government modeled and emulated by the non-Indians that surrounded us. We were 90 percent literate in our language. We had nine courthouses, a Supreme Court building, and the first institution of higher learning for women west of the Mississippi River. We built vocational schools and day schools and began to prosper and excel.

Cherokees today have been entrusted with this valuable legacy, and we should look to our cultural core of independence, self-reliance, contributing back to the community, and patriotism of the Cherokee Nation. We are not victims unless we choose to be. Our ancestors paid dearly on the Trail of Tears. This legacy should inspire us to achieve the highest levels of excellence and prosperity and lead us to be healthy and happy.

As the orange sun rises over the Cookson Hills and fog-filled valleys, bringing light to a myriad of green spanning every tone and hue the eye could differentiate, we remember that the east is the way of life. With each new day, the future of our people looks brighter than before. We have no excuse to not prosper and excel.

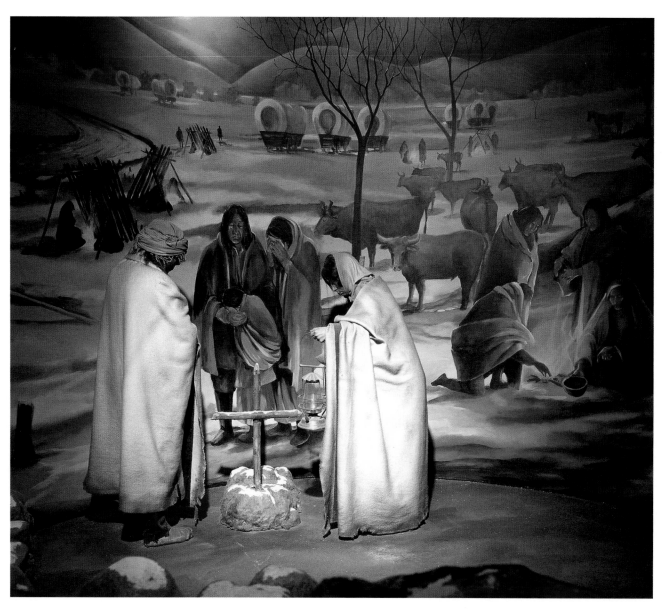

△ This poignant Trail of Tears exhibit is on display at the Museum of the Cherokee Indian in Cherokee, North Carolina.

Introduction

BY DUANE H. KING

Between June 6 and December 5, 1838, more than fifteen thousand Cherokees in seventeen detachments were forcibly removed from their ancestral homeland in the southern Appalachians to the Indian Territory on a journey that would later become known as the "Trail of Tears." It was a tragedy for a progressive and independent people whose population was markedly decreased as a result of the hardships associated with lengthy confinement and an arduous journey. The forced Removal left an indelible impression on the Cherokee psyche and is today still regarded as the most significant event in Cherokee history. The politics of the Removal continue to be debated and the advisability challenged. More than a century and a half after the event, we are still struggling to understand why it happened, how it affected the people involved, and how it changed the future of American political thought and justice. The Removal has given rise to myths, legends, and public perceptions, which continue to weigh heavily on the American conscience.

Over the years, scholars have written volumes about the politics and effects of Indian Removal. Only recently, however, have serious attempts been made to understand the journey itself. In 1987, Congress designated the Cherokee Trail of Tears as a National Historic Trail. At that time, the emigration routes were virtually unknown. Since then, the collective research of many people has resulted in a corpus of data that has made it possible to ascertain, with a high degree of confidence, most of the routes used by seventeen Cherokee detachments during the period of forced Removal.

The wealth of knowledge about the Trail of Tears that has been assembled in the past two decades has come from the examination of thousands of primary documents, including military journals, diaries of eyewitnesses, payment vouchers, contemporary newspaper accounts, nineteenth-century maps, and oral traditions. The work has resulted in

the identification of hundreds of locations on maps of the region that can be connected by alignments of roads known to exist at the time of Removal. This book relies heavily on primary documentation, by matching the observations of participants with historic maps and known topography to reach conclusions about the Trail of Tears. The research made it possible to identify and verify many historic sites along the trail. Discerning the route of the various detachments is a matter of noting the places on the map where the location of each detachment was reported at various times and connecting the dots with lines following the most logical routes, based on information about the historic road system. From the information available on all detachments, several basic assumptions can be made: 1) that they chose the best available roads, deviating only occasionally to avoid toll roads or toll ferries when it was convenient to do so; 2) that they camped near water of sufficient quantity to supply large numbers of people and livestock; 3) that they averaged about ten miles per day, never more than eighteen miles and seldom fewer than seven. Some groups refrained from traveling on Sunday and some remained stationary on occasion because of illness or weather. With these assumptions, it is possible to propose a possible route and likely campsites judging by the availability of adequate water. By calculating distances traveled, it is sometimes possible to project dates by which certain points were reached, even in the absence of historical records.

Some of the sites along the Trail of Tears were previously unknown and are reported and photographed for the first time in this book. David Fitzgerald traversed the various routes to capture the images, many of which appear the same today as they did during the forced Removal of 1838 to 1839.

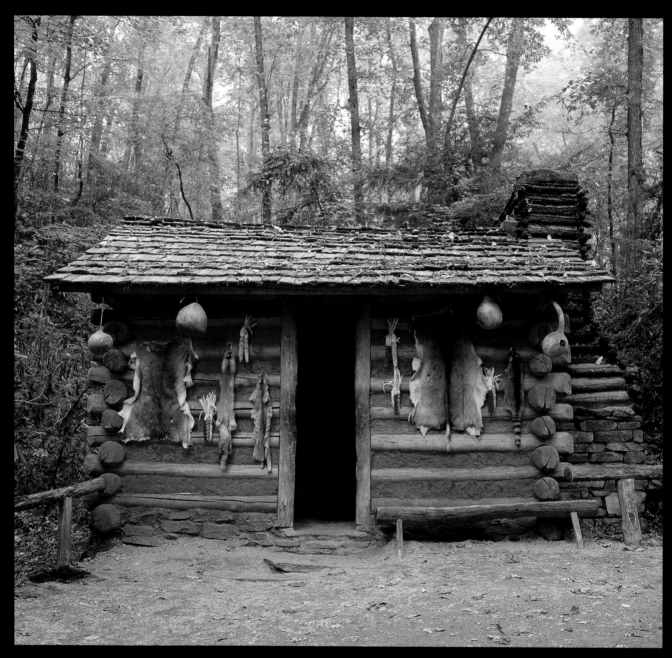

△ The true starting points of the Cherokee Trail of Tears were the individual homes of the thousands of Cherokee who were forcibly removed from their homeland. Some families were quite affluent and lived in brick homes. The majority of Cherokee families, at the time of Removal, lived in hand-hewn log houses such as this reconstruction of a historic period dwelling at the Oconaluftee Indian Village in Cherokee, North Carolina.

▷ Chimney Tops is tied to a Cherokee legend of Uktena, a large monster snake with horns and a bright crystal in its forehead that hid in isolated mountain passes. Chimney got its present name from white settlers who were reminded of chimney tops. At 4,700 feet, it is visible from several locations along Newfound Gap Road in the Great Smoky Mountains National Park in Tennessee.

CHEROKEE HOMELAND

CHAPTER I

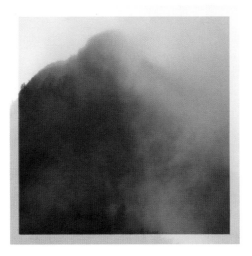

At the time of European contact, the Cherokee numbered about twenty-two thousand and controlled forty million square miles of land in parts of eight present states.[1] In 1721, less than fifty years after the beginning of sustained contact with Europeans, the Cherokees made their first land cession. It was a small tract between the Saluda and Edisto rivers in South Carolina.[2] By 1835, nearly three dozen additional land cessions had been concluded, reducing the once vast Cherokee territory to nothing.[3] Before the American Revolution, expanses of uninhabited land still separated the white settlers from the Cherokees, but the handwriting was already on the wall. At the Treaty of Sycamore Shoals in 1775, an aged Cherokee chief, reportedly Oconastota, declared: "Indian Nations before the Whites are like balls of snow before the Sun." Despite reassurances to the contrary, he was convinced that the white's desire for land was insatiable, and prophesied that the Cherokees would eventually be required to yield all their land, including that on which their houses stood, and they would then be forced to some distant wilderness.[4]

△ Repressive laws passed by the State of Georgia made it impossible for the Cherokee Nation to continue governmental functions there. In 1832, the Cherokee Nation's government moved across the state line to Red Clay in Bradley County, Tennessee. Today, the site is Red Clay State Historic Park. The Council House, which served as the seat of Cherokee government for six years until the forced Removal in 1838, has been reconstructed near its original location. Red Clay also served as an internment camp for Cherokee prisoners in the summer of 1838, awaiting deportation to the west.

▷ Born near the Hiwassee River in 1770, Major Ridge moved to this location near Rome, Lafayette County, Georgia, about 1794. Now the Chieftan's Museum, the original building is encased by renovations of later owners. Prior to Removal, the ferry and trading post operated by Major Ridge turned his farm into a tribal center. In 1829, Major Ridge introduced legislation making it a capital offense for any Cherokee to cede land to the U.S. government without permission of the National Council and National Committee. In 1835 he signed the Treaty of New Echota, ceding the last remaining Cherokee land east of the Mississippi. On June 22, 1839, Major Ridge, his son John, and nephew Elias Boudinot were killed by Cherokees who blamed the signers of the treaty for the forced Removal.

In truth, however, the fate of the Cherokees may have been sealed long before any white settlers encroached upon Cherokee lands. The European conquest of the Americas brought about major beneficial changes in Europe, which, in turn, resulted in catastrophic changes for the native populations in the Western Hemisphere. The introduction of American foods and American cotton to Europe shortly after contact resulted in a population explosion. The population of Europe has increased more than seven-fold since contact with the Western Hemisphere. Today, foods first cultivated in the New World comprise about 60 percent of the world's cuisines.[5]

The potato, more than any other crop, changed life in Europe as it spread from west to east beginning in the sixteenth century, quickly becoming the food staple in all of the areas it reached. Corn did for European livestock what potatoes did for the human population. Together they cured Europe of the episodic famines that had been the primary restraint on population growth.[6]

Corn and potatoes could be grown in Europe; Sea Island cotton, which replaced wool as the primary material for European clothing, could not, and it continued to be exported from the American southeast. The increased popularity of cotton, which as an agricultural crop rapidly depletes the soil, escalated the demand for suitable land and pushed southern planters from Georgia and the Carolinas all the way to Texas in the first decades of the nineteenth century.[7] In the process, tremendous pressure was brought to bear on the Cherokees and other tribes in the Southeast—the Creeks, Choctaws, Chickasaws, and Seminoles—to yield all land with agricultural potential. By

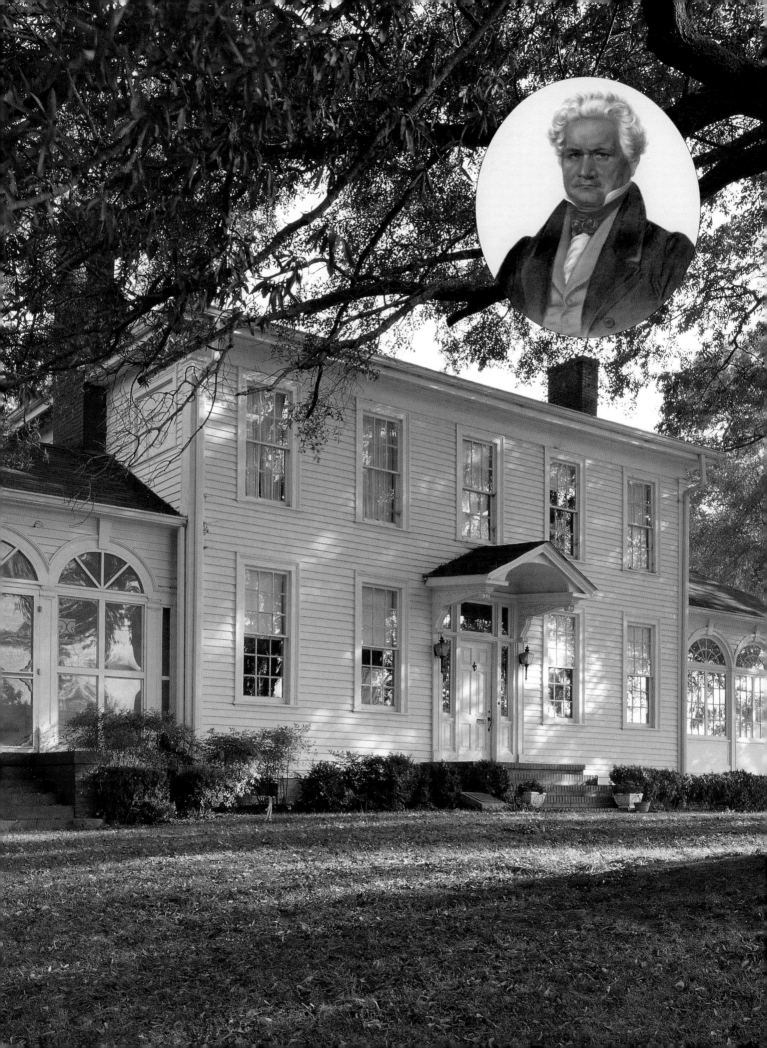

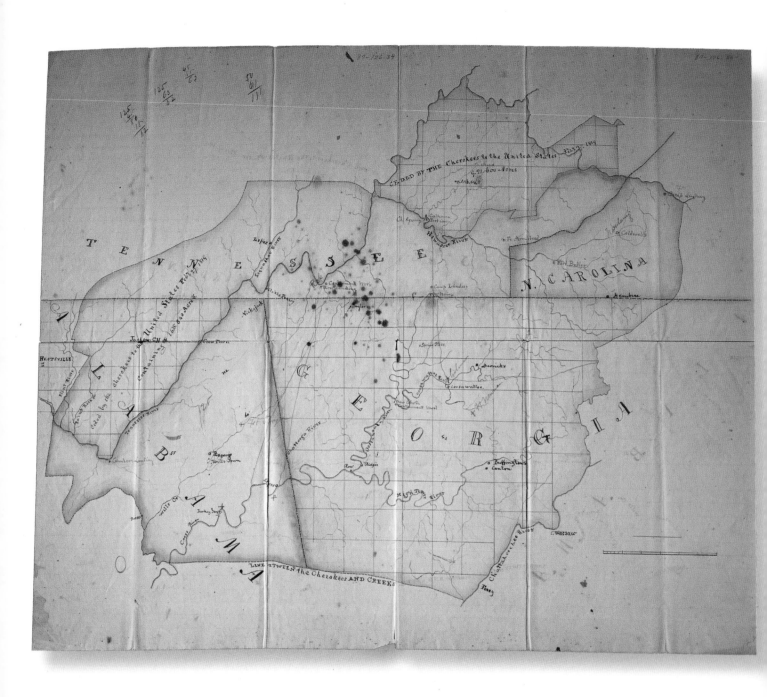

1840, Indians managed to remain only in the most unproductive land in the Southeast—the rugged mountains of North Carolina, the swamps of Mississippi tributaries, and the Florida Everglades.

By the early nineteenth century, the thin soils of the large coastal plantations, which grew rich through slavery and cotton production, were becoming rapidly depleted from overplanting. The state of Georgia also had a large class of poor and landless whites, and the best unspoiled farmland was still under Indian control. The citizens of Georgia lived in a class-conscious and race-conscious society. The continued advancement of the white population was dependent on the subjugation and exploitation of minorities. Some whites perceived the increasing prosperity of Cherokees and Creeks as a threat to the existing social order. Aspiring whites viewed the trappings of the aristocracy as a respected virtue when exhibited by other whites and decadent vice when displayed by nonwhites.

By 1810, the Cherokee elite were beginning to look and act like white aristocrats. In 1821, Sequoyah became the first person in recorded history to devise a writing system without first being literate in some language. Within months, using the Sequoyan syllabary, the Cherokees achieved a higher literacy rate than their white neighbors. This led to rapid social and political advances. They established a national bilingual newspaper, adopted a constitutional government, passed laws through a bicameral legislature, and created judicial districts and the mechanisms to govern the districts. They had a Supreme Court ten years before the State of Georgia had one. And as a group, they had surpassed rural Georgians in embracing mainstream American values and virtues.

The Creek Indians, who suffered a disastrous military defeat at the hands of the Americans and their Cherokee allies during the Red Stick War, which ended after the Battle of Horseshoe Bend on March 27, 1814, were the first to feel the pressure to leave Georgia. After the Creeks were finally removed in 1827, the state turned its full attention to the Cherokees. Over the next decade, Georgia's unrelenting effort to remove the Cherokees created a firestorm of controversy, heightened regional differences dividing the United States, and generated tensions and animosities that carried over into other issues, such as slavery and tariffs. The inability of the United States to develop a strong central government during this period gave rise to a further divisiveness along the lines of regional interests, which eventually resulted in the American Civil War in the 1860s and the assertion of states' rights as a political ideal in the twentieth century.

The issue of Indian Removal in the early nineteenth century became a test of political will and resolve. The proponents of Removal argued that American progress and manifest destiny were dependent upon the removal of "savages" from the pathway of civilization. The opponents of the Indian Removal Act

In 1821, Sequoyah became the first person in recorded history to devise a writing system without first being literate in some language. Within months, using the Sequoyan syllabary, the Cherokees achieved a higher literacy rate than their white neighbors.

◁ This map of the Cherokee Country was drawn by military cartographers about 1835 when the first complete census of the Cherokee Nation was taken in preparation for the Removal. It is the only map that shows the location of Fort Armistead in east Tennessee. It also designates a number of settlements, forts, and residences of prominent Cherokees. (Collection of the Cherokee Indian, Cherokee, Swain County, North Carolina)

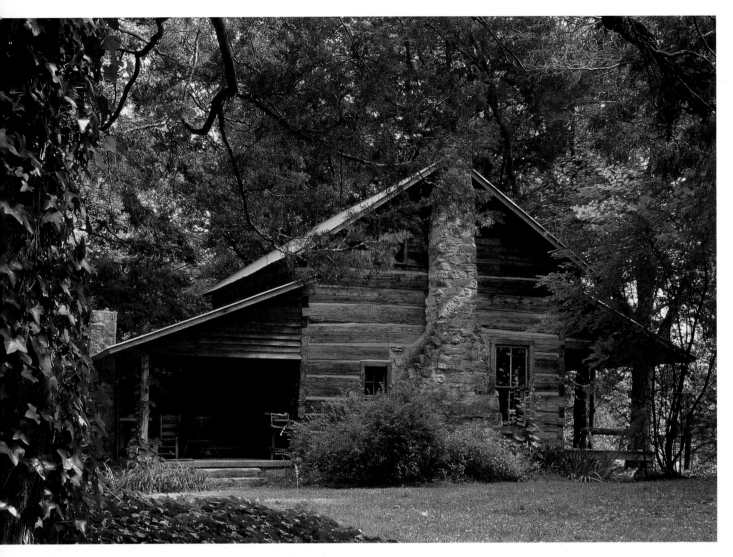

△ The Hair Conrad Home was built in the 1820s near Cleveland, Bradley County, Tennessee. It was a typical Cherokee dwelling at the time of the Removal. In mid-June 1838, the military began forcing Cherokees in southeastern Tennessee into concentration camps around Fort Cass. Conrad and more than 12,000 other Cherokees spent the summer of 1838 as prisoners of the U.S. army in open camps south of Fort Cass. Conrad was selected by Principal Chief John Ross to conduct the first detachment. His assistant conductor, Daniel Colston, assumed the responsibilities as conductor before they departed Rattlesnake Springs, Tennessee, on August 28, 1838.

pointed to the rapid advancements of the Cherokees, their military service during the Creek War, and the guarantees of previous treaties.

The Case for Removal

During this period, Georgia, of all the states with Indian populations, had developed the strongest case for Indian Removal. The Cherokees, of all the eastern tribes, had developed the strongest case against forced Removal. Georgia's case was based heavily on an 1802 agreement with the United States whereby the federal government committed itself to extinguish Indian land titles within the remaining boundaries of the state. The Compact of 1802, as it was known, was the result of the most blatant political scandal in Georgia's history. Throughout the eighteenth century, Georgia's boundaries extended westward to the Mississippi River and included most of the present states of Mississippi and Alabama.

In 1795, Georgia's corrupt legislature, influenced by overt bribery, passed the infamous Yazoo Land Act, which gave to land speculators thirty-five million acres of Georgia's western lands for about one and a half cents per acre. The electorate was outraged that so much land was sold for so little money. Most elected officials involved in the scandal were soon removed from office. A "reform legislature" headed by James Jackson was convened on January 14, 1796. All of the records associated with the sale were assembled in front of the Capitol building on February 21, 1796, and "consumed by a Holy Fire from Heaven" assisted by prayers and a magnifying glass. The state attempted to refund money that had already been paid, only to find that many people to whom the land had been resold refused to accept payment. When a rescinding act passed in 1796 failed to undo the damage, and complications increased, the state decided to rid itself of the Yazoo problem by ceding its western lands to the federal government.[8]

"The Articles of Agreement and Cession" were concluded on April 24, 1802. In giving up the Alabama and Mississippi territories to the United States, Georgia received three commitments in exchange: the federal government would assume responsibility for settlement of the Yazoo land claims; it would pay Georgia $1,250,000 for the ceded land, and "the United States shall at their own expense extinguish for the use of Georgia, as early as the same can be peaceably obtained on reasonable terms, the Indian title to . . . all . . . lands within the State of Georgia."[9]

In 1802, extinguishing Indian title within the limits of Georgia probably was not envisioned as the removal of Indian populations to west of the Mississippi. After all, George Washington had proposed in 1789 that Indians should become citizens as soon as they became "civilized and Christianized." Also, since the Louisiana Purchase did not occur until 1803, there was no land available west of the Mississippi for the United States. Although approval of the compact by the Cherokees, who were recognized as the rightful owners to nearly one-third of the land in the state of Georgia, was not sought by either federal or state officials, the agreement would prove to be the single instrument most effectively employed to remove all Indians from the state.[10]

When Napoleon became strapped for cash trying to finance his conquest of Europe, he sold France's claim to all land west of the Mississippi River to the United States for a meager sum of $15,000,000. The following year, in 1804, President Thomas Jefferson suggested to a Cherokee delegation visiting Washington that if any or all Cherokees chose to remove west of the Mississippi, land would be given to them in proportion to the number removing.[11] At that time, only about six hundred Cherokee lived west of the Mississippi, primarily on the St. Francis River west of Memphis. Five years later, in 1809, a group from the Hiwassee River under Tolunteeskee accepted President Jefferson's

. . . President Thomas Jefferson suggested to a Cherokee delegation visiting Washington that if any or all Cherokees chose to remove west of the Mississippi, land would be given to them in proportion to the number removing.

△ Land along the Oconaluftee River was ceded by the Cherokees to the U.S. government in 1819. Cherokees living in the area were given the choice of removing to remaining tribal land or accepting individual reservations and citizenship of the state in which they resided. In 1828, at least fifty-seven Cherokee families claimed North Carolina citizenship. During the Removal the military referred to this group as the Oconaluftee Citizen Indians and allowed them to remain in their homes. The Oconaluftee River flows out of the Great Smoky Mountains National Park through the middle of Cherokee, Swain County, North Carolina.

new offer for the Cherokees to settle on any unclaimed territory along the Arkansas and White rivers.

The Indian Policy developed during the Federal Period under George Washington and Henry Knox, who as secretary of war, sought an honorable role for the U.S. government. They were very cognizant of the history of Latin America and the wholesale genocide that had occurred in the Caribbean, Peru, and Mexico. They certainly wanted to avoid being relegated to the same appellations as the conquerors of those areas. Knox, in particular, believed that Indian title could be extinguished gradually as white expansion moved west and as Indians became acculturated. He did not contemplate, however, that the encroachment on Indian lands would be so rapid and with such a blatant disregard of the rights of Indians by the frontier population, nor did he contemplate that Indians might not want to sell their lands or become American citizens. As a result of these factors, American Indian policy began to change from bringing Indians into the American system, as proposed by Washington, to excluding them from it, as championed by Andrew Jackson. Even as the policy changed, the purported motivation remained the same: to save the Indians from destruction.

The policy of the Cherokees changed just as dramatically during the same period. From 1776 to 1794 the Cherokees sought to maintain their territorial imperative through military force. After the destruction of the lower towns by the Orr Expedition in 1794, coupled with the defeat of northern allies at the Battle of Fallen Timbers and the loss of Spanish support in the same year, they passionately embraced Washington's concept of civilization. They established a central government and formalized the titles of Principal Chief and Deputy Chief. By 1798, they established a national police force, called the Light Horse. In 1801, the first schools opened in the Cherokee Nation, and Christian missionaries were welcomed as long as their primary focus was academics instead of religion. By 1810, the National Council abrogated the traditional law of blood revenge for all crimes except horse stealing. By 1817, they had established a two-house legislature patterned after the United States Senate and House of Representatives. By the time of the 1824 presidential election, Indian Removal had become a national issue. The candidates for president of the United States in the 1824 election were Andrew Jackson, John Quincy Adams, William H. Crawford, and Henry Clay. The southern votes were divided among three regional candidates: Jackson of Tennessee, Clay of Kentucky, and Crawford of Georgia. In Georgia, Crawford, who was the favorite son but in failing health, received two-thirds or ninety of the votes of the Electoral College. In spite of the fact the Jackson received the largest number of popular votes, the election was decided in the House of Representatives, and John Quincy Adams was selected as President. Undaunted by the defeat,

Jackson immediately began campaigning for the 1828 election with Indian Removal a central theme in his campaign.

Land for the Railroad

In 1825, the Georgia legislature created a board of public works, whose responsibilities included surveying the state to determine how canals, railroads, and highways might improve the state's economy. The board had six members appointed by the legislature. One of these members was Wilson Lumpkin, who saw railroads as the way of the future. He and State Engineer Hamilton Fulton examined the land between the then state capital at Milledgeville and Chattanooga, Tennessee, and quickly concluded that a canal between the two was impractical, but that a railroad could be built to great advantage. The only problem was that most of the land between those points was owned by the Cherokees. Lumpkin became the architect of Cherokee Removal in Georgia, luring the masses of whites to the cause with the promise of free land. He reserved for himself a grander vision of becoming a railroad magnate. At that time, the railroad industry was in an embryonic state; only a few miles of railroad were then known to the world, and those were constructed of wood, and propelled by animal force, the steam engine and iron rails only a few years away. Lumpkin wrote that he, "after full investigation of the subject, became fully satisfied that even wooden railroads, with mule and horse power, should be preferred to any canal which could be constructed in middle and upper Georgia."[12] In retrospect, Lumpkin also took great pride in the fact that the routes that he and Fulton selected "in its whole distance have varied so slightly from the location of our present railroads now in operation [1851]. . . . From that time to this I have looked to railroads as the great and leading work to promote the best interest of the country and have upon all fit occasions, whether in private or public life, contributed my best aid to the promotion of the railroad cause."[13]

In 1828, gold was discovered at Dahlonega in the Cherokee Nation in Georgia. A horde of fortune seekers descended on the Cherokee Nation. Inspired by the election of Andrew Jackson that year, the State of Georgia quickly passed a series of anti-Indian acts. Cherokees were forbidden from mining gold on their own land. They could not assemble in groups of three or more for any purpose, including religious services. They could not testify in a court of law against a white person. In extending the laws of the state over the annexed territory, Georgia abolished the Cherokee laws, and authorized the use of the state militia to enforce the state laws and land claims. The rest of the country had a different view on Removal than did Georgia. Northern audiences were frequently impressed with the eloquent speeches

In 1828, gold was discovered at Dahlonega in the Cherokee Nation in Georgia. A horde of fortune seekers descended on the Cherokee Nation.

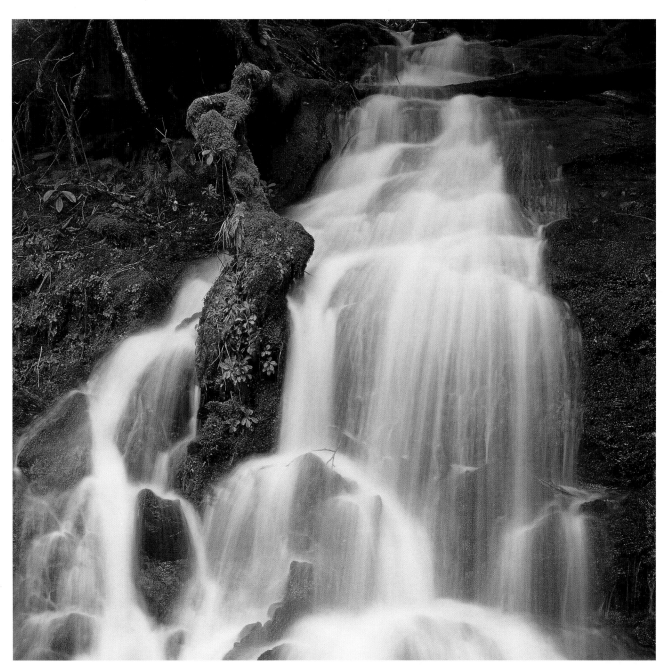

△ A cascading waterfall along U.S. Highway 441 in the Great Smoky Mountains National Park marks the rugged landscape that gave refuge to the Cherokees eluding federal troops in the summer and fall of 1838. The water flows into Oconaluftee River near the park's southern entrance.

given by touring Cherokee scholars such as Elias Boudinot and John Ridge. They not only opened their hearts but also their pocketbooks in fund-raising efforts to buy a printing press for New Echota, the capital of the Cherokee Nation. Many Cherokees felt that their strongest fight against Removal was public opinion. The *Cherokee Phoenix*, which provided the main means of disseminating information, was short-lived. Six years after its debut in 1828, the State of Georgia confiscated the printing press, declaring the *Phoenix* to be a subversive newspaper.

In his inaugural address in 1829, Jackson gave a great deal of attention to the situation in Georgia. Avowing that no independent government could be formed within the jurisdiction of an existing state, he countered the Cherokees' claim that the State of Georgia was infringing on their sovereign rights. President Jackson said that he had "advised them to emigrate beyond the Mississippi or submit to the laws of the states."

Wilson Lumpkin, the former surveyor and Indian commissioner, was elected to the U.S. House of Representatives from Georgia in 1826. A friend of Governor Troup and an ardent supporter of President Jackson, Lumpkin authored two versions of the Indian Removal Act, both of which were passed by Congress. Not everyone supported Lumpkin's bills, however. He encountered strong resistance from the North, especially from Jeremiah Evarts of the American Board. Evarts, under the pseudonym of William Penn, wrote a series of widely published letters defending the Cherokee position.

Legal Cases

The Cherokees also hired respected lawyers to help fight their legal battles. The most important was William Wirt, the former attorney general of the United States. On the state level in Georgia, they employed the firm of Underwood and Harris. In the early 1830s, two cases involving the Cherokees reached the United States Supreme Court. The first, *Cherokee Nation v. Georgia*, contended that the State of Georgia did not have the right to extend its laws over the Cherokee Nation, arguing that the tribe was a nation. The court concluded, however, that the tribe was not a foreign nation but a dependent sovereign nation. Under the extension of Georgia law, a man named Corn Tassel was tried for the murder of another Cherokee. He was brought to Gainesville before Augustine Smith Clayton (1783–1839), presiding as Judge of the Hall County Superior Court. After being convicted, Corn Tassel was sentenced to hang. Wirt immediately appealed the case to the United States Supreme Court on a writ of error, which was sanctioned by Chief Justice John Marshall. Georgia Governor George Gilmer was ordered to appear before the Supreme Court to defend the State's position; he refused. Corn Tassel was hanged.

In the early 1830s, two cases involving the Cherokees reached the United States Supreme Court. The first, *Cherokee Nation v. Georgia*, contended that the State of Georgia did not have the right to extend its laws over the Cherokee Nation, arguing that the tribe was a nation.

In the case of *Worcester v. Georgia,* former Attorney General William Wirt based the Cherokee position upon the constitutional provision that the establishment and regulation of intercourse with the Indians belonged exclusively to the government of the United States.

One measure passed by the State of Georgia in the wake of Andrew Jackson's presidential election required all white men living in the Cherokee Nation to take an oath of allegiance to the State of Georgia. Among those who refused to do so were the missionaries Samuel A. Worcester and Elizur Butler. Both were arrested, tried, convicted, and sentenced to four years of hard labor in the state penitentiary at Milledgeville. Their case was appealed to the Supreme Court.

Attempting a new strategy, in the case of *Worcester v. Georgia,* former Attorney General William Wirt based the Cherokee position upon the constitutional provision that the establishment and regulation of intercourse with the Indians belonged exclusively to the government of the United States, based on treaties and acts of Congress, now in force at that time. He argued that no state could interfere without a manifest violation of such treaties and laws. In conclusion, Wirt maintained that in the case of Samuel Worcester, the indictment, conviction, and sentence being founded upon a Statute of Georgia, which was unconstitutional and void, were also void and of no effect, and should be reversed.

Associate Supreme Court Justice Henry Baldwin ordered the State of Georgia to present arguments before the Court as to why the convictions of the missionaries should not be overturned. Wilson Lumpkin, who took office as Governor on November 9, declined to appear or even admit that the Supreme Court had jurisdiction in the case. On March 3, 1832, Chief Justice Marshall delivered the Court's majority opinion, declaring the State's laws unconstitutional and ordering the release of the missionaries.[14] The State refused to acquiesce, and the president of the United States publicly denounced the Court's decision, stating: "John Marshall has made his decision, now let him enforce it." Samuel Worcester and Elizur Butler remained in the state penitentiary.

The Cherokees watched helplessly until the missionaries were released in January 1833 after accepting the ultimate humiliation and acknowledging the authority of the State. The verdict, however, was an enduring victory, and has become a case study in constitutional law. It is required reading for every aspiring law student, and along with the earlier decision in *Cherokee Nation v. Georgia* (1831), is still regularly cited in legal cases involving Indian law.

Increasing Pressure

In 1832, the State of Georgia held a land lottery parceling out 160-acre tracts of land, with whatever improvements had been made by the Cherokees, to white citizens. In 1833, Principal Chief John Ross, on a return trip from Washington, found his ill wife living in the storeroom of their home and paying rent to the new owners.

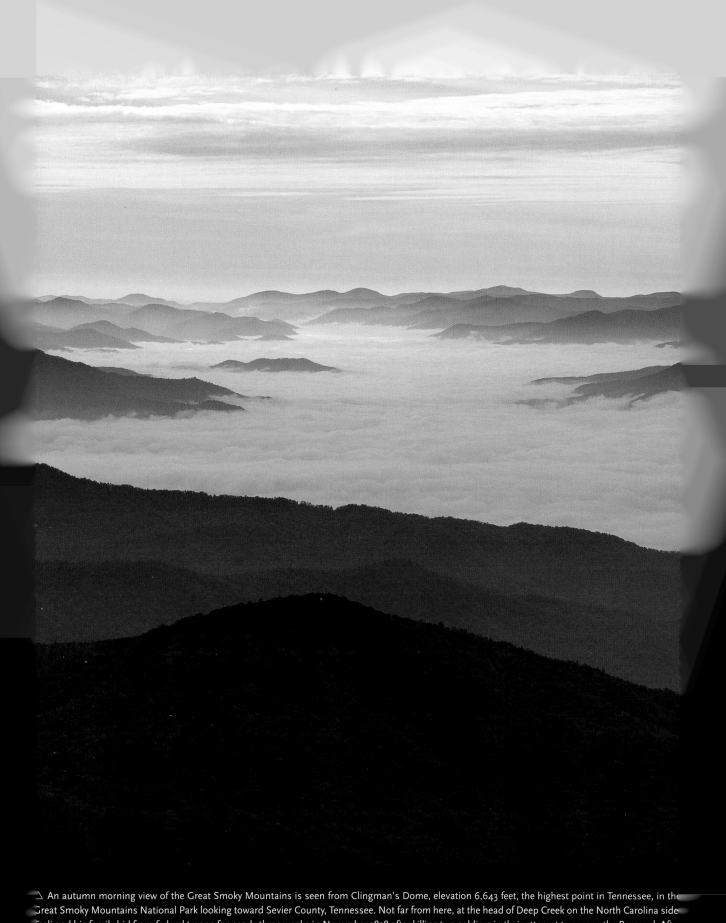

△ An autumn morning view of the Great Smoky Mountains is seen from Clingman's Dome, elevation 6,643 feet, the highest point in Tennessee, in the Great Smoky Mountains National Park looking toward Sevier County, Tennessee. Not far from here, at the head of Deep Creek on the North Carolina side, Tsali and his family hid from federal troops for nearly three weeks in November 1838 after killing two soldiers in their attempt to escape the Removal. After a quick trial, two of his sons and his son-in-law were executed on November 21, 1838. Tsali was killed by Euchella and Wachacha on November 25, the day after the troops left the mountains. Euchella's small band of about 100 fugitives from the Nantahala River was allowed to remain in North Carolina fo

The pressure to remove intensified. Offering larger and larger inducements to remove with only minimal results, the federal government despaired of reaching a treaty with the duly elected representatives of the Cherokee Nation. Unable to convince the legitimate Cherokee government to give up their land, U.S. officials sought to recognize a minority faction as the new leadership with the intent of imposing any treaty they signed on the entire population. The Treaty Party, as it became known, was led by Major Ridge, his son John Ridge, and nephews Elias Boudinot, former editor of the *Cherokee Phoenix*, and Stand Watie.

In the fall of 1835, John Howard Payne, one of the best known writers in America at the time and the author of the poem "Home Sweet Home," was invited to write a history of the Cherokee people, which the national council hoped to use to sway public opinion to the Cherokee cause. Tribal elders knowledgeable in Cherokee oral tradition were employed to assist Payne in this work. Although Payne collected a great deal of information, his effort on behalf of the Cherokees was interrupted by his arrest by the Georgia Guard on December 5, 1835, at the home of John Ross near Cleveland, Tennessee. After a thirteen-day detainment at Camp Benton, Georgia, Payne and Ross were released without charge. Ross immediately left for Washington. Less than two weeks later, the fate of the Cherokee people was sealed. Government officials used the papers confiscated from Payne by the Georgia Guard to discredit Payne, branding him a French spy and an abolitionist. In spite of this, Payne sent a series of scathing anti-Removal articles to various newspapers. Congressmen and senators were as little moved by Payne's writings as they were by the recalcitrant pleas of the Cherokees.

▽ The Vann House, Chatsworth, Georgia, was built in 1804 by James Vann, a wealthy Cherokee chief and polygamist who had three wives and five children. He was killed in 1809 and Joseph Vann, his son, eventually acquired the house and was to become known as "Rich Joe" Vann. The Vann family was removed from their home and plantation. They traveled to and settled at Webbers Falls, Oklahoma.

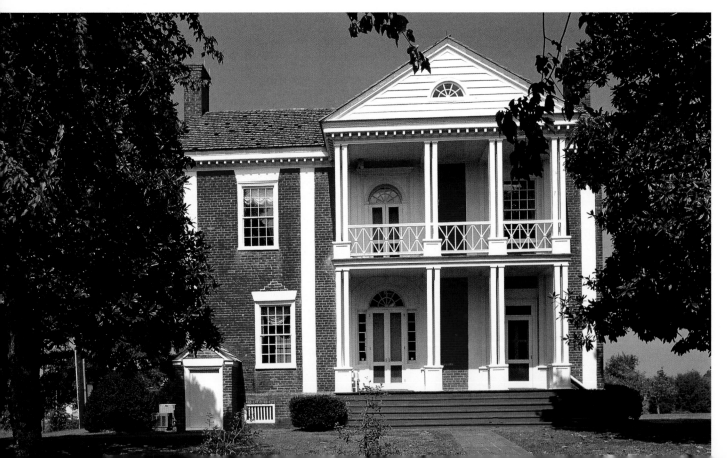

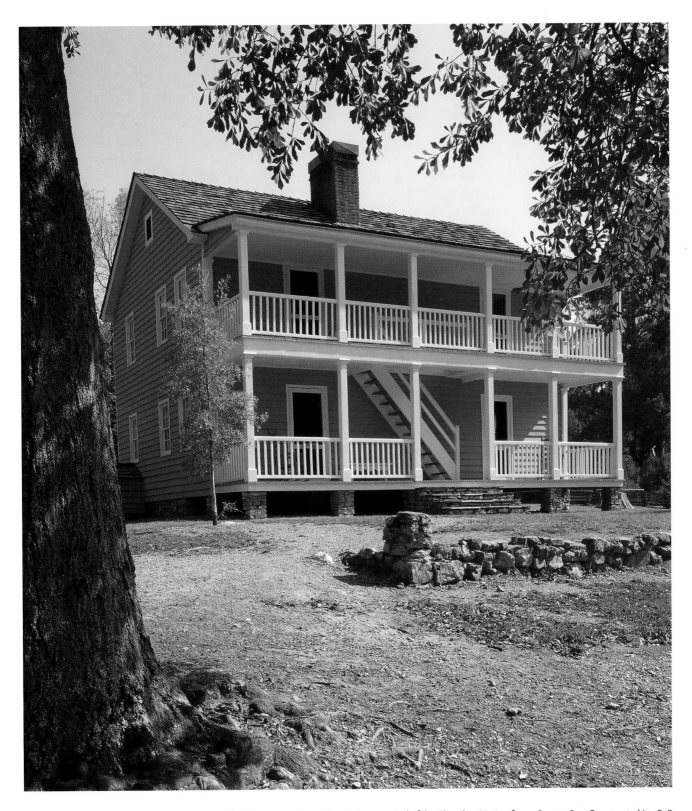

△ The Worcester House is the only pre-Removal building to survive at New Echota, capital of the Cherokee Nation from 1825 to 1832. Constructed in 1828 by Rev. Samuel A. Worcester, it served as a Presbyterian mission station, the New Echota Post Office, and the Worcester family home, Calhoun, Gordon County, Georgia. It was here that Samuel Worcester was arrested by the Georgia Guard. He and another missionary, Elizur Butler, were sentenced to four years at hard labor for failing to take an oath of allegiance to the State of Georgia. A favorable decision by the U.S. Supreme Court (*Worcester v. Georgia*) in 1832 failed to win their release when President Andrew Jackson proclaimed, "John Marshall has made his decision, let him enforce it."

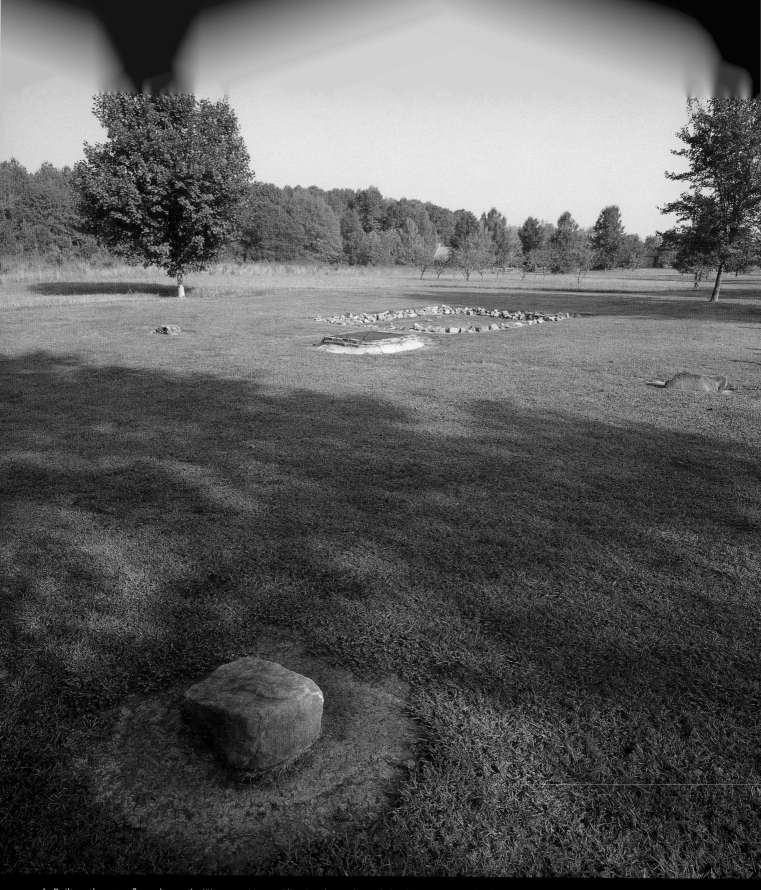

△ Built on the same floor plan as the Worcester House, Elias Boudinot's home helped bring New England architecture to the Cherokee Nation. Elias Boudinot, whose Cherokee name was Galagina or "Buck," was educated at Brainerd Mission and Cornwall Mission School. He was the first editor of the *Cherokee Phoenix*, a national bilingual newspaper that made its debut on February 21, 1828. The Treaty of New Echota was signed in the parlor of Boudinot's home on December 29, 1835. The house was next to the *Cherokee Phoenix* Printing Office, New Echota, Calhoun, Georgia.

▷ A dogwood tree brings life to the sparsely populated area around Smithville, Lawrence County, Arkansas. When the Benge Detachment passed through the area, on December 12, 1838, a local newspaper reported that they were suffering three to four fatalities per day due to illness.

The Treaty of New Echota and Preparation for Removal

CHAPTER II

Unable to conclude a treaty with the duly elected representatives of the Cherokee Nation, the United States signed a treaty with a minority faction on December 29, 1835. In spite of petitions with 15,656 Cherokee signatures denouncing the treaty as a fraud, the U.S. Senate ratified the treaty on May 23, 1836. Under the provisions of the treaty, the Cherokees were given two years in which to voluntarily remove from their ancestral homeland. By the spring of 1838, only two thousand Cherokees had immigrated to the Indian Territory. The federal government realized that the Indians could only be removed by force, and sent Major General Winfield Scott with a sizable army of federal and state troops to forcefully remove the Cherokee people from their homeland. In the ten months prior to Scott's arrival, his predecessor Colonel William Lindsay had built up a force of thirty militia companies, established twenty-three posts for the troops, collected ordnance stores at Fort Cass and subsistence stores at various strategic locations, and supplied hospitals at Fort Cass and Cantonment Wool near Missionary Ridge.

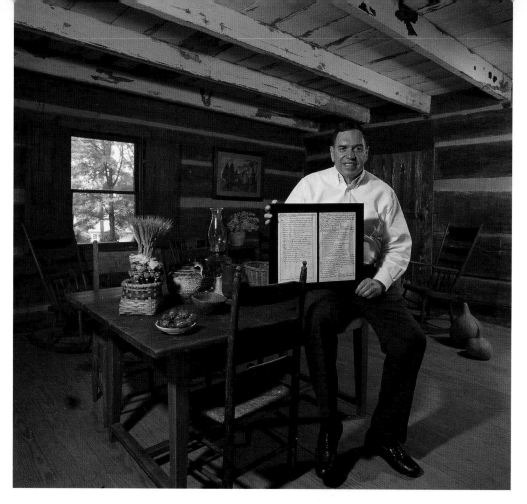

△ In preparation for the Removal the U.S. government sent agents to the Cherokee Nation to evaluate property held by individuals. Cherokees who agreed to voluntarily remove were promised quick payments for property losses. Those that were forcefully removed were still filing spoliation claims into the 1840s. The property evaluations and the spoliation claims provide considerable insights into the extent of the improvements and personal property held by Cherokee families at the time of Removal. Jack Baker, a member of the Cherokee Nation Tribal Council and a fifth-great grandson of Hair Conrad, is shown inside the Conrad Home with the 1836 property evaluation. The Conrad Home is one of the few pre-Removal Cherokee dwellings in the east that has remained virtually unchanged since the original owners were forced out in 1838.

Scott arrived in Athens, Tennessee, on May 8, 1838, and issued his first orders from there on May 10. The federal troops under General Scott totaled about twenty-two hundred men and included elements of the First, Second, Third, and Fourth Artillery, the Fourth Infantry, six companies of the Second Dragoons detailed to the Fourth Infantry, and a battalion of U.S. Marines. The combined units were officially known as the Army of the Cherokee Nation. A battalion of Tennessee militia was added to Scott's original call for state troops, bringing the total of militia to about four thousand men. This included two regiments from Georgia, one each from North Carolina and Alabama, and one and a half regiments from Tennessee. In all, approximately seven thousand federal and state troops comprised the Army of the Cherokee Nation by early June 1838.

In contrast to the federal troops who were professional soldiers, the state volunteers generally tried to make up for poor training and discipline with enthusiasm for assigned tasks. For this reason the state troops were frequently as much of a problem to friends as they were to foes.

On May 23, 1838, when the two years allowed for voluntary removal had expired, only two thousand Cherokees had departed for the West. A few days later the military roundup began.

A. E. Blunt, a missionary for the American Board of Commissioners for Foreign Missions, wrote from Candy's Creek Station on May 28, 1838:

The long looked for day (23rd of May) however as much was it desired by some and feared by others has arrived. Notwithstanding the prospects before us have looked appalling, it has been a matter of surprise to see the steady onward course of the Cherokees. I have heard it remembered by persons traveling in various parts of the Nation (Ga. excepted) that the people were never so forward in their crops and never appeared as industrious as at the present crisis. The movements in the whole country for several weeks past seemed to indicate war. The arrival of the military—cannon, powder, lead, and boxes of arms—has indeed looked like the shedding of blood. But . . . no enemy has been found to contend with, and while some of the volunteers have been most insulting, in some instances, the people have borne it patiently and have gone on, attending to their business.

For some days previous to the 23rd, the military were riding through the country ordering the Cherokees to report to certain points for emigration before the expiration of the time specified by the fraudulent treaty. All seems to have no effect. Onward, seems to be the motto of all the Cherokees. We have justice on our side let come what will, and some have told the officers that they should continue to attend to their own business until forced at the point of the bayonet.

During all the storms which has clouded the nation there has been no sudden alarms or fright with the Cherokees, while on the other hand the whites in some instances have removed out of the Nation and many have been ready to start at the rustling of a leaf.[15]

▽ This military map titled "Supposed Places, Forts, Posts, Routes, and Distances in the Cherokee Nation" was drawn by Lieut. E. D. Keys in 1838. The map, with its wealth of detail, was drawn for the benefit of military couriers between forts. The map is in the collection of the Museum of the Cherokee Indian, Cherokee, Swain County, North Carolina.

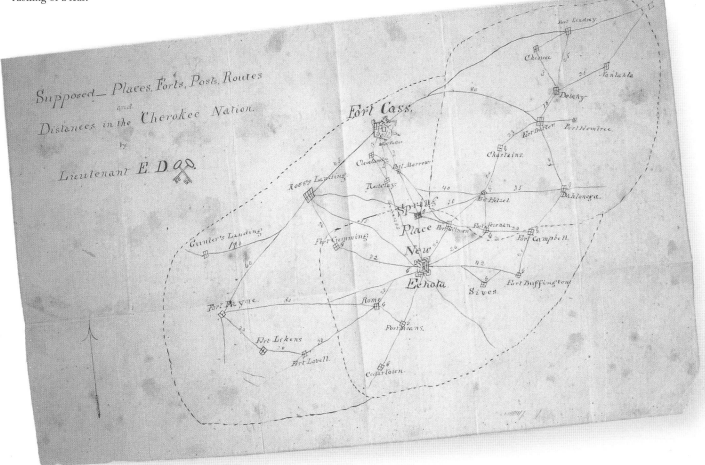

Stephen Foreman, a mixed-blood Cherokee in Tennessee, explained why he and other Cherokees did not surrender:

...much longer we shall be permitted to remain here among our lands, to enjoy our ...privileges, I do not know. From the present aspect of affairs, we shall very soon be without house and home. Indeed, ever since the 23rd of May, we have been looking almost daily for the soldiers to come, and turn us out of our houses. They have already warned us to make preparations, and come in to camps, before were forced to do so. But I have stated distinctly to some of the officers at Head quarters, what I thought of this so called treaty and what course I intended to pursue in the event no new treaty was made; and see no reason yet why I should change my mind. My determination, and the determination of a large majority of the Cherokees, yet in the Nation is, never to recognize this fraudulent instrument as a treaty nor remove under it until we are forced to do so at the point of the bayonet. It may seem unwise and hazardous to the framers and friends of this instrument, that we should pursue such a course; but I am fully satisfied it is the only one we can pursue with clear consciences.[16]

The Military Roundup

The military roundup began on May 26, 1838, in Georgia. Within a ... of Georgia militia under Brigadier General Charles ... confined in makeshift stockades most of the Cherokees in that state. ... May 30 and June 9, 1838, a total of 3,636 prisoners from the middle military district of the Cherokee Nation[17] were assembled near Ross's Landing,[18] one of the principal emigrating depots. Other internment forts included Rattlesnake Spring, Mouse Creek, Bedwell Springs, Chestooee, the Upper Chatate, and Gunstocker Spring, thirteen miles from Calhoun, Tennessee. One group of Cherokees refused to leave the mountains of North Carolina, claiming that the 1835 census did not apply to them and that an 1819 treaty gave them American citizenship on lands not belonging to the Cherokee Nation. Known as the Oconaluftee Cherokees, this band eventually was allowed to stay and became the Eastern Band of Cherokees, who still reside in North Carolina.

Conditions at the forts were deplorable and death and illness rampant. Some Cherokees were held for more than five months before being

...ter most of the Cherokee population became prisoners, Principal Chief John Ross and a Cherokee delegation were still in Washington engaged in political maneuvering to attempt to avoid or at least postpone the Removal. The pleas for more time, however, were to no avail.

'How much longer we shall be permitted to remain here among our lands, to enjoy our rights and privileges, I do not know.'

▽ The personal effects of Principal Chief John Ross were brought to the Indian Territory on the steamboat *Victoria* (December 5, 1838 to March 18, 1839). This soup bowl is from Ross's place setting from Rose Cottage, his Park Hill residence from 1844 to 1863. (Collection of the Cherokee National Museum, Tahlequah, Oklahoma)

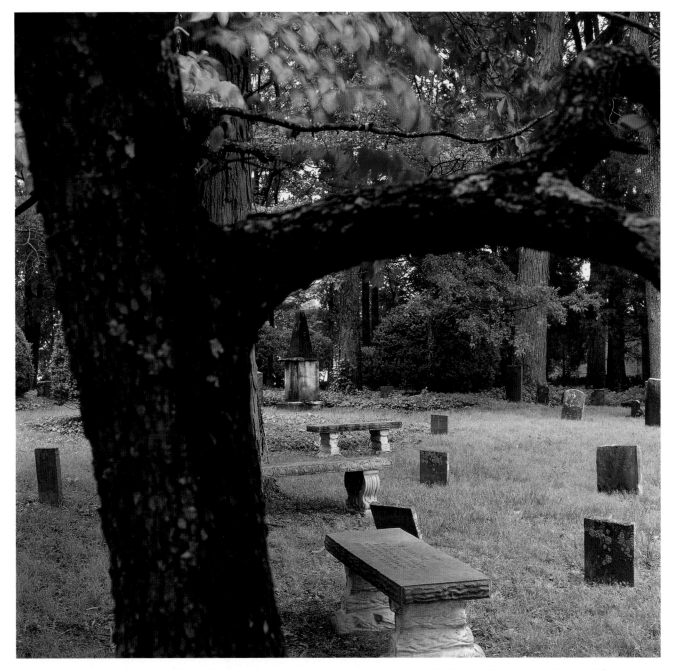

△ Today only the grave markers in the Brainerd Mission Cemetery serve as a physical reminder of the Brainerd Mission, which flourished for more than twenty years prior to the Removal. It was established on Chickamauga Creek near Chattanooga, Hamilton County, Tennessee, in 1817 to educate and Christianize the Cherokees. The history of the mission and the people who lived and studied here is well-documented through the missionary records. During the Removal the mission served as a stopping point and hospital for Cherokees forced from Georgia to the internment camps near Ross's Landing. Members of the Brainerd Church traveled together to the west as part of Richard Taylor's eleventh detachment from October 1, 1838, until March 22, 1839. The Bell Detachment also passed by here in October 1838 on their way to the ferry at Ross's Landing.

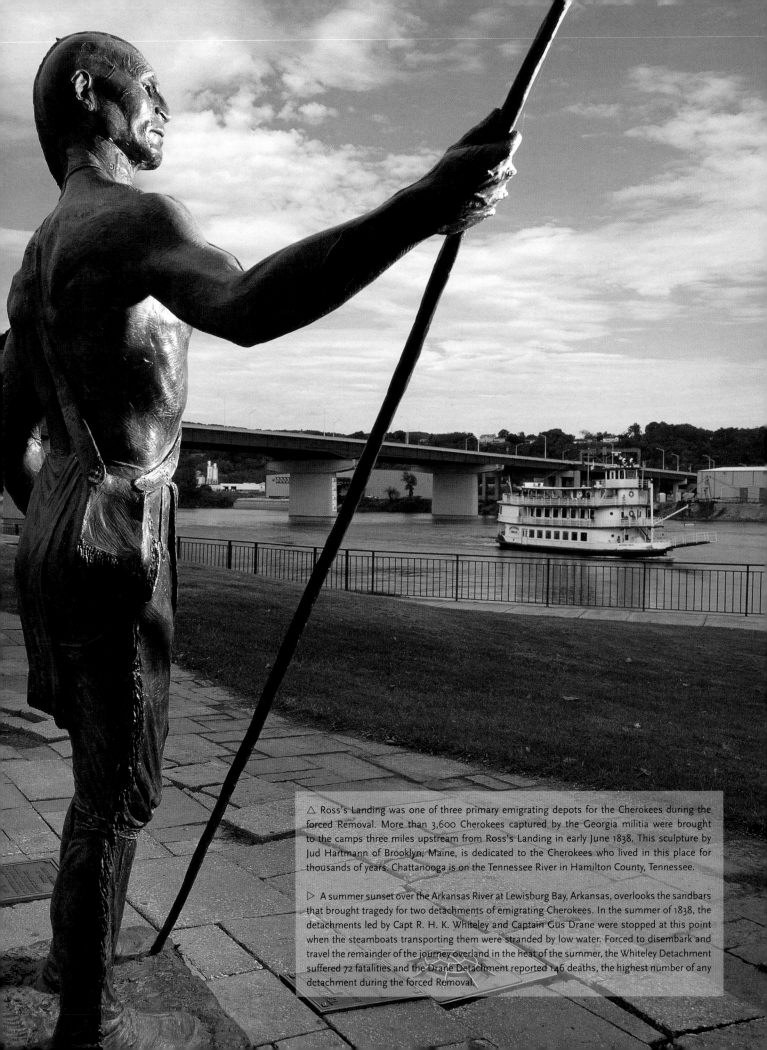

△ Ross's Landing was one of three primary emigrating depots for the Cherokees during the forced Removal. More than 3,600 Cherokees captured by the Georgia militia were brought to the camps three miles upstream from Ross's Landing in early June 1838. This sculpture by Jud Hartmann of Brooklyn, Maine, is dedicated to the Cherokees who lived in this place for thousands of years. Chattanooga is on the Tennessee River in Hamilton County, Tennessee.

▷ A summer sunset over the Arkansas River at Lewisburg Bay, Arkansas, overlooks the sandbars that brought tragedy for two detachments of emigrating Cherokees. In the summer of 1838, the detachments led by Capt R. H. K. Whiteley and Captain Gus Drane were stopped at this point when the steamboats transporting them were stranded by low water. Forced to disembark and travel the remainder of the journey overland in the heat of the summer, the Whiteley Detachment suffered 72 fatalities and the Drane Detachment reported 146 deaths, the highest number of any detachment during the forced Removal.

THE WATER ROUTE
DETACHMENTS

CHAPTER III

Of the seventeen detachments that made the journey during the period of forced Removal, only four traveled with military escort. The first three left Ross's Landing in June 1838, under very adverse conditions. The detachments consisted primarily of Georgia Cherokees who were strongly opposed to Removal and were uncooperative with the military. The fourth detachment with a military conductor was the Bell Detachment, which left the Cherokee Agency near Calhoun on October 11, 1838, and arrived in the Indian Territory on January 7, 1839, going overland through Memphis. The remaining thirteen detachments were under the supervision of John Ross and all had Cherokee conductors. Twelve of these went overland, and one, consisting primarily of aged and incapacitated individuals, journeyed by water. Of the twelve Ross Detachments that went overland, eleven made the journey via the preferred route of Nashville, Golconda, and Springfield. The other detachment, led by John Benge, took a route that crossed the Tennessee

River at Gunter's Landing, again at Reynoldsburg, and crossed the Mississippi River at the Iron Banks in Kentucky.

Departure from Ross's Landing

General Nathanial Smith, superintendent for the Removal, ordered swift departures of the detachments of Georgia Cherokees. The *Niles Register* reported:

> Then came the shipping off to the west. The agent endeavored to induce them to go into the boats voluntarily; but none would agree to go. The agent then struck a line through the camp; the soldiers rushed in and drove the devoted victims into the boats, regardless of the cries and agonies of the poor helpless sufferers. In this cruel work, the most painful separations of families occurred. Children were sent off and parents left, and so of other relations.[19]

The first detachment, which departed Ross's Landing on June 6, 1838, was much more fortunate than the two that followed. This detachment under Lieutenant Edward Deas made the trip in only seventeen days and had no deaths en route. In sharp contrast, the parties led by Captain Drane and Lieutenant Whiteley took considerably longer and had numerous deaths. Drane reported 146 and Whiteley reported 70.[20] Whiteley left six days after Deas on June 12, and arrived at his destination in the Flint district on August 5, almost two months after Deas reached Fort Coffee. The detachment under Captain Drane left Ross's Landing on June 17, arrived at Webber's Plantation in the Indian Territory on September 4, and turned over the detachment to an officer from Fort Gibson on September 7, 1838.

Both of the latter detachments were stranded by low water just below Lewisburg, Arkansas, and forced to travel overland the remainder of the journey during the peak of the summer. In addition to hot, dry, dusty conditions, both detachments suffered from excessive sickness along the way. Toward the end of the journey, Whiteley had to halt the detachment because more than half the members were sick.

All three detachments were comprised of Cherokees who were removed from their homes at the point of a bayonet, crowded onto wagons, boats, and trains, and kept under guard until they left the Cherokee Nation. They were poorly fed, badly treated, and when afforded an opportunity, attempted to escape. Their plight was used in the propaganda war against the government to further embarrass the military, and to play into the hands of opportunists seeking to profit from the transportation and supply contracts.

General Winfield Scott, military commander for the Removal, had

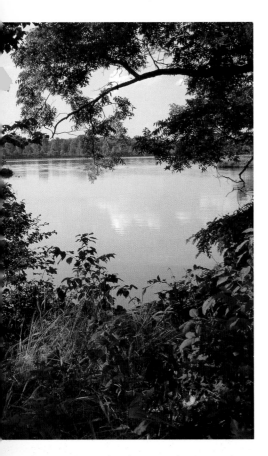

△ Lt. Edward Deas with 484 people on board the steamboat *Smelter* reached Ft. Coffee, Indian Territory, near sunset on June 19, 1838, after a journey of only thirteen days from Ross's Landing. It was the only Cherokee detachment during the forced Removal that did not suffer a single fatality en route. The detachment disembarked and camped on the north bank of the river, opposite the fort. This view of the Arkansas River is from its south bank, just northwest of the site of old Ft. Coffee, at the same time of year that the Cherokees arrived. LeFlore County, Oklahoma, is in the foreground and Sequoyah County is across the river.

◁ (top) Only the foundation of the Tuscumbia Landing train depot survives today. In June 1838 the water route of the Deas Detachment traveled sixty miles by train from Decatur, Alabama, to Tuscumbia Landing to board steamboats. The limestone block foundation built in the mid-1830s is located within Park West, owned by the City of Sheffield, Lawrence County, Alabama.

(bottom) Tuscumbia Landing was a place where water and land transportation routes intersected in the 1830s. In 1838, one of the earliest railroads in the United States circumvented the most difficult stretch of the Tennessee River to navigate, bypassing Muscle Shoals. At this landing the steamboat *Smelter* met Cherokee emigrants of the Deas and later, the Whiteley detachments to take them down the Tennessee, the Ohio, the Mississippi, and then up the Arkansas River to the Indian Territory.

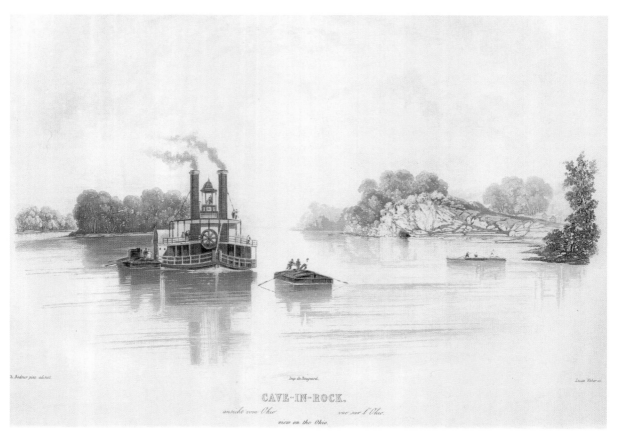

CAVE-IN-ROCK.

ansicht vom Ohio *vue sur l'Ohio*

view on the Ohio.

△ This steamboat is representative of those used on the Water Route of the Cherokee Removal. This illustration is by Karl Bodmer, a native of Zurich, Switzerland, who was part of German Prince Maximilian's expedition across the American West. From 1832 to 1834, Bodmer made detailed illustrations of the life, habits, and customs of the Indians. (Courtesy of the Oklahoma Historical Society)

hoped to use the three detachments as an example of military efficiency and evenhandedness. Instead the military appeared as the instrument of oppression and invoked ridicule and scorn even by the citizenry who were indifferent toward Removal. His motivation for moving the Georgia Cherokees out quickly may have been, in part, to demonstrate military resolve and competency but also to expediently dismiss the state militia.

The reports of death and suffering brought back to concentration camps in East Tennessee by escapees pleading for help had a profound effect on the strategy of the Cherokee leadership as well as the disposition of the military officials in charge of the Removal. Almost immediately, the adversarial groups began a dialogue that resulted in a postponement of the departure of the remaining detachments until after the summer season, arrangements for the Cherokees to superintend their own Removal, and the choice by most of the remaining Cherokees of the overland route necessitated by water levels purported to be too low for steamboat passage. In spite of earlier predictions that the water route and overland route would cost approximately the same, the land route proved more expensive primarily because of the amount of time involved. The selection of the overland route was most fortunate for the agents and contractors appointed by John Ross as they had more to gain in profits from a lengthy trek, and for the credibility of the Principal Chief, who had repeatedly warned that the Removal could be very costly for the government.[21]

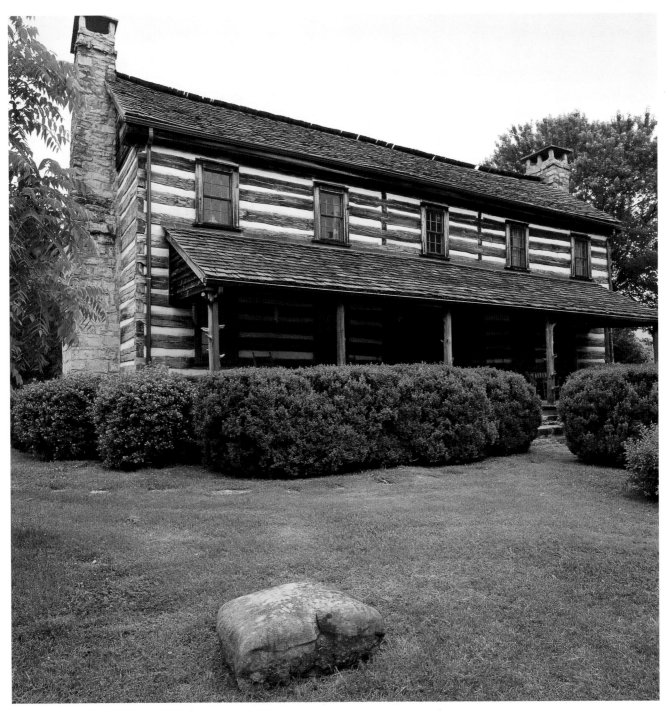

△ John Brown's Ferry Tavern was built about 1803, near Chattanooga, Hamilton County, Tennessee. It is made of chestnut logs with hand-cut stone chimneys. The "upping stone" in the foreground helped folks mount horses. It is said John and Quatie Ross spent their wedding night upstairs at the inn. In 1838, the site was a stopping point for the Bell and Drane detachments and a staging area for the Whiteley Detachment augmenting his group with new arrivals.

△ The asphalt of a gated driveway covers the historic Savannah Road that leads down to Robinson Ferry landing. On November 11–12, 1838, nearly 660 people with 56 wagons and 318 horses lined the approach to the river waiting for their turn to be ferried across. It was the fourth and final time the detachment crossed the Tennessee River on their journey to the Indian Territory. Today this portion of the historic road is the private driveway for Cherry Mansion, a fashionable home built in 1835 with revenues from the lucrative ferry operation. The "S" on the wrought-iron gate silhouetted on the pavement stands for Savannah.

▷ Completed in 1829, the historic Military Road was the first improved route between Memphis, Tennessee, and Little Rock, Arkansas. This well-preserved portion of the road is visible in today's Village Creek State Park. Bell's detachment traveled this route in November 1828. Cross County in eastern Arkansas

THE BELL ROUTE

A detachment of 660 Treaty Party Cherokees departed the primary emigrating depot at Fort Cass near Calhoun, Tennessee, on October 11, 1838, for an arduous journey to the Indian Territory. They traveled 707 miles in 89 days and disbanded at Vinyard Post Office near present-day Evansville, Arkansas, on January 7, 1839. John A. Bell, a mixed-blood Cherokee, conducted the detachment and Lieutenant Edward Deas, U.S. Army, served as the disbursing agent.

The Bell Detachment was the only one that traveled overland during the period of forced Removal that was not under the supervision of Principal Chief John Ross. It was also the only detachment to take the southern route through Memphis and Little Rock. Although this was the most direct route, it was also the least preferred due to the general condition of the roads across the bayous of eastern Arkansas and the belief that corn and fodder for large numbers of people and horses would be more difficult to

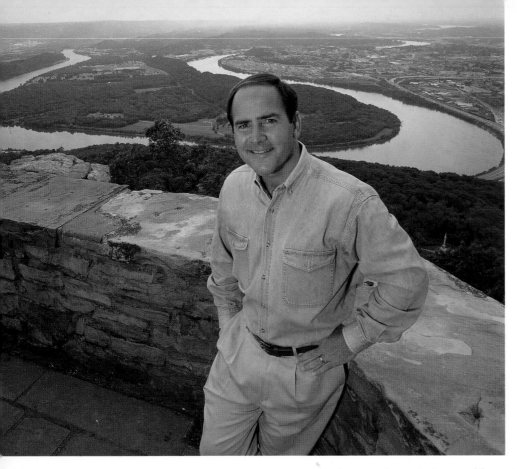

△ Congressman Zach Wamp stands at the Ochs Observatory in Point Park, Chickamauga-Chattanooga National Military Park, on Lookout Mountain in Chattanooga, Hamilton County, Tennessee. In the background is Moccasin Bend National Park, a historic and archaeological landmark. In February 2003 Representative Wamp was responsible for legislation establishing Moccasin Bend as a unit of the National Park System. Moccasin Bend is surrounded by water routes and land routes of the Cherokee Trail of Tears. Congressman Wamp also sponsored the Trail of Tears Study Act, recently signed into law, that directs the National Park Service to finish research on routes used by American Indians during the forced Removal from their ancestral homeland.

▷ Cherry Mansion is the oldest home in Savannah, Hardin County, Tennessee. It was built in 1835 by ferry operator David Robinson. It was later enlarged by his son-in-law, William Cherry. On November 11–12, 1838, the Bell Detachment paid Alex F. Robinson for ferriage across the Tennessee River at this ferry. At the left of the photo is the road that leads down to the ferry landing directly north of the mansion.

obtain in sparsely settled areas. The primary reason for choosing this route, however, may have been simply to avoid contact with the Ross Detachments, who were vehemently opposed to the position taken by a small minority of Cherokees, including members of the Bell Detachment, who supported the Treaty of New Echota, which ceded the last remaining part of the Cherokee homeland to the federal government.

Fifty-six wagons and 318 horses transported the detachment. The U.S. government paid $21,251.25 to hire the wagons, which were owned by thirty-eight individuals, all members of this detachment. Of the fifty-six wagons, twenty-seven were pulled by five horses, seventeen by four horses, six by three horses, and six were two-horse carriages or carryalls. The Burr Postal Map of 1839 classifies the quality of roads in the southern states into four categories: four-horse mail post coach road, two-horse stage road, one-horse mail or sulkey road, and cross road. Half the wagons of the Bell Detachment were pulled by five horses, which suggests that they were substantial in size and weight, and their travel would have been confined to the more improved roads of the day. Of the 660 people who began the journey, twenty-one died en route. Much of what we know about this detachment and their journey comes from the records of Lieutenant Edward Deas, Fourth Artillery, who in his capacity as the disbursing agent kept the financial records for the detachment. Because of his receipts for payments of bridge and ferry crossings, and purchases of supplies from people whose identities and locations are known, fixed landmarks can be ascribed with dates charting the detachment's progress. It is the process of

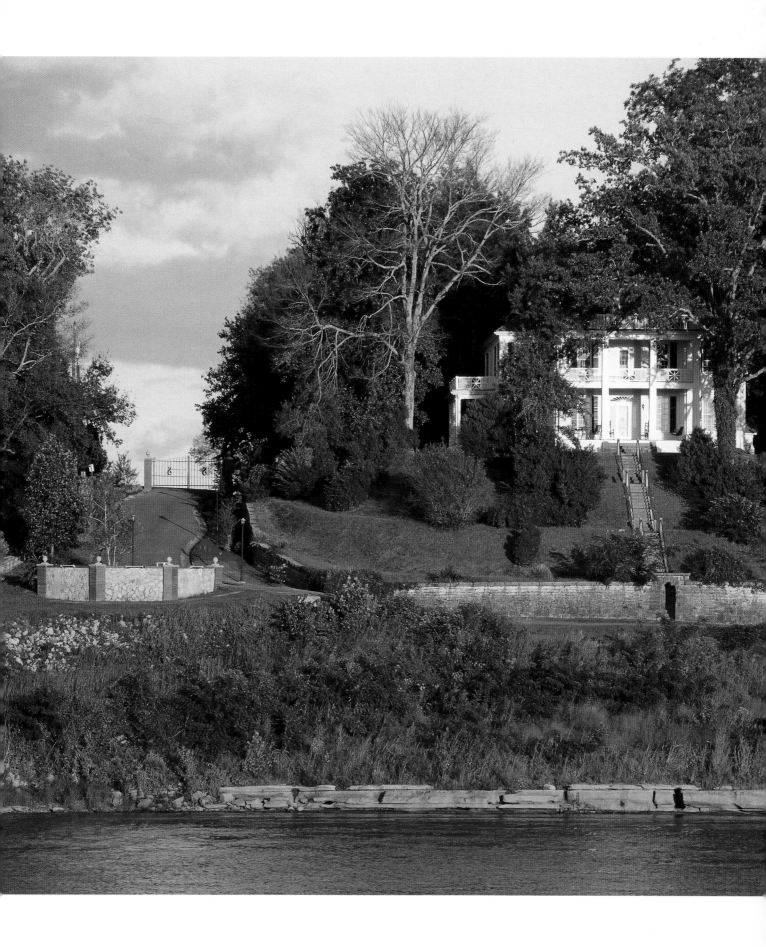

connecting these landmarks with lines corresponding to known roads in 1838 that provides speculation about the route traveled by the detachment across Arkansas.

Lieutenant Edward Deas: Disbursing Agent

At the time, Deas was twenty-six years old and had accompanied two previous detachments by water to the Indian Territory earlier in the year. Deas kept "Journals of Occurrences" to document his travel, and submitted these to the War Department after each trip. Unfortunately, his journal for this trip has not been seen since 1840, and Deas died seven years later—drowned in the Rio Grande during the Mexican War.

Deas references the journal in a subsequent letter he wrote after the Removal, and T. Hartley Crawford, then Commissioner of Indian Affairs, gave a detailed description of it:[22]

> The distance, upon examination of the journal transmitted by Lieutenant Deas, of the army of the United States, who was disbursing agent of the treaty party conducted by John A. Bell, appears to be, by the route they took, but 707 miles, which they performed in 89 days, from the 11th October to 7th January, 1839, both inclusive. They traveled very leisurely, making for one only 18 miles; for three days 15 miles each; for five days respectively, 13 miles; for one 14; for fifteen days, severally, 12 miles; and for the residue of the travel, various distances, running for 4 to 11 miles. They were stationary, and spent eleven days crossing the several rivers in their way.

Crawford encourages readers to examine the journal kept by Deas. Crawford obviously had Deas's journal in his possession at the time he wrote this report in August of 1840, but it has never been referenced in the literature since. The correspondence and journals from Deas received by C. A. Harris, who was unceremoniously ousted as Commissioner of Indian Affairs in November 1838, were promptly catalogued and survive today in the National Archives; however, those received after Crawford came to office have not survived. The whereabouts of Deas's journal for the Bell Detachment, perhaps the single most important document on the Cherokee Removal to have been written, is unknown.

Traveling through Tennessee

One letter Deas wrote to General Scott from opposite Ross's Landing on Thursday, October 18, 1838, reported:

△ Prior to the Removal, Cherokee delegations sent to inspect the new territory brought back reports of barren deserts with "only carcasses of timber." Anxiety gave way to relief when surviving immigrants arrived in 1839 to find the Cherokee portion of the Indian Territory with adequate water and timber as this scene of fall foliage along the Illinois River, near Tahlequah, Cherokee County, Oklahoma, suggests.

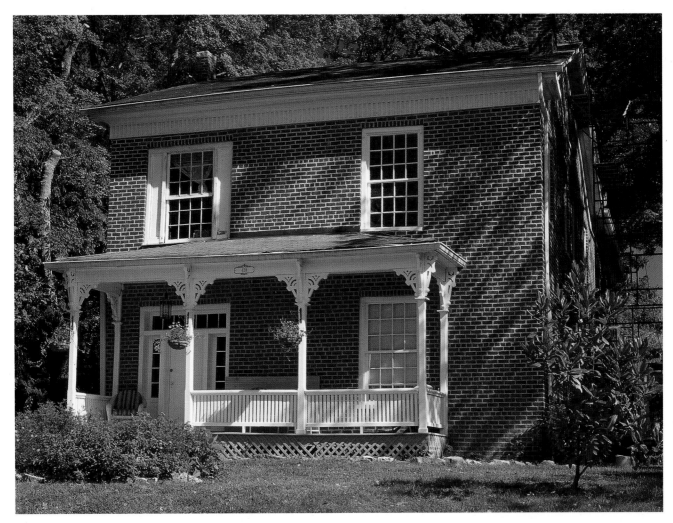

The day before yesterday and the forenoon of yesterday were consumed in the Ferrying the Tennessee in an attempt to start the party. After crossing, I found many of the people unwilling to proceed in consequence of the absence of the Conductor Mr. John Bell. . . . Unless Mr. Bell on his arrival shall be able to infuse a more reasonable spirit into many of the Emigrants composing this party, I am entirely of the opinion that nothing but Force will be able to make them consult their own interest and proceed quietly upon the Route to the West.

On that day, Deas paid Samuel Hamill fifty dollars, "For the ferriage over the Tennessee River at Ross's Landing of a Party of 650 Cherokees together with the wagons Teams Saddle Horses, and also the Agents accompanying them." On October 19, Deas reported another ferry crossing of the Tennessee River, this time in Hamilton County, Tennessee.

On October 22, 1838, the detachment crossed the Tennessee River for a third time, using John Kelley's ferry near Jasper, Tennessee, after which Lieutenant Deas wrote to General Winfield Scott:

△ The Henegar House in Charleston, Bradley County, Tennessee, was built shortly after the Removal on the site of Fort Cass barracks. Some of the building materials may have been taken from buildings in the fort. Capt. H. B. Henegar accompanied the eleventh detachment conducted by Captain Richard Taylor on the Trail of Tears. Henegar, who served as the commissary for the detachment, returned to Tennessee after the detachment was disbanded on March 22, 1839. He recounted his experiences during the Removal for an area newspaper in 1899.

△ The Old Stage Road, now known as old Highway 15, near Hornsby, Tennessee, was used by Cherokee emigrants in 1838. This road segment extends west from Powell Chapel Road and leads to Bolivar. Bell's detachment traveled this road in November 1838. Hardeman County is in southwestern Tennessee.

It having been necessary, by the route we travel, to cross the Tennessee River three times, our progress thus far has been slow, but after crossing the Cumberland Mountains our rate of traveling will be very different.

It is apparent from Deas's payment vouchers that he did not pay for ferriage across the Sequatchie River or Battle Creek, as did the Drane Detachment a few months earlier. Although both detachments would have crossed these streams, it is possible they were on different roads leading to Jasper. The Bell Detachment, on a more northerly route, may have forded both streams.

West of Jasper, Tennessee, Deas wrote three additional letters during the journey to C. A. Harris, Commissioner of Indian Affairs.

On October 27, 1838, near Winchester, Tennessee, Deas wrote:

I left the vicinity of the Cherokee Agency on the 11th instant in charge of this party, but up to this time our progress has been necessarily slow, in consequence of the obstructions in the roads over which we have passed.

A week later on November 3, 1838, Deas reported:

. . . we have pursued the direct road thro' Fayetville [sic] and Pulaski leading to Memphis part of which we found very rough, but our rate of traveling has averaged between 10 and 12 miles a day. Nothing of much importance has taken place since I last wrote. Some of the Indians have lost a number of oxen from eating poisonous weeds, but the progress of the party was not interrupted on that account. The people are generally healthy, and everything relative to our movements is at present going on well.

From the vouchers of Edward Deas it is possible to determine that the detachment traveled a route that approximates the alignment of present-day Highway 64 through middle and west Tennessee. They were at the head of Battle Creek from October 23 to 24, and on the Cumberland Mountain on October 25. They reached Savannah, Tennessee, on November 10, where they crossed the Tennessee River on November 11 and 12. They also paid James Graham for corn and fodder, the only significance of this fact being that Graham's house is still standing today. On November 16, they were in Bolivar and paid tolls for bridge crossings of the Hatchee River and adjacent swamps. On November 20 and 21, they were near Raleigh, Tennessee, where they paid Adam Alexander and William Woodson for supplies. These vouchers suggest a departure from the present alignment of Highway 64 and a more direct western path along present-day State Highway 15, reaching the river just north of the present I-40 Bridge.

'. . . we have pursued the direct road thro' Fayetville [sic] and Pulaski leading to Memphis part of which we found very rough, but our rate of traveling has averaged between 10 and 12 miles a day."

Entering Arkansas

Deas wrote to Commissioner Harris on November 24, 1838, from just west of Memphis:

> The Party of Cherokees Emigrating under my Superintendence has just finished the crossing of the Mississippi, and we shall set out again tomorrow morning in the direction of Little Rock.
>
> Nothing of particular importance has occurred worthy of being mentioned since I last had the honor to address you upon this subject, on the 3rd instant.
>
> Every thing relating to our progress has gone on well since that time, excepting some delay in the crossing of the River at this place, caused by the breaking of the Steam Ferry Boat.
>
> Yesterday I shipped up the Arkansas River a considerable quantity of the baggage, potware, on very low terms, which I think will result in a good deal of saving in time and expense.

As early as October 22, while still in east Tennessee, Deas expressed concern about the route west of the Mississippi. Writing to General Scott, he stated:

> I have concluded that we had better pursue the Route by Memphis, provided the people themselves are willing to do so. The latter must be more than 150 miles shorter, than the Route thro' Missouri, and the cost thus saved, would far more than pay the extra expense of running round the Mississippi Swamp by water, to North-Row on White River, should the road thro' the Swamp, be found in a bad state for wagons, upon our arrival at Memphis, which I can scarcely believe will be the case.

Deas had proposed to move the detachment down the Mississippi River from Memphis to the White River cutoff and then presumably overland along the Arkansas River to the Indian Territory. Deas had made the journey west with two other detachments by water earlier in the year and was familiar with the terrain.

At Memphis, however, he reported:

> I hear agreeably to the expectation which I entertained that the roads west of this through the Mississippi and White River Bottoms are in very good order for the present season, and I therefore hope we shall be able to proceed on our journey with as much rapidity as we have hither been able to travel; and unless great changes would take place we shall have every cause to congratulate ourselves on having taken the lower Route, for the reasons which I have mentioned in a former communication.

△ Sequoyah, inventor of the Cherokee writing system, lived on the Illinois Bayou in Arkansas for some years prior to 1828 when the Arkansas lands were ceded to the U.S. government. In 1838, three detachments of emigrating Cherokees—Whiteley, Drane, and Bell—crossed the Illinois Bayou on their way to the Indian Territory. The Illinois Bayou flows into Lake Dardanelle between Russellville and London, Arkansas.

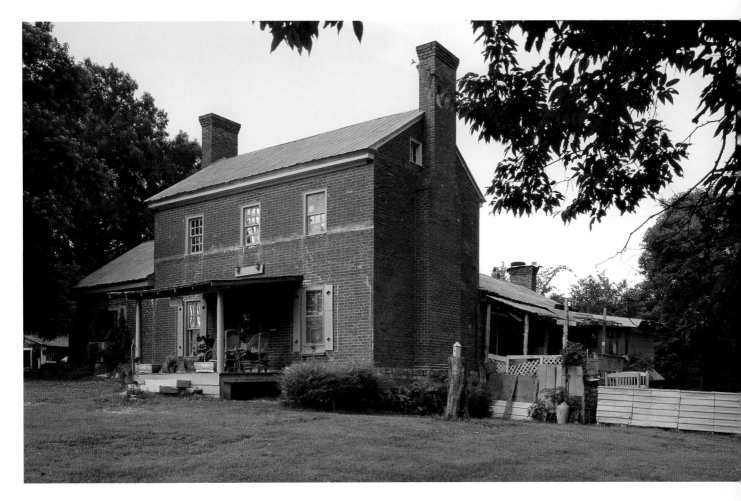

Deas's vouchers indicate that he paid for ferriage across Black Fish Lake and the St. Francis River, bought supplies from William A. Strong in St. Francis County, paid one of his employees at Langee Creek, bought supplies from John Cotton in Monroe County, and ferried the White River at the mouth of Cache Creek. The *Arkansas Gazette* reported that a detachment of Cherokee spent two nights in warehouses in north Little Rock in mid-December. The vouchers verify that they crossed the toll bridge at Palarm Bayou and were ferried across Point Remove Creek. They made purchases at Horsehead Creek and Frog Bayou. The last vouchers were for payments made at Vinyard Post Office at the time the detachment was disbanded.

Although connecting the known landmarks associated with this detachment using twentieth-century highway maps is not possible, it is easy to do so using nineteenth-century maps drawn within a quarter century of the Removal. In fact, using three cartographic sources, an 1833 map for the forty-mile stretch of the new Military Road west of Memphis, the township and range survey maps in the General Land Office in Little Rock that date between 1815 and 1854, and a map of Arkansas compiled from surveys and military reconnaissance during the Civil War, it is apparent that the known stopping points all fall on the most logical route that the Bell Detachment could have taken in 1838 to 1839.

△ The James Graham House was built between 1822 and 1825, in Savannah, Hardin County, Tennessee. Graham, a wealthy farmer, built this two-story brick home on his plantation. On November 13, 1838, he was paid for corn and fodder to feed the Bell Detachment, and was also reimbursed for transporting his goods on the ferry across the Tennessee River.

△ An extant section of the Old Military Road in Village Creek State Park, Cross County, Arkansas, was traveled by members of the Bell Detachment in early December 1838. Completed in 1829, the historic Military Road was the first improved route between Memphis, Tennessee, and Little Rock, Arkansas. One of its purposes was to facilitate Indian Removal from the southeastern United States. Choctaws, Chickasaws, Creeks, and one detachment of Cherokees followed this road on their journey to the Indian Territory in the 1830s.

▷ Henard Cemetery Road was part of the Old Military Road constructed in the late 1820s in Monroe County, Arkansas. The Bell Detachment traveled this road in early December 1838.

Road in Arkansas

Until the second quarter of the nineteenth century overland travel across Arkansas was extremely difficult if not impossible. In 1825, the *Arkansas Gazette* reported:

> The actual distance from Little Rock to Memphis, on a straight line, is 128 miles by the present mail route between the two places, via the Post of Arkansas and Helena, it is nearly 300 miles by the nearest route heretofore traveled, it is upwards of 200, and neither of these routes is passable when the waters are high; and at no time can they be traveled by carriages of any description. . . . By the new route marked by the Commissioners, the distance is reduced to 135 1/2 miles.

On March 20, 1827, the *Arkansas Gazette* included an advertisement for the construction of bridges. The plans for the new road called for at least ten bridges in the first sixty miles west of the Mississippi River. It is believed that the Ross Detachment followed this route just beyond Black Fish Lake where they then took a lower route labeled simply "Military Road" on an 1833 map.

The Military Road was not only used by the Cherokees, but by other emigrating southeastern Indians as well. In July 1837, a party of five hundred Chickasaws removing to the Indian Territory traveled this stretch of road between Memphis and Little Rock. The conductor reported on July 8 that they reached Black Fish Lake twenty miles from Memphis and that this was the terminus of the newly constructed road. They crossed the lake on July 9 and camped on the west side. On July 11, they camped at Marietta, three miles west of the St. Francis River. This would have been the approximate location of a plantation

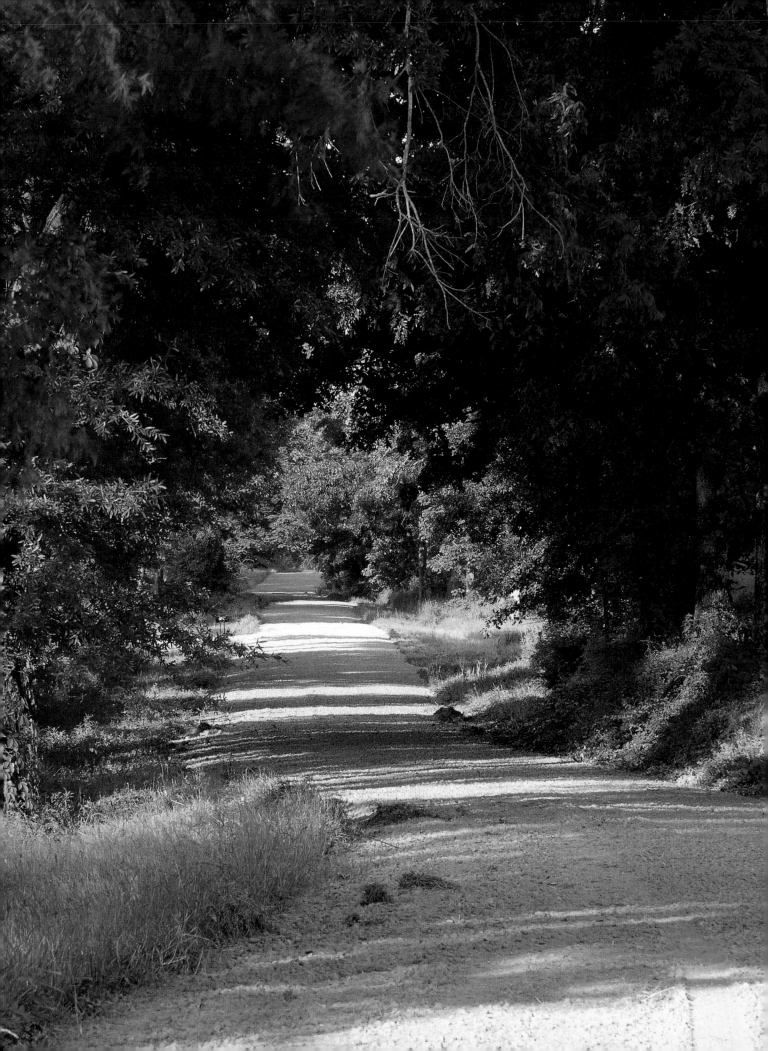

known as Strong's Place. Based on contemporary descriptions, it would appear that Strong's Place was most likely located on the east side of the intersection of a north–south road adjacent to the present-day Village Creek State Park.

Strong's Place

On November 29 and 30, 1838, four vouchers represent purchases from William Strong whose residence in St. Francis County, Arkansas, is not only located on an 1833 map but is described in several nineteenth-century reports. In his research on *Emigration and Settlement of Cherokee Leaders on the St. Francis River, 1785–1813*, Robert A. Myers recorded the following:

> Crossing the St. Francis River by ferry, a westward traveler no doubt was comforted by the sight ahead of rising land, a ridge of sandy hills now called Crowley's Ridge. Two miles beyond the river, one unfamiliar with the road might even have understandably been startled at the sight of a stupendous plantation home. Known as "Strong's Place," its patriarch, William Strong, bought the real estate in 1820, and his home was constructed about 1827.

It was said to have been one of the most imposing structures of early Arkansas, and something of an oddity with its pillared verandas, rooftop garden, and lily pond. The building was still standing in 1890. It is believed that the building's site was once an Indian village and that William Strong was one of the contractors for cutting and locating the old Military Road. Strong's Place was at a crossroads where the Memphis to Little Rock Military Road crossed a well-worn path from Arkansas to Missouri. In 1829, Strong established the town of Franklin at this crossroad and used his influence to see it become the first county seat of St. Francis County. In 1931, the William Strong Chapter of the Daughters of the American Revolution placed an historical marker at Marion, Arkansas, commemorating the Military Road. It reads:

> Military Road
> First Highway Constructed in Arkansas. Hopefield to Little Rock, Extended to Fort Smith and into the Indian Territory (Oklahoma). Built by the United States under the supervision of the Quartermaster's Department of the United States Army. Survey was begun in October, 1824, and construction commenced soon thereafter for the primary purpose of transporting Chickasaw and Choctaw Tribes of Indians from Mississippi to the Indian Territory, starting in 1832. Soldiers and Transports for the Mexican War 1845–1848 used this road, as well as soldiers and transports during the War Between the States 1861–1865. Pioneers used this route to Arkansas and to the west.

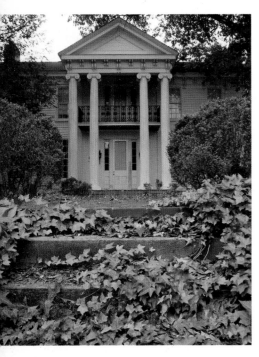

△ Levi Joy House was built about 1829, in Bolivar, Tennessee. In 1838, the Bell Detachment passed by this home. It is one of the few structures in this part of Tennessee still standing that would have been seen by Cherokee emigrants during the forced Removal. The house is known today as the Levi Joy-Neely-Baker House, reflecting a succession of owners.

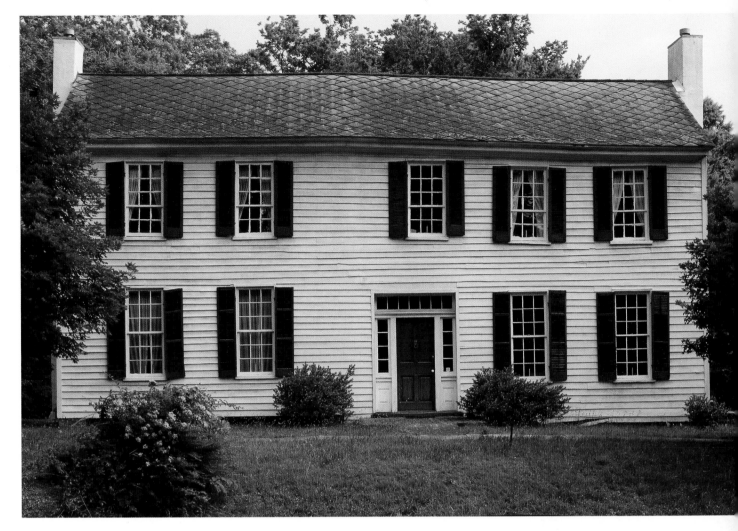

Although the Military Road crossed the state of Arkansas in the nineteenth century, only three stretches of road are still identified by the original name in the most recent *Arkansas Atlas and Gazetteer*. The first is protected in its original condition by the Village Creek State Park. It is noted on Map 44 in the *Gazetteer* as the Military Road Trail. The second is a stretch of State Highway 294 on Map 42 between Furlow and Jacksonville, which is designated as the Military Road. The third is found on Map 41 southwest of Conway and is called the Old Military Road.

△ The Little Court House was built about 1824, in Bolivar, Hardeman County, Tennessee. In November 1838 the Bell Detachment passed in front of the building. Today it is a museum interpreting local history.

Village Creek and the L'Anguille River

For much of the trip, Deas sent a purchasing agent ahead of the detachment to buy supplies, including corn and fodder, to be waiting for the detachment upon their arrival at various campsites. From October 11, when they left the Agency, until December 3, 1838, Thomas Likens served in that capacity, and Alfred Edington was the express (from November 5 until December 17, 1838),

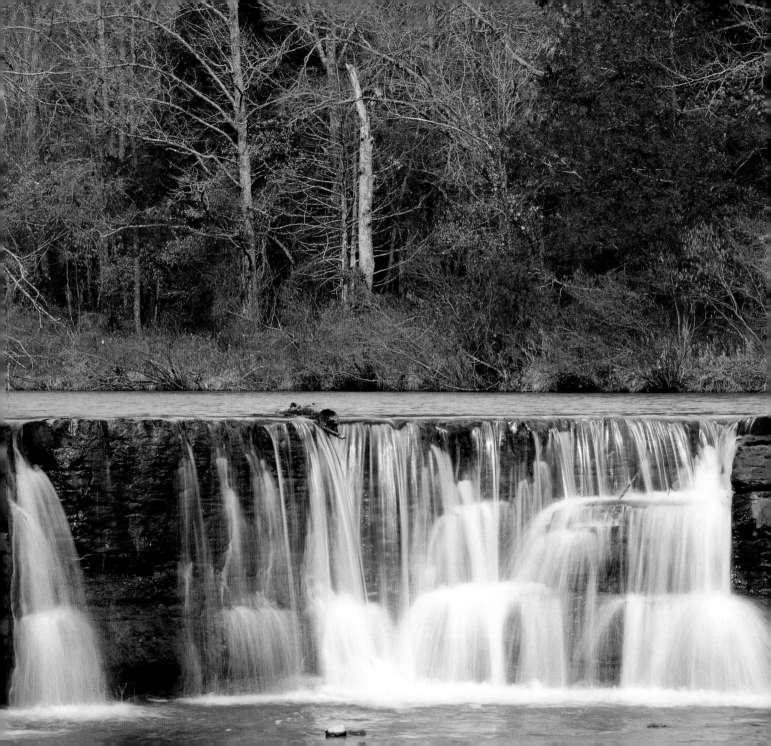

carrying messages back and forth between the detachment and the advance agent. On December 3, Likens was dismissed at Langee Creek (L'Anguille River), St. Francis County, Arkansas, and paid for his services, expenses, and $.10 per mile for his return trip to the Cherokee Agency in Tennessee, then estimated to be 414 miles.

By December 4, 1838, the Bell Detachment had reached Monroe County, Arkansas, when Benjamin Ragsdale was paid $51 for furnishing materials and making seventeen coffins for the dead at sundry times from October 11 to December and for assisting in the digging of graves and burying the dead. Ragsdale was also paid $3 each for similar services on December 7, December 16 (at Little Rock), December 31, and January 8 (at Vinyard Post Office). In all, Ragsdale was paid for burying twenty-one Cherokees with the Bell Detachment.

On December 10, Deas paid Richard Pyburn $150 to ferry the detachment across the White River in Monroe County. It took two days for the fifty-six wagons to make the crossing.

Mrs. Black's Public House

Mrs. Black's house was a popular stopping place for travelers in the 1830s. A number of detachments of emigrating southeastern Indians visited there. These included Choctaws in November 1832 and November 1833, Creeks in February 1835, and Chickasaws in July 1837. Captain Gus Drane, who conducted a detachment of the Cherokees by water to the Indian Territory in the summer of 1838, returned overland with a stop at Mrs. Black's.

On the 1853 survey map for Township 1N 5W, Mrs. Black's is clearly identified just east of Oak Creek at the intersection of a north–south road with the Military Road. The location is just southwest of present-day Tollville. Captain George A. McCall, who visited Mrs. Black's house in 1835, left the following description, which was published in *Letters from the Frontier* in 1868:

> Mrs. Black's was a public house on the Big Prairie, halfway between Rock Roe and Little Rock. The house was a log building called in the West two pens and a passage, which means two rooms from ten to twenty feet apart, the whole under one roof. One of these was a dining room, the other a sleeping room, in which there were four single beds. The kitchen and the apartments occupied by the family, built likewise of logs were in the rear. I found Ms. Black a widow of goodly proportions: I have seen fatter women but not many. She had several sons and daughters growing up.

"The house was a log building called in the West two pens and a passage, which means two rooms from ten to twenty feet apart, the whole under one roof."

◁ Three detachments of emigrating Cherokees camped at the Natural Dam, in Crawford County, Arkansas, as they followed the line road from Van Buren to the Flint District. The Whiteley Detachment lost sixty-five people through desertion as the detachment followed the road that paralleled the Boundary Line with the Indian Territory, hence its name the Line Road. Just below the dam, the Mt. Fork River intersects Lee Creek. The Whiteley Detachment reached this location in late July 1838, the Drane Detachment stopped here in early September, and the Bell arrived in early 1839 prior to its reaching Vinyard Post Office (in Washington County, Arkansas) where they disbanded on January 7, 1839.

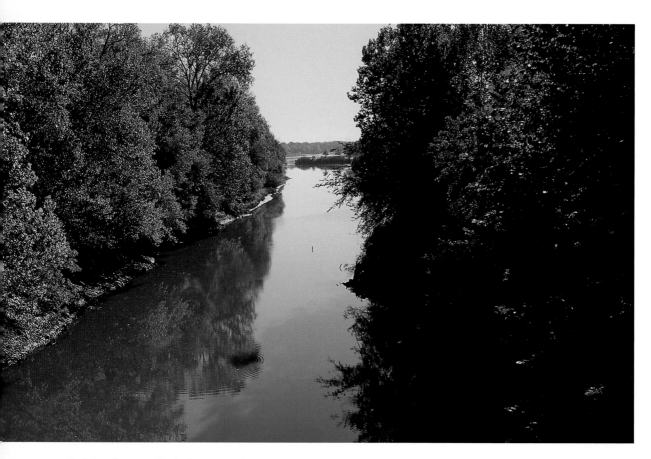

△ Point Remove Creek intersects the Arkansas River at the horizon line in this photograph. From here a line was run in a northwest direction to Batesville on White River. This was designated as the eastern boundary of land ceded in an 1817 treaty to western Cherokees in exchange for their lands in Georgia and Tennessee. In 1828, the Cherokees' Arkansas land was ceded to the United States in exchange for lands in Oklahoma. In 1832 John Ellis opened a ferry/bridge across Point Remove Creek. When the water was high it was a ferryboat; when the water was low the boat spanned the width of a creek, forming a bridge. The Whiteley Detachment paid for crossing the toll bridge in July 1838. The Bell Detachment paid for crossing the Point Remove Ferry on Christmas, 1838. It is located near Morrilton, Conway County, Arkansas.

Little Rock and Beyond

The Deas vouchers for the Bell Detachment indicate that the detachment reached Little Rock by December 14. They stayed until December 17. The *Arkansas Gazette* reported that this detachment camped for two days in warehouses on the north side of the river. On December 17, Deas reported buying corn and fodder from George King near Little Rock. The survey map for Township 1N 12W shows "Kings" on the north side of the river west of Little Rock.

The road out of Little Rock toward the Indian Territory goes north following the alignment of State Highway 365 as far as Palarm. From there the old road runs due north toward Belk Corner. A section of road just south of Belk Corner still shows on modern maps as the Old Military Road.

Traveling the Same Road as Earlier Detachments

From Lewisburg westward, the Bell Detachment covered the same ground as at least three other Cherokee detachments, those conducted by Lieutenant John Whipple Harris in May–June 1834, by Captain R. H. K. Whiteley in July–August, 1838, and by Captain Gus Drane in July–September, 1838. It is not clear whether the detachments traveled on the same road, especially since

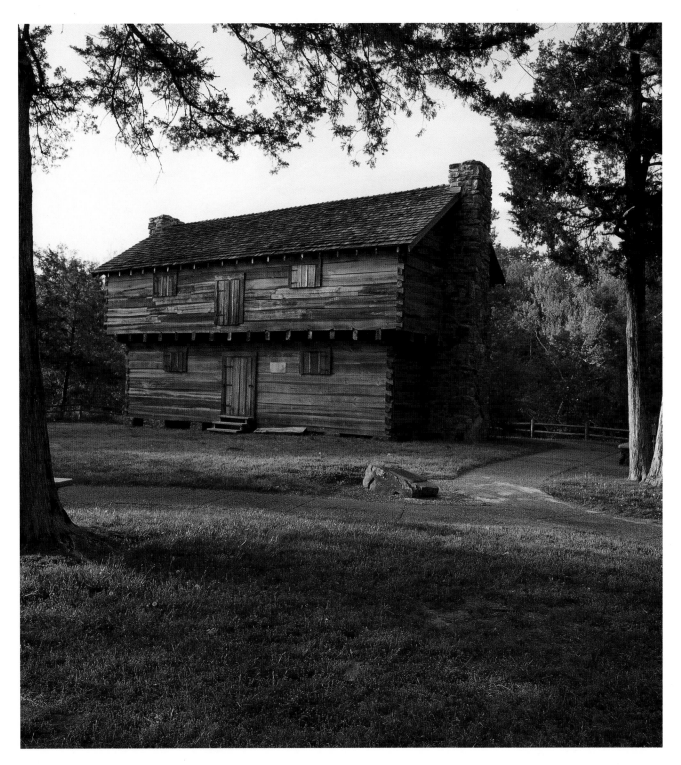

△ Cadron, Faulkner County, Arkansas, was a steamboat landing in the early nineteenth century. On April 8, 1834, the steamboat *Yeatman* landed here due to low water with a detachment of 750 Cherokees conducted by Lt. John Whipple Harris. In the weeks that followed most of the members of the detachment were too sick to travel. Eighty died from cholera and were buried here. This blockhouse is a replica of one built here in the late eighteenth century, mainly for defense. This section of the old Military Road built in 1824 passes nearby. It was followed by the Bell Detachment in December 1838.

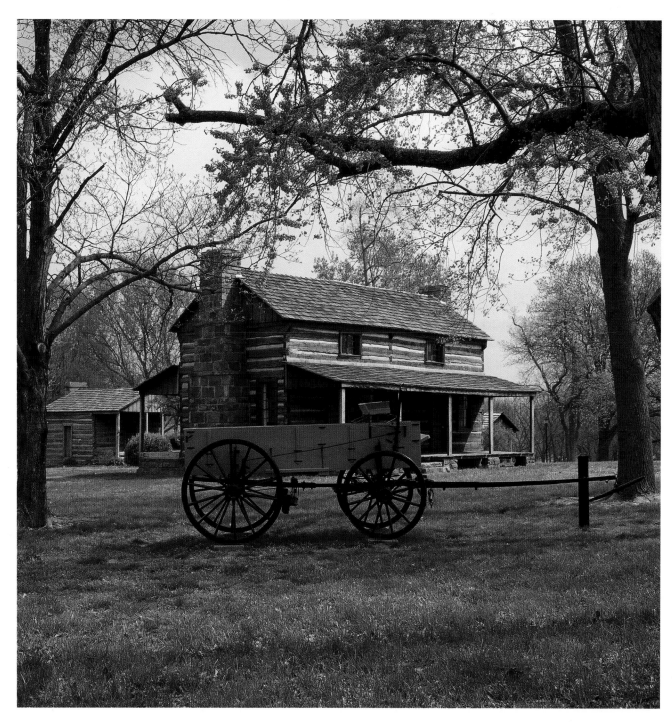

△ The Latta House was built by John Latta in 1834 on Evansville Creek in Washington County, Arkansas. The Latta settlement was called Vinyard (from "the Lord's Vineyard") and was the county's first post office. Latta was postmaster from 1835 to 1838 and operated the office in the front room of his house. It was a stop on the early stage route. The detachment of 660 Treaty Party members conducted by John A. Bell disbanded here on January 7, 1839. In 1958, the building was moved from its original location near Evansville, Arkansas, a distance of twelve miles northeast to its present site at Prairie Grove Battlefield State Park, Washington County, Arkansas.

Lieutenant Harris discussed the options for various roads and the rationale behind his selection. At Point Remove Creek, Captain Whiteley, on July 21, 1838, reported that he fed the detachment at the Point Remove Bridge. Deas, on the other hand, paid William Ellis for ferriage across Point Remove Creek on December 25, 1838. At first glance, it may appear that Whiteley and Deas were on different roads until considering an article in the *Arkansas Advocate* on November 14, 1832:

New Ferry, October 20, 1832

Cut a new road, diverging from the U.S. road to the right at the Edge of Point Remove bottom and crossing Point Remove Creek at his house. Avoids the old site of the U.S. road for a distance of two miles and is on dryer and firmer ground. Road now confirmed by the court. Has graduated the banks of the creek to accommodate wagons. Banks are causewayed to the water edge, boat recently built is 60 feet long. Landings so constructed with firm abutments that the boat serves as a bridge from one abutment to another in low water and a ferry in high.

The Whiteley Detachment, which was stranded by low water in the Arkansas River on the Benton Sand Bar a few miles below Lewisburg, crossed the bridge at low water during the drought of the summer, and Bell crossed the sixty-foot boat/bridge as a ferry in December, after the drought ended.

Journey's End

By January 5, the detachment had reached Frog Bayou. Near Van Buren, the Bell Detachment turned north and, on January 6, Deas paid John B. Carns near Vinyard, Arkansas, for supplies, and the detachment was disbanded the following day at Vinyard Post Office, present-day Evansville, Arkansas. By disbanding in Arkansas, Deas succeeded, as he had hoped, in avoiding any encounters with Ross Party Detachments en route. This was the only detachment disbanded before reaching the Indian Territory. Many of the members of this detachment settled only a short distance away in present-day Adair County, in the vicinity of Stilwell and Bell, Oklahoma.

The Bell Detachment started the journey with 660 people and 318 horses. Of the twenty-one people who died and are buried in unmarked graves along the trail about a half dozen are in the state of Arkansas.

△ The Zuraw Wagon, which dates to the late 1700s, is the only known surviving wagon from the Cherokee Indians' historic Trail of Tears. Foxfire Museum and Center in Mountain City, Georgia, loaned the wagon to Dollywood's Valley Carriage Works wagon makers, where this photo was taken, to build a replica. The replica wagon was a gift from Dollywood, in Pigeon Forge, Tennessee, to the Museum of the Cherokee Indian in Cherokee, North Carolina. It was one of more than 700 wagons that were used on the Trail of Tears in 1838. The wagon is 9 feet 6 inches long.

▷ Telegraph Road runs through what is now Pea Ridge National Military Park. It passes directly in front of Elkhorn Tavern, first built in 1833. This road was traveled by the Cherokees on the Northern Route in 1838. Benton County, Arkansas.

THE NORTHERN ROUTE

CHAPTER V

The accounts of suffering of the original detachments that left Ross's Landing in June 1838 were so great that the army suspended the forced emigration until the fall. The Cherokees petitioned General Scott to be allowed to superintend their own removal. When permission was granted, Principal Chief John Ross organized his followers into twelve detachments of about one thousand each. These groups left the East between August 23 and October 23, 1838, and arrived in the Indian Territory between January and April 1839. Additionally, a group of Treaty Party members, not under Ross, left the agency on October 11, and several hundred sick and infirm among Ross's followers left by boat on December 5, 1838.

The feeling of many of the immigrants is expressed in a letter written by Evan Jones on December 30, 1838. Jones, a Baptist minister and the assistant conductor of Situwakee's detachment, wrote from the camp of the fourth detachment at Little Prairie, Missouri:

I am afraid that, with all the care that can be exercised with the various detachments, there will be an immense amount of suffering and loss of life attending the removal. Great numbers of the old, the young, and the infirm will inevitably be sacrificed. And the fact that the removal is effected by coercion makes it the more galling to the feelings of the survivors.

The fourth detachment under Situwakee and ten other detachments also under the supervision of Principal Chief John Ross traveled overland by way of Nashville, Golconda, Springfield, and Fayetteville.

For many years it was assumed that those detachments that took the Nashville–Golconda route followed the same road across Tennessee and Kentucky. Captain H. B. Henegar, who belonged to the quartermaster's department of the Taylor Detachment, recounted the experience nearly six decades later in 1897. He reported that: "The Indians all went the same route . . . across Walden's Ridge to Pikeville, thence to McMinnville, thence over to Nashville."

A close examination of the primary documentation has revealed that they did not all take the same route. Nine of the eleven detachments departed from various camps near the Cherokee Agency/Fort Cass and Camp Ross. The routes taken by the detachments varied near the beginning of the journey in southeast Tennessee, middle Tennessee, and in central Missouri. Most of the detachments departed from camps located on tributaries of the Hiwassee River in Bradley County in the vicinity of the Cherokee Agency at Calhoun. Camp Ross, thirteen miles from the agency, was the departure point for the detachment led by Elijah Hicks. All of the camps were within the bounds of the former Cherokee Nation south of the Hiwassee River. Although a party conducted by B. B. Cannon in 1837 crossed the Hiwassee River at Charleston and crossed the Tennessee River at Kelly's Ferry, there is no evidence to suggest that the detachments under John Ross that left in 1838 crossed the Hiwassee, but it appears rather that they followed the river to its mouth and crossed the Tennessee at Blythe's Ferry, just below Hiwassee Island.

The ninth detachment, under James Brown, and the eleventh detachment, conducted by Richard Taylor, were organized at camps upstream from Ross's Landing between Citico and Chickamauga creeks. In September 1838, they moved farther up the Tennessee River to Joseph Vann's Plantation, north of Ooltewah Creek, in preparation for their final departure. They crossed the Tennessee at that point because it could be forded. The Brown and Taylor detachments traveled over Poe's Road to Walden's Ridge, and then followed Hill's Turnpike to its intersection with the Higginbotham Trace and the convergence with the route taken by the nine detachments that left from the agency and Camp Ross. In Rutherford County, Tennessee, some detachments

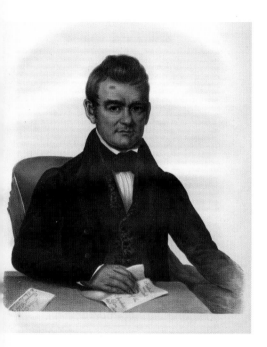

△ John Ross (1790–1866) was Principal Chief of the Cherokee Nation from 1828 until his death thirty-eight years later. He was adamantly opposed to ceding Cherokee lands to the U.S. government, and declared the Treaty of New Echota to be a fraud on the Cherokee Nation and the people of the United States. In spite of the animosities, the U.S. army eventually turned to John Ross to superintend the Cherokee Removal. He served in the office of Principal Chief longer than any other person in history.

△ A pleasant surprise for travelers on the Trail of Tears was the Big Spring located in the town center of Princeton, Caldwell County, Kentucky. The community grew up around this water source that supplied all of the Ross Detachments following the Northern Route as well as hundreds of thousands of other travelers who passed through the area during the nineteenth century.

chose to avoid tollbooths on the Murfreesborough Turnpike by taking the Stones River Road through Old Jefferson.

In Missouri, there is considerable evidence to suggest that the Hildebrand Detachment chose a more southerly route through the central part of the state than did the other detachments.

Apart from the several independent oral history accounts collected from living individuals in the 1980s by Robert Runner of Salem, Missouri, the firsthand accounts suggesting an alternative route include a report given by a teenage eyewitness, Theodore Pease, more than fifty years after the fact; a letter from John Ross to Joel R. Poinsett dated May 18, 1840, stating that multiple routes were taken in Missouri; and the March 11, 1839, diary entry of Daniel Butrick, indicating that Hildebrand was traveling another road. Butrick, a missionary for the American Board of Commissioners of Foreign Missions, had been assigned to the Cherokees since 1819, and he made the journey to the Indian Territory with Richard Taylor's eleventh detachment. He and his congregation of the Brainerd Church constituted a sizable part of the Taylor

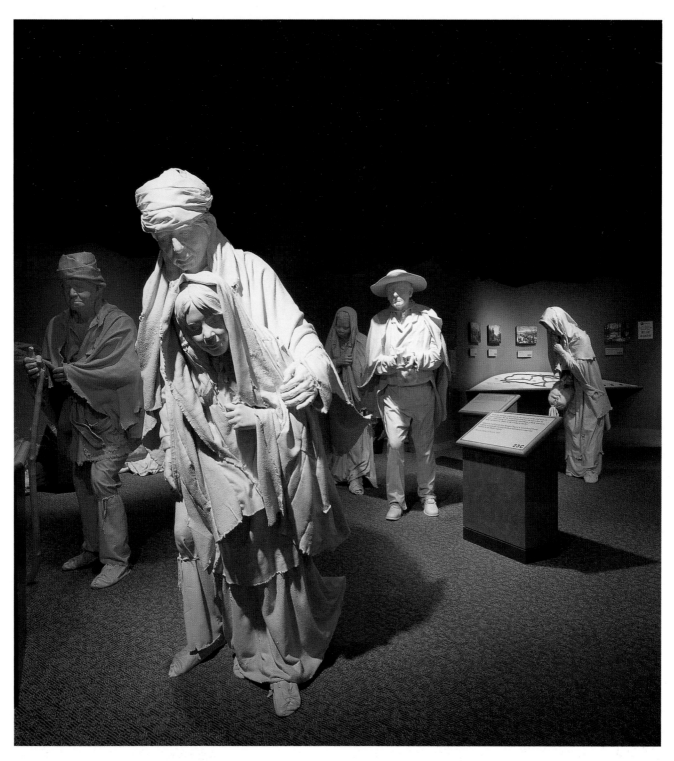

△ Life-size mannequins in ghostly white help interpret the story of the Trail of Tears in an exhibit at the Cherokee National Museum. The museum is located on the grounds of the Cherokee Heritage Center in Tahlequah (Park Hill), Cherokee County, Oklahoma.

Detachment. Butrick ministered to the Cherokees for more than three decades until his death in 1851.

Although General Scott postponed the general Removal during the summer of 1838 until September, starting at that time also proved precarious. Elijah Hicks's group, the second detachment, found themselves stranded by lack of water shortly after they crossed the Tennessee River. On September 14, 1838, Elizur Butler, a missionary and medical doctor with the Hicks Detachments, wrote to David Greene from the Cherokee Camp near Washington, in eastern Tennessee:

Reverend David Greene

𝒟ear Sir

Yours of Aug. has been received. You will have learned long before the reception of this of my appointment to attend a detachment of Cherokees to Arkansaw [sic] and my arrangements in consequence of that appointment. I arrived here on the first day of the month, where the first detachment from immigration was collecting for removal. This is thirty-three miles from Red Clay—owing to the excessive drought we cannot move forwards until it rains. Should we remove from here both man and beast must suffer greatly for the want of water. We are already thrown back in our journey at least one hundred and twenty miles, with little prospect of starting from here for several days to come. We have had here a large amount of sickness and several deaths. Dysentery, Measles, Whooping Cough and Remitting fevers are the prevailing diseases.

I fear now that I shall not be able to again return to my family, from Arkansaw until Dec. or Jan.

The journey before me will be one of great fatigue and great responsibilities. The Cherokees seem to put much confidence in me, and nearly all in camp who are sick apply to me for medicine. I very much need the prayers of Christians for divine assistance that I may be able to discharge, faithfully, my various duties as Physician, and Evangelist. How can I go forward in this arduous work if the presence of God be not with me? On this visit, for the first time in my life, I took my lodging in a tent, which if my life is spared, I expect will be my home for three months.
Sincerely yours,

ℰlizur Butler

Murfreesborough Turnpike and the Stones River Road

The only diaries known to exist for the portion of the trip between McMinnville and Nashville indicate that Murfreesborough was an intermediate stop. Daniel

△ The campground of the Cumberland Presbyterian Church west of Mt. Pleasant, Union County, Illinois, was a stopping point for many of the detachments on the Northern Route. In the winter of 1838–39 more than eight thousand Cherokees camped for weeks in southern Illinois trapped between the ice floes in the Ohio and Mississippi rivers. The church dates to 1906 but an adjacent section of the cemetery is said to contain graves of Cherokee emigrants who perished under the harsh conditions of winter.

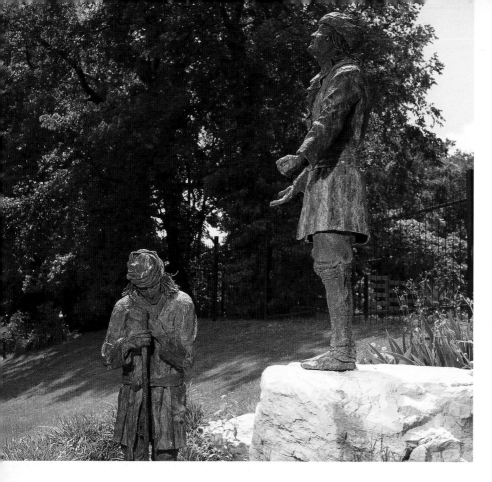

△ Life-size bronze statues of Chiefs Fly Smith (left) and White Path mark the spot where they were buried in November 1838. They were members of the Elijah Hicks Detachment. According to a local newspaper, after they were buried long poles were placed over the graves with flags on top so that other detachments could pay their respects as they passed. The site is now part of the Trail of Tears Commemorative Park in Hopkinsville, Christian County, Kentucky.

▷ Mantle Rock in Livingston County, Kentucky, is a natural sandstone arch 30 feet high and 188 feet long. In December 1838, Peter Hildebrand's detachment of more than 1,700 Cherokees camped here for several weeks, waiting for the ice-clogged Ohio River to clear so that they could cross at Berry's Ferry to Golconda, Illinois. Once across they found themselves stranded in southern Illinois with 8,000 other Cherokees waiting for the ice in the Mississippi River to clear.

Butrick wrote on Monday, November 19, 1838, "The detachment started early, and passed through Murfreesborough, on the road toward Nashville, twenty miles." The following day, Tuesday, November 20, 1838, he recorded, "We traveled ten miles and camped within four miles of Nashville."

Almost a year earlier, B. B. Cannon reported on October 25 that his detachment ". . . passed through Murfreesborough and halted at Overall's Creek."

Although the Murfreesborough Turnpike was perhaps the best road in the state at the time, some of the detachments may have avoided it purely for financial reasons.

B. B. Cannon noted that in the sixteen miles beyond Overall's Creek, his detachment passed through three tollgates. The following day he traveled thirteen miles to Nashville and encountered two more tollgates before crossing the Cumberland River on the Nashville Toll Bridge. Reverend Evan Jones complained to John Ross about the high costs of tolls in a letter from the camp of Situwakee's detachment one mile east of McMinnville on October 27, 1838:

We paid Forty dollars at the Walerns [sic] Ridge gate, and the man agreed to let the other detachments pass at price 37 for four wheeled Carriages and 6 1/4 for a horse. On the Cumberland Mountain they fleeced us: 75 cents a wagon and 12 Cents a horse without the least abatement or thanks. We will avoid several gates on the road to Nashville.

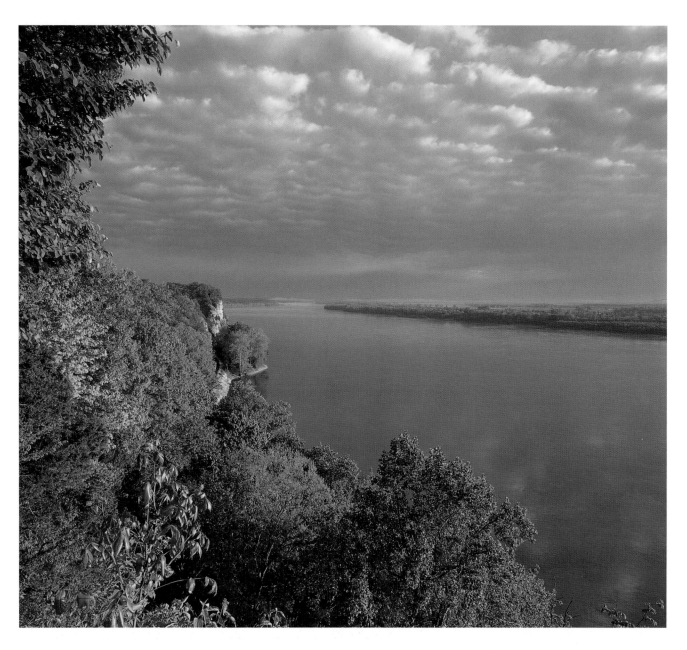

△ The high bluffs overlooking the Mississippi River were seen by Cherokees as they approached Green's Ferry (Willard's Landing) from Illinois. These bluffs are now part of the Trail of Tears State Park, Cape Girardeau County, Missouri. In 1838 many of the Cherokees on the Northern Route traveled through the present-day Trail of Tears State Park. The park's interpretive center explains the significance of this event for the public.

The detachment led by Situwakee and Jones had 62 wagons and 560 horses so each tollgate they bypassed meant a considerable savings for the group. If Jones knew the locations of the gates on the Murfreesborough Turnpike and if he had a copy of Matthew Rhea's 1832 map of Tennessee, he would have seen that several gates could be avoided by taking the road northwest from Readyville instead of the main route due west to Murfreesborough. This road passed through the now abandoned town of Jefferson.

The best evidence that some detachments may have taken this alternate route is found in a letter from John Ross to Winfield Scott on November 12, 1838. This correspondence reports the recent return of Theodore Johnson, an employee of Lewis Ross, the brother of John Ross and the primary contractor for supplying the emigrant detachments on the journey west. On November 3,

1838, Johnson overtook the detachment led by John Benge at Reynoldsburg and then returned by way of Nashville. He "met with Messrs. Jones and Bushyhead at that place; Situwakee's detachment had reached six miles and Bushyhead's three miles beyond the town. The conductors were supplying the poor with clothing and would proceed without useless delay—that he met Capt. Old Fields' detachment west of old Jefferson and with [Moses] Daniels four miles in the rear—also with major [James] Brown's eight miles west of Woodbury and [J. D.] Woffords at Collins River, six miles of McMinnville and Geo. Hicks on Waldens ridge within four miles of Sequatchee [sic] Valley."

By November 3, 1838, the first detachment, which was led by Daniel Colston, who replaced Hair Conrad, and the second detachment, which was led by Elijah Hicks, had already reached Kentucky. Taylor's detachment had crossed the Tennessee River on November 1, and reached McMinnville on November 12. It is likely that Taylor may have been on Hill's Turnpike south of the Higginbotham Trace on which Johnson was traveling and thus is not mentioned in his report. Hildebrand, as reported in the Ross letter, was engaged in crossing the Tennessee River at Blythe's Ferry from the afternoon of November 10 until noon on November 12.

From the proximity to Old Jefferson of the Old Fields and Daniels detachments reported by John Ross, it can be concluded that they did not travel on the Murfreesborough Turnpike to Nashville. From the letter of Evan Jones on October 27, 1838, it can be inferred that his detachment and probably that of Jesse Bushyhead, which were traveling in tandem, also took the Stones River Road through Old Jefferson, thus avoiding the tolls on the Murfreesborough Turnpike.

Reports of Conditions on the Trail

As the Cherokees began the journey to the Indian Territory, General Winfield Scott justified the military actions. On October 15, 1838, he wrote:

> The Cherokees, as it is known, were divided into two political parties—friends and opponents of the treaty of New Echota. Of the former there were remaining East, in May last, about 500 souls—of the latter, including 376 Creeks, out of a little more than 15,000. About 2500 of the anti-treaty party were emigrated in June last, when, (on the 19th) the movement was suspended by my order, until the first of September, on account of the heat and the sickness of the season. The suspension was approved by the War Department, in anticipation, by an order to that effect, received a few days later. The Indians had already, with but very few exceptions, been collected by the troops, and I was further instructed to enter into the arrangement with the delegation, (Mr. John Ross and his colleagues) which placed the removal of the 12,500 immediately into their hands.

"By the new arrangement not an additional dollar is to be paid by the United States to, or on account of, the Cherokees."

The drought, which commenced in July and continued till the end of September, caused the loss of a month in the execution of the new arrangement. Four detachments are, however, now in march for the West; three or four others will follow this week, and as many more the next—all by land, 900 miles, for the rivers are yet very low. The other party, making a small detachment, is also on the road, after being treated by the United States, in common with their opponents, with the utmost kindness and liberality. Recent reports from these five detachments represent, as I am happy to say, the whole as advancing with alacrity in the most perfect order. The remainder of the tribe are already organized into detachments, and each is eager for precedence in the march—except the sick and decripit, [sic] with a few of their friends as attendants, who will constitute the last detachment, and which must wait for the renewal of steam navigation.

By the new arrangement not an additional dollar is to be paid by the United States to, or on account of, the Cherokees. The whole expense of the removal, as before, is to be deducted from the moneys previously set apart by the treaty and the late act of Congress in aid thereof.

Among the party of 12,500 there has prevailed an almost universal cheerfulness since the date of the new arrangement. The only exceptions were among the North Carolinians, a few of whom, tampered with by designing white men, and under the auspices alluded to above, were induced to run back, in the hope of buying lands and remaining in their native mountains. A part of these deluded Indians have already been brought in by the troops, aided by Indian runners sent by Mr. Ross and his colleagues and the others are daily expected down by the same means.

In your State, I am confident there are not left a dozen Indian families, and at the head of each is a citizen of the United States.

For the aid and courtesies I have received from Georgia, throughout this most critical and painful service, I am truly thankful; and I have the honor to remain, with high consideration, your Excellency's most obedient servant.

Winfield Scott

▽ A basket that came to the Indian Territory on the Trail of Tears is now a family heirloom in Delaware County, Oklahoma. The basket's maker carried it on the 1,000-mile forced Removal of the Cherokees.

In this letter, Scott shows some empathy for the 376 Creek Indians who managed to escape the Removal of the Creek Nation a few years earlier and now faced deportation with the Cherokees. The "universal cheerfulness" about which Scott wrote was never expressed by the Cherokees, however. Even the most favorable reports written on the trail gave insights into the difficulties of the journey.

Four days after Scott's letter was published by the *New York Gazette*, the *Nashville Whig* conveyed to its readers on November 14, 1838:

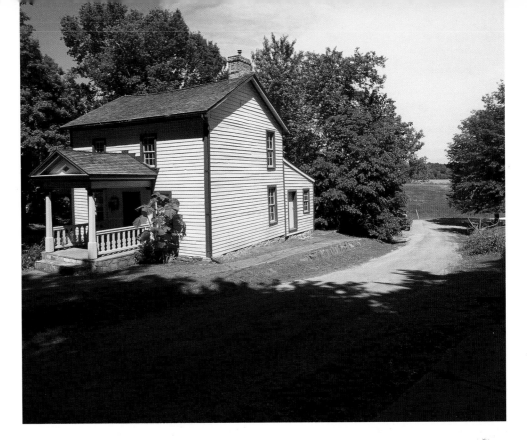

Another detachment of this people passed through town yesterday, and yet another is looked for in four or five days.

We understand from our correspondent, who communicated the fact that many of the first and second detachments of Cherokees were comparatively destitute of clothing, that such is not the case with the last two or three parties—John Ross having made the most ample provision for their comfort. And on further inquiry, we learn that even the first companies were better furnished before leaving their encampments on the opposite side of the river. One of our largest, Wholesale houses has the most liberal orders from Ross and his sub-contractors to furnish whatever may be required in the clothing line; and we are assured that no pains has been spared to render the emigrants as comfortable as the nature of the case will admit. If the detachment more particularly alluded to in our former notice, (on the authority of a correspondent) appeared somewhat destitute while at Foster's Mill, it was because they had not then received their supplies.

We make this explanation with much pleasure: since our first statement, we have had occasion personally to observe the condition of the parties that have since passed through, and without a knowledge of the fact that additional provisions had been made by the agents of emigration at this point, we had arrived at the conclusion that comparatively few had just cause of complaint.

The absence of intoxication has been spoken of by a neighboring print. To this we can also bear witness from actual observation. While traveling through or loitering about the public square, the Indians have exhibited the utmost quiet and good order, and not half a score we venture to say, of the thousands who have passed on to the west, gave evidence of intoxication while here. It may be mentioned, too, a further evidence of their sobriety, that of one party from three to four hundred are Christian communicants.

△ The Alexander Buel House is said to have been built in 1837, in Golconda, Pope County, Illinois, even though the deed to the lot is reported as 1841. Family tradition as reported in a 1956 newspaper article states that Mrs. Buel was cooking pumpkins and had set a pot in the windowsill to cool. The aroma attracted hungry emigrants on the road only fifteen feet from the Buel house that lead from the ferry landing to the town of Golconda. Mrs. Buel graciously shared her freshly cooked pumpkin with the weary travelers. The State of Illinois recently purchased the house for its historic significance.

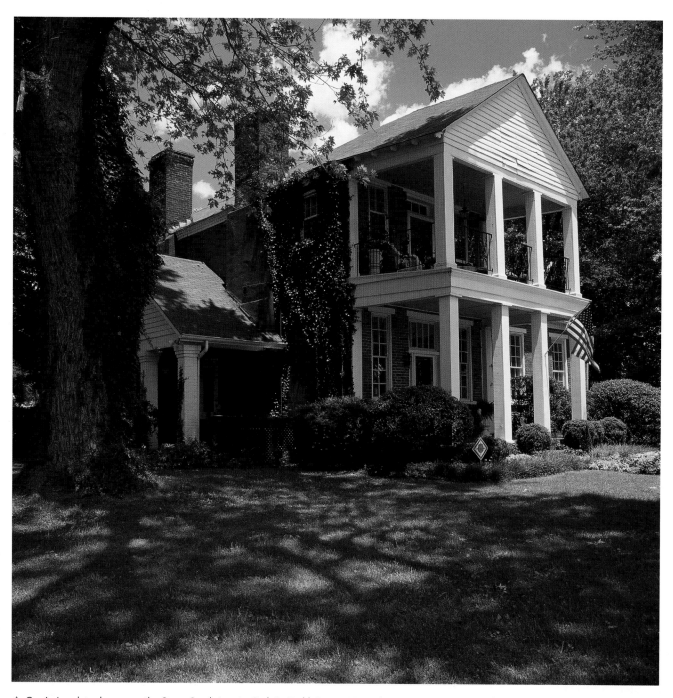

△ Gray's Inn, later known as the Stage Coach Inn, in Guthrie, Todd County, Kentucky, was a stopping point for all of the detachments in southern Kentucky. In 1833 Major John Gray established an inn here as a relay house for his stagecoach lines. The large detachments of emigrating Cherokees frequently overwhelmed local resources such as Gray's Inn, accustomed to accommodating small groups of travelers.

Daniel Butrick contradicts the accounts of General Scott and the *Nashville Whig* with the report of six deaths in the first 150 miles of the journey:

Encampment 25 miles west of Nashville
Nov. 28, 1838

Reverend David Greene,

Dear Sir, I have intended writing to you much sooner than now, but have found it very difficult to write on the road, as the weather has been cold. We crossed the Tennessee River the first day of this month, and have proceeded but about 150 miles. Six deaths have occurred during the time. We have a tent, which the little boy with us, sleeps under, while Mrs. Butrick and myself sleep in our little carryall.

. . . The citizens of Nashville and the vicinity have merited our warmest thanks. We have found no such kindness since we left home.

According to local oral tradition, Gray's Inn, just across the state line in Kentucky, was a stopping point for Cherokee emigrants during the Removal.

A traveler from Maine met several detachments in southern Kentucky. One detachment that he described had about eleven hundred Indians and was probably either that of George Hicks or Richard Taylor. The last detachment encountered was undoubtedly that led by Peter Hildebrand, the only one that could have been described as having two thousand members. The following account, published in the *New York Observer* on January 26, 1839, provides a moving account of the hardships suffered by the Cherokee detachments:

On Tuesday evening we fell in with a detachment of the poor Cherokee Indians . . . about eleven hundred Indians—sixty waggons—six hundred horses, and perhaps forty pairs of oxen. We found them in the forest camped for the night by the road side . . . under a severe fall of rain accompanied by heavy wind. With their canvas for a shield from the inclemency of the weather, and the cold wet ground for a resting place, after the fatigue of the day, they spent the night . . . many of the aged Indians were suffering extremely from the fatigue of the journey, and the ill health consequent upon it. Several were then quite ill, and one aged man we were informed was then in the last struggles of death.

About ten officers and overseers in each detachment . . . were to provide supplies for the journey, and attend to the general wants of the company We met several detachments in the southern part of Kentucky on the 4th, 5th and 6th of December. The last detachment which we passed on the 7th embraced rising two thousand Indians with horses and mules in proportion. The forward part of the train we found just pitching their tents for the night, and notwithstanding some thirty or forty waggons were already

△ According to local tradition, the emigrating Cherokees referred to the well at Gray's Inn as the "Well of Sweet Water." It is said an ill chief, White Path, drank from the well and rallied for a few days before his death at Hopkinsville, Kentucky. The well is in the side yard of Gray's Inn, also known as the Stage Coach Inn, in Todd County, Kentucky. As many as eleven Cherokee detachments passed this location in November and December 1838.

"The Indians as a whole carry in their countenances every thing but the appearance of happiness."

▷ The grave of Nancy (Otahki) Bushyhead Hildebrand has become a special monument within the Trail of Tears State Park, Cape Girardeau County, Missouri. She was the sister of Rev. Jesse Bushyhead. Her first husband, John Walker Jr., was assassinated in 1834 for his view supporting the Removal. She was one of a number of Cherokees on the Northern Route who died while camped at Moccasin Springs, but the only one with a marked grave.

stationed, we found the road literally filled with the procession for about three miles in length. The sick and feeble were carried in waggons—about as comfortable for traveling as a New England ox cart with a covering over it—a great many ride on horseback and multitudes go on foot. Even aged females, apparently nearly ready to drop into the grave, were traveling with heavy burdens attached to the back, on the sometimes frozen ground, and sometimes muddy streets, with no covering for the feet except what nature had given them. We were some hours making our way through the crowd, which brought us in close contact with the wagons and multitude, so much that we felt fortunate to find ourselves freed from the crowd without leaving any part of our carriage. We learned from the inhabitants on the road where the Indians passed, that they buried fourteen or fifteen at every stopping place, and they make a journey of ten miles per day only on an average. One fact which to my own mind seemed a lesson indeed to the American nation is that they will not travel on the Sabbath When the Sabbath came, they must stop, and not merely stop, they must worship the Great Spirit too, for they had divine service on the Sabbath—a camp-meeting in truth.

One aged Indian who was commander of the friendly Creeks and Seminoles in a very important engagement in the company with General Jackson, was accosted on arriving in a little village in Kentucky by an aged man residing there, and who was one of Jackson's men in the engagement referred to, and asking him if he (the Indian) recollected him? The aged Chieftain looked him in the face and recognized him, and with a down-cast look and heavy sigh, referring to the engagement, he said "Ah! my life and the lives of my people were then at stake for you and your country. I then thought Jackson my best friend. But ah! Jackson no serve me right. Your country no do me justice now!"

The Indians as a whole carry in their countenances every thing but the appearance of happiness. Some carry a downcast dejected look bordering upon the appearance of despair; others a wild frantic appearance as if about to burst the chains of nature and pounce like a tiger upon their enemies . . . Most of them seemed intelligent and refined. Mr. Bushyhead, son of an aged man of the same name, is a very intelligent and interesting Baptist clergyman. Several missionaries were accompanying them to their destination.

Some of the Cherokees are wealthy and travel in style. One lady passed on in her hack in company with her husband, apparently with as much refinement and equipage as any of the mothers of New England; and she was a mother too and her youngest child, about three years old, was sick in her arms, and all she could do was to make it comfortable as circumstances would permit. . . . She could only carry her dying child in her arms a few miles farther, and then she must stop in a stranger-land and consign her much loved babe to the cold ground, and that without pomp or ceremony, and pass on with the multitude

When I past the last detachment of those suffering exiles and thought that my native countrymen had thus expelled them from their native soil and their much

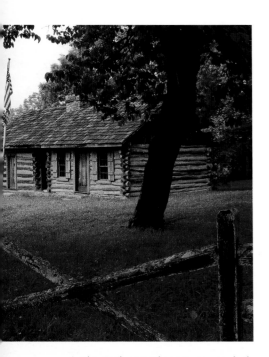

△ The Snelson-Brinker House was built about 1834 and is the oldest house in Crawford County, Missouri. It was a stopping point for many of the detachments on the Northern Route. The eleventh detachment spent the night here on February 27, 1839. Dr. W. I. I. Morrow, the attending physician wrote: "27th clear and cold, traveled 10 miles to Brinker near Massys Iron Works—snowed some during the day a very cold night—four Indians died, and were buried viz—2 of the Mills family, Old Bird, and Mary Fields." According to Daniel Butrick, a missionary with the detachment, Mary was the young daughter of Archibald Fields. They were interred in the Brinker family cemetery.

loved homes, and that too in this inclement season of the year in all their suffering, I turned from the sight with feelings which language cannot express and "wept like childhood then." I felt that I would not encounter the secret silent prayer of one of these sufferers armed with the energy that faith and hope would give it (if there be a God who avenges the wrongs of the injured) for all the lands of Georgia!

When I read in the President's Message that he was happy to inform the Senate that the Cherokees were peaceably and without reluctance removed—and remembered that it was on the third of December when not one of the detachments had reached their destination; and that a large majority had not made even half their journey when he made that declaration—I thought I wished the President could have been there that very day in Kentucky with myself, and have seen the comfort and the willingness with which the Cherokees were making their journey. But I forbear; full well I know that many prayers have gone up to the King of Heaven from Maine in behalf of the poor Cherokees.

The dates given by Daniel Butrick in his diary while in Kentucky correspond with the dates of the traveler from Maine, further suggesting that Taylor's eleventh detachment was one of the groups encountered. Butrick's account of this portion of the journey indicates that the Taylor Detachment camped on a branch of Red River in Kentucky, on Saturday, December 1, having traveled during the week about sixty miles. He reported births and deaths: "On Wednesday night of this week sister Ooskooni gave birth to a son, and on Thursday two children, one a daughter of our dear sister Ashopper were called into eternity. They had long been sick."

On the morning of December 3, Butrick recounted that the "ground was mostly covered with snow and frozen rain. We traveled about 12 miles, and camped within half a mile of Hopkinsville."

At Hopkinsville, Kentucky, poles with banners had been erected over the graves of White Path and Fly Smith, fatalities from the first detachments, so that later travelers could pay tribute. Today, the land around the graves is now a park commemorating the Trail of Tears. From Hopkinsville, the trail followed an alignment similar to present-day State Highway 91 to Princeton.

On occasion Butrick was met with acts of kindness from those they encountered. On Friday, December 7, Butrick reported, "we passed through a very beautiful village called Princeton. In the midst of this town we were saluted by a young clergyman, by the name of Payne. He knew us, from a former acquaintance at Brainerd. When he was a boy, his pious mother went with him to that mission and spent a number of months. At his request, we dined with him. About a mile from this village, in full view is Cumberland College, an institution belonging to the Cumberland Presbyterians. This is a handsome building."

On Thursday, December 13, the detachment was within ten miles of the Ohio River at Golconda, where Butrick noted, " . . . we passed Isaac Bushyhead, Colonel Powell and another man, left sick about three weeks before, by Reverend Jesse Bushyhead's detachment." According to Butrick, sixty people from their detachment had died up to that point. He wrote of a Cherokee woman who died in the camps a few days after giving birth. She was found early one morning with her infant in her arms. Wrote Butrick, "As the man living near was not willing to have her buried there, and as no plank could be obtained for a coffin, the corpse was carried all day in the waggon, and at night a coffin was made, and the next morning she was buried near the graves of some other Cherokees who had died in a detachment that preceded us."

By Friday, December 14, the Taylor Detachment had counted the fifteenth death since they had crossed the Tennessee River. On that day they traveled about six miles, and camped four miles from the Ohio River, possibly near Mantle Rock, a rock overhang just off Highway 133 east of Berry's Ferry.

On Saturday morning, December 15, the detachment reached the Ohio River and began crossing about 10:00 A.M. The weather was clear and pleasant affording a favorable opportunity for crossing.

A preceding detachment did not fare as well. After crossing the Ohio River, Daniel Davis, a white man hired as a teamster and commissary in the Moses Daniel Detachment, wrote to his parents in Georgia:[23]

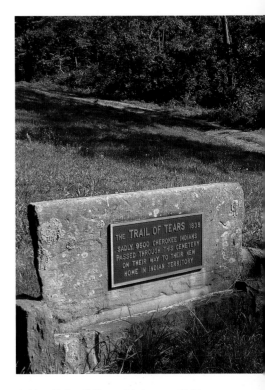

△ The Trail of Tears Marker at Field Trovillion Cemetery, west of Golconda, Pope County, Illinois, bears silent witness to the thousands of Cherokees that passed this spot on the journey west. Unable to cross the Mississippi River because of the ice, eight detachments of emigrating Cherokees were camped for weeks along a twenty-mile stretch of road leading to the river. The unusually harsh winter and the limited resources in the sparsely populated area of Illinois made survival the highest priority for thousands of Cherokees. In desperation, Principal Chief John Ross sent couriers as far as St. Louis, Missouri, in an attempt to procure supplies for the beleaguered travelers.

Dear Father,

I take this opportunity to inform you I am well at present. I might have wrote sooner, but I have been in bad health ever since I passed Golconda with the cramp cholic but I have got entirely well.

You have no doubt heard by this time the accident that happened [to] our detachment in crossing the Ohio River at Golconda. The ferry boat is cared [carried] by steam across the river. Barrys Ferry well known John. [a type of flat bottom boat] The boat had reached the west bank of the river and the waggons and load all taken off and the boat on starting after another load had gotten about thirty yards from the bank when the boiler bursted and scalded a great many persons. There was only too [two] killed at all and these of our detachment, one a white man and the other a Cherokee. This happened the next load after I crossed the river in the evening.

On the morning following, there is the coldest weather in Illinois I ever experience anywhere. The streams all frozen over something like eight or twelve inches thick. We are compelled to cut through the ice to get water for ourselves and animals. It snows here every too [two] or three days at farthest.

We are now camped in the Mississippi four miles from the river, there is no possible chance of crossing the river for the numerous quantities of ice that comes floating down the river every day.

△ Moccasin Springs Road is a primary road through today's Trail of Tears State Park in Cape Girardeau County, Missouri. It was formerly known as Greens Ferry Road. Green's ferry was one of two ferries used by emigrating Cherokees in the winter of 1838–39 to cross the Mississippi River from Illinois. The road connected the ferry crossing on the river with Jackson, Missouri.

We have traveled only 66 miles in the last month, including our stay at this place which has been about three weeks. It is unknown when we shall be able to cross the river. It may be over one month from this time, which is the 26th day of December 1838. I think we shall not reach Arkansas till March at least time.

My ox teams hold out extremely well at our slow rate of traveling. They have now bin [been] worth more than three hundred dollars each the hire of drivers.

I am unable to say at what time I will be home. I have issued seventy six thousand lbs. of beef and pork since I went into the service of Mr. Ross, and in proportion of meal flour, sugar, coffee, soap, and salt. That is to the ration three parts of corn meal for one lb. of flour to the ration per day. Four pounds of coffee and eight lbs. of sugar to every hundred rations four quarts of salt to every hundred rations and three pounds of soap.

I have been able all the time to attend to my business which is a great trouble and very disagreeable in bad cold weather like it is at this time. We travel slowly, but as to my part, I don't care if we reach Arkansas until next summer. Christmas passed without notice in this country.

I shall wright [write] oftener to all of you. Wright me at Fort Gibson by the time you think I reach there. Give my respects to all inquiring friends, Mr. Singleton and [illegible]. So no more at present but remains your affectionate son until death, this 26 December 1838.

Daniel Davis

On the road from the river to the village of Golconda is the Buel House, which was recently purchased by the State of Illinois because of its historic significance and possible association with the Cherokee Removal. According to a family tradition published in 1956, the matriarch of the house was cooking pumpkin when one detachment of Cherokees made the trek up the hill. The pumpkin was generously shared with the travelers.

Only about half of the eleventh detachment were able to cross the river on December 15. The remainder crossed on the following day. The afternoon and evening were stormy, and it was the first Sabbath since they left Brainerd that the detachment had no public worship. The rains continued on through December 17.

By Tuesday, December 18, Butrick was extremely sick. He had a high fever and stomach pains. The physician, he said, "bled me, and put a poultice of mustard seed on my side which afforded relief."

Butrick was well enough the following day to travel six miles to the next camp. On December 20, he wrote about the death of a ten-year-old boy who was buried in a coffin made of puncheons. It is here where Butrick first expressed doubt as to whether he would live to reach their destination.

△ Brinker-Houston Cemetery is on the grounds of the Snelson-Brinker House (1834) in Crawford County, Missouri. Four members of the Richard Taylor Detachment died here, including two members of the Mills family, Old Bird, and Mary Fields, the young daughter of Archibald Fields, the interpreter for the detachments. They were buried here on February 27 and 28, 1839. This site served as a campsite for a number of detachments on the Northern Route.

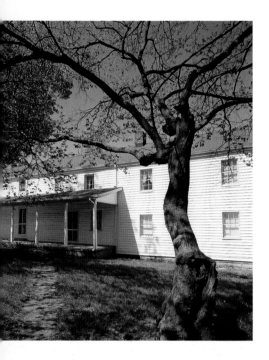

△ The Long House in Farmington, Missouri, was first built as a one-room log cabin in 1833. It was expanded as the Long family grew. The oldest house standing in the town today, it is the only existing structure in Farmington to have witnessed the passing of the thousands of Cherokees through the town in 1838–39, as they made their way to the Indian Territory on the Trail of Tears.

On Monday and Tuesday, December 24 and 25, the group traveled about fifteen miles. For the Butricks and most of the emigrating Cherokees, Christmas passed without celebration. About noon on Christmas Day, the cinch pin came out of one end of the fore axletree of Butrick's carryall. It fell on the frozen ground and broke, so that the Butricks had difficulty getting to the wagon maker six miles ahead. Mrs. Butrick had to walk considerably, and Mr. Butrick became quite fatigued. The Butricks stayed in the home of the wagon maker, which contained one room, with five adult members of the family all of whom were illiterate. The man of the house, whom Butrick described as about sixty years old, arrived shortly before dark in a high state of intoxication. According to Butrick, "Thus far the citizens of Illinois appear more and more pitiable. They seem not only low in all their manners, but ignorant, poor, and ill humored."

Wednesday morning, December 26, was exceptionally cold. Butrick rode one mile to the encampment of the Taylor Detachment. Richard Taylor decided that they would not move that day. The detachments that had reached the Mississippi were stopped, unable to cross the river because of floating ice. Hildebrand's detachment was stopped at the Ohio River for the same reason. The Butricks returned to the wagon maker's for their carryall, but as it was still not repaired they were obliged to spend another night at the house.

The next day, the Butricks returned to the detachment about six miles away, where they camped for the week. The snow was about three or four inches deep, and the weather was extremely cold.

Butrick wrote:

It is distressing to reflect on the situation of the Nation. One detachment stopped at the Ohio River, two at the Mississippi, one four miles this side, one 18 miles and one 3 miles behind us. In all these detachments comprising about 8,000 souls, there is now a vast amount of sickness, and many deaths. Six have died within a short time in Major Brown's company0 and in this detachment of Mr. Taylor's—there are more or less affected with sickness in almost every tent and yet all are houseless and homeless in a strange land and in a cold region exposed to weather almost unknown in their native country. But they are prisoners.

On Monday, December 31, Butrick reflected on the past year:

"O what a year it has been! O what a sweeping wind has gone over, and carried its thousands into the grave, while thousands of others have been tortured and scarcely survive, and the whole Nation, comparatively thrown out of house and home during this most dreary winter. And why? As coming from God, we know it is just. But what have they done to the United States? Have they violated any treaty? or any

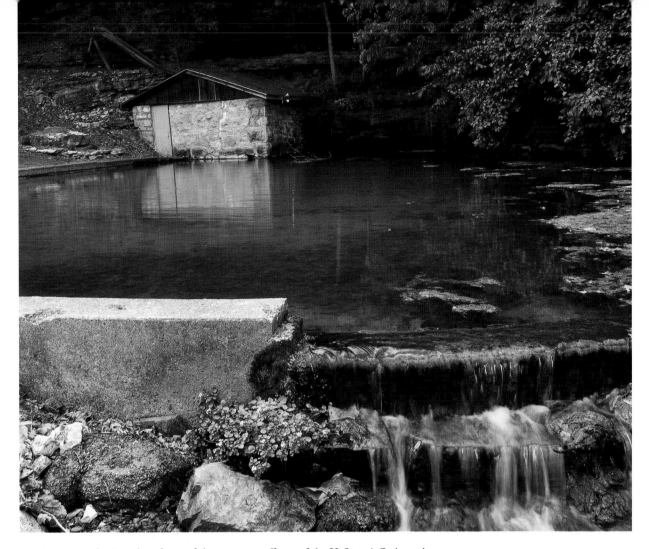

intercourse law? or abused any of the agents or officers of the U. States? Or have they refused to accommodate U. States citizens when passing through the country? NO such thing is pretended. For what crime then was the whole Nation doomed to this perpetual death.

Throughout early January, Butrick reported deaths in the camp on a daily basis. On Monday, January 7, most of the detachment moved about a mile and a half to a location where water was more accessible.

In spite of the rains that caused streams of water to run through the tents, Butrick took time on January 11 to visit the George Hicks Detachment. Hicks was well, but thirty members of his detachment had died since they commenced their march.

On January 12, Butrick learned that Judge Brown's and George Still's detachments had already crossed the Mississippi River and that the Wofford Detachment would probably cross the following day.

On Thursday, January 17, the Hildebrand Detachment passed the Taylor Detachment still in camp. After remaining stationary for two weeks, Taylor's detachment resumed their journey on Monday, January 21. They traveled only four and one-half miles before camping. The Butricks were sick, but the

△ McMurtry Spring, in Barry County, Missouri, was a campsite for detachments on the Northern Route in 1838. The eleventh detachment conducted by Captain Richard Taylor reached this location on March 17, 1839. Dr. W. I. I. Morrow, the attending physician for the detachment, wrote in his diary: "Sunday 17th March. Traveled up Flat creek 15 miles to McMurtres— Eat dinner at Masons 2 miles N E of McMurtres."

next day they managed to travel five miles and camp where the Hildebrand Detachment had been the night before. A burial party from the Hildebrand Detachment remained to bury a woman who had died during the night. Butrick reported that "We also learn that last Friday night, a woman in the same company was killed by the fall of a tree, and two others wounded. The tree fell on them, it seems, while asleep."

Butrick continued in his diary:

Friday (Jan. 25) We proceeded seven miles to the bank of the Mississippi River. At this place a sand bar in the middle extends probably half across the bed of the river, leaving two sluices of about an equal width on each side. Therefore it is like two rivers, crossed by two ferries, that is, two sets of boats, one conveying passengers to the bar, and the other from it. But three waggons and a Carryall crossed today. We find our tent on the bank of this great river, one of the wonders of Creation. Soon after we arrived, our attention was arrested by the passing of a large, beautiful and grand steamboat. Neither my dear wife nor myself had ever seen one before. Of course the appearance was quite imposing. We have long been looking forward to this river; and numbers who crossed the Ohio with us have not lived to arrive at this.

By January 28, 1839, the Butricks were in Bainbridge, Missouri, where they waited for the Cherokees to finish crossing the Mississippi River. For two and a half weeks they accepted the hospitality of the families of Mr. R. Brevard and Judge Obannon. Butrick wrote: "In these two families we found everything we needed to refresh our bodies and comfort and revive our drooping spirits. This kind Providence was probably the means of saving the life of my dear Elizabeth, if not my own also, as I had been afflicted with the same complaint."

The remainder of the Taylor Detachment did not cross the Mississippi until February 11 and did not move from their encampment on the Missouri side of the river until February 15. The three-week delay resulted from ice floes in the river making the crossing treacherous. During this period in which half of the Taylor Detachment was trapped in Illinois and the other waiting for them in Missouri, five people died. Their ~~deaths brought~~ the total fatalities to twenty-six since the Taylor Detachment crossed the Tennessee River near Ooltewah.

By Thursday, February 21, the detachment had traveled eighty miles from the Mississippi River and were eleven miles west of Farmington, Missouri. During the night an elderly man named Drowning Bear died. Over the next week, the detachment traveled more than forty miles. During the journey there were two deaths, an old man named Bird, and the daughter of Archibald Fields, named Mary, and on the evening of February 28, two children aged two and three died in the camps.

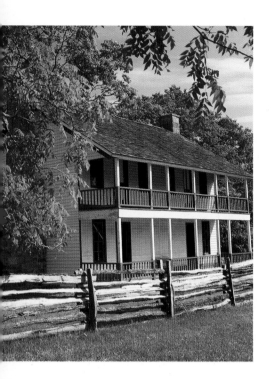

△ On December 23, 1837, the detachment conducted by B. B. Cannon spent the night at a two-story log cabin owned by the Reddick family. The building would later become the Elkhorn Tavern in Pea Ridge Battlefield, Benton County, Arkansas. Cannon recorded in his journal:

Decr. 22nd, 1837
Burried (sic) Goddards Grand child, Marched at 8 oc A.M. halted at McMurtree's 3 o'c P.M., encamped and issued corn meal corn & fodder, 15 miles to day.

Decr. 23, 1837
Buried Rainfrog's, or Lucy Redsticks daughter, Marched at 8 o'c A.M. halted at Riddicks 3 oc P.M. Encamped and issued Beef, corn & fodder, 10 miles to day.

△ Massey (Maramec) Ironworks located in Crawford County, Missouri, was passed by ten detachments under John Ross on the Northern Route of the Trail of Tears. It is on Missouri Highway 8 between Steelville and St. James. It is the oldest ironworks in the state, with stone structures dating back to 1829. Dr. W. I. I. Morrow, attending physician on the eleventh detachment under Richard Taylor, wrote in his diary on February 27, 1839, "Examined the forge & furnace at Massys—I think it [is the] most convenient and splendid place of the kind I ever saw." It is now a public use area managed by the James Foundation.

△ The Danforth House was completed in 1849 and replaced the original log dwelling in which Josiah Danforth lived when emigrating Cherokee camped here from 1837 to 1839. The Danforth farm is near Strafford, Greene County, Missouri, and was a favorite stopping point for nineteenth-century travelers on their way to Springfield. The Cannon Detachment stopped at Danforth at 2:00 p.m. on December 15, 1837, and the wagoners worked late into the night having the horses shod. The Richard Taylor Detachment stopped here on March 12, 1839. The detachment had left the last farm owned by Neavis before daybreak and traveled twelve miles to Danforth's. It was a warm day that turned cold by evening and it was snowing by the morning of March 13 when they traveled eight miles farther to Springfield. Danforth descendants still reside here today.

Friday, March 1, was as warm as May, and the people began to talk of summer. The optimism proved false, however, as that very evening the weather changed. Summer gave way to the chill of winter and rain quickly turned to round, hard snow. Soon, the snow fell in flakes and before long it was ankle deep.

On Monday, March 4, Butrick wrote: "This morning the word came that a Cherokee woman was dying. I hastened to her tent, and found that she was a member of Harris Church. She was put in the waggon which carried her family when the detachment started, but soon expired. The corpse was carried to the next encampment, on the banks of Big Piney River, and for want of boards, puncheons were split, and something made of them to answer the purpose of a coffin, and the corpse was interred after dark."

By the evening of Tuesday, March 5, 1839, the detachment had reached Port Royal or Waynesville on the Rubedoo Creek, a branch of the Gasconade River. The following day they trekked fourteen miles, through barren country, to the Gasconade River. From there they proceeded to the west branch of the Gasconade and then about ten miles further to Grigsby's farm on the Osage branch of the Gasconade River. By Sunday, March 10, the detachment had traveled another eighteen miles to Burnett's farm and camped. That morning Butrick preached the Sunday service a little after the usual time.

Butrick wrote, "I spoke from 2 Cor. 8:9. Just before meeting I visited a family, in which was a boy ten or twelve years old, sick with the bowel complaint. He extended his emaciated hand to take mine and then pointed to the place of his extreme pain. Before our meeting was closed he was a corpse."

The Hildebrand Detachment, the last to leave the Cherokee Agency on the Hiwassee River, had passed the Taylor Detachment in Illinois. In Missouri, the Hildebrand group departed from the main road to take a shortcut through the Arcadia Valley. According to local oral tradition, a detachment of two thousand Cherokees camped on the Gasconade River for much of the month of February because they were too sick to travel.

The Taylor Detachment rose early on March 12th and took the road ahead of the Hildebrand Detachment. According to the chief medical officer Dr. W. I. I. Morrow, they traveled twelve miles to the Danforth farm, a stopping place for the B. B. Cannon Detachment the year before.

On March 15, they traveled seventeen miles over a barren desert, destitute of water and wood where "almost naked hills rose to view as far as the eye could reach," eventually stopping at a suitable site about which Butrick wrote, "We camped in a beautiful place on a small stream called Sugar Creek. Just before arriving at the encampment, a little boy was run over by a large waggon, the wheel passing over his neck and the back part of his head. The physicians were called, but supposing he would certainly die, did nothing for him. Mr. Taylor

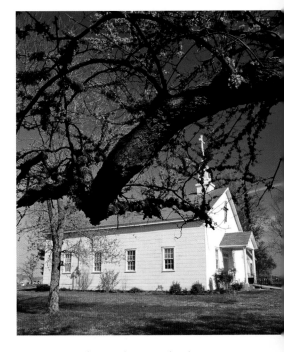

△ Mt. Comfort Presbyterian Church was established in 1828 in Washington County, Arkansas. This community was first settled when S. Tuttle built his log house on this site. A few years later his son-in-law, W. D. Cunningham, built his two-story brick home that witnessed many historic events, including the passing of the Cherokees on their Trail of Tears in 1839. The Cannon Detachment in 1837 and the Taylor Detachment in March 1839 noted that Cunningham's was a stopping point after leaving Fayetteville.

△ In the distance is Baptist Mission Church in Adair County, Oklahoma, north of Westville; Baptist Mission was established in 1841 by Reverend Evan Jones. Burned during the Civil War, the mission was never rebuilt, but the church has continued to meet. The present building was constructed in 1888. Originally on the site of the Woodall farm, the eleventh detachment under Captain Richard Taylor disbanded here on March 22, 1839, followed closely behind by the Hildebrand Detachment. Within a month the location was known as "Bushyhead's." Shortly thereafter Reverend Evan Jones established Breadtown, which served as a mission station and issuing depot. Jesse Bushyhead was the conductor of the third detachment. He died in 1844 and is buried in this cemetery.

thinks the detachment will be obliged to travel next Sabbath to keep out of the way of Mr. Hildebrand pressing them behind."

On March 18, the detachment crossed the Arkansas line seven miles northeast of Pratts near Meeks on Sugar Creek. The road entered Arkansas on the east side of Sugar Creek. The Pratt Cemetery is located just east of the road, not far from Winton Spring, approximately two miles southwest of Elkhorn Tavern and approximately seven miles from the Missouri line.

By Thursday, March 21, they passed through Fayetteville and by March 23, they had reached their point of dispersal at Woodall's, inside the Indian Territory.

Butrick wrote: "Saturday (Mar. 23 1839) After early breakfast, we proceeded to Mr. Woodall's, 8 miles. This is the place of deposit and also the place where Mr. Taylor is to deliver the detachment over to the U. States officers, who are to supply them with provisions one year. We arrived about noon, and made arrangements for a meeting tomorrow—Find that Mrs. Woodall is our dear sister Eleanor, daughter of Bro. and sister More of Hightower."

The Taylor Detachment arrived at Woodall's on March 23, 1839, after a journey of 185 days. The Hildebrand Detachment pulled in the following day after traveling 154 days. Shortly after their arrival, Jesse Bushyhead purchased the Woodall place and built a church nearby. He is buried in the cemetery across the road from the church.

The End of the Trail

Most of the detachments on the Northern Route disbanded at particular issuing stations assigned either before or during their journey, some detachments decided on their own where to disband, and some were redirected to different depots by the military in the final stages of their journey.

The first three detachments to leave from Ross's Landing each had military conductors who were ordered to turn over their detachments at Fort Gibson, but none of the three reached the assigned destination. The first detachment disbanded at Fort Coffee after the emigrants unloaded their baggage from the steamboat *Smelter* and refused to go farther. The next two were rerouted to the Flint District by army officers as they approached the Indian Territory.

The Ross Detachments disbanded at several depots established for the purpose of issuing provisions for one year as required by the Treaty of New Echota. The Taylor Detachment disbanded at Woodall's near present-day Westville as indicated in the diaries of Rev. Daniel Butrick and Dr. W. I. I. Morrow. It is possible to identify with certainty the places where most of the Ross Detachments disbanded by gleaning information from *Report Number 271,* House of Representatives 27th Congress Third Session, dated February 25, 1843. New Fort Wayne at Beattie's Prairie, Indian Territory, southwest of Maysville, was the terminating point for the third detachment led by Jesse Bushyhead, the fifth detachment led by Situwakee, the eighth detachment led by Choowalooka, and the tenth detachment led by George Hicks. It is possible that the sixth detachment under Captain Old Field may have disbanded at New Fort Wayne since he signed a letter of protest from there in April 1839.

Mrs. Webber's, the principal depot and later the home of Colonel Walter Adair, was the terminating point for the fourth detachment led by John Benge, and the seventh detachment led by Mose Daniel. It may be that Elijah Hicks's second detachment also disbanded there although that is not conclusive. James Brown's ninth detachment may have disbanded at Mrs. Webber's, although Brown himself was reported by Dr. Morrow to be at Key's near Park Hill in April 1839.

Woodall's near Westville, which was later known as Bushyhead's, was the terminating point for the eleventh detachment led by Richard Taylor. The twelfth detachment led by Peter Hildebrand, following close behind Taylor, may have also disbanded at Woodall's, although this is not certain. It is also possible that the Conrad Detachment disbanded at Woodall's, based on clues in a letter from Elizur Butler of that detachment written from Van Buren on January 25, 1839, and the fact that Conrad was at Woodall's in mid-April 1839.

△ Reverend Jesse Bushyhead conducted the third detachment under John Ross. The detachment disbanded at new Fort Wayne about fifty miles north of present-day Westville. He soon moved to the former Woodall farmstead near Westville and collaborated with Reverend Evan Jones on Baptist Mission activities. He also served as a judge for the Cherokee Nation. He died two months before his fortieth birthday on July 17, 1844, and is buried at Baptist Mission Cemetery. The obelisk that marks his grave is inscribed in English and in Cherokee syllabary. Adair County, Oklahoma.

△ This blacksmith shop, typical of those from the early and mid-1800s in Arkansas, is adorned by a redbud tree on the grounds of Prairie Grove Battlefield State Park, Washington County, Arkansas. The Cherokee detachments frequently sought out the services of blacksmiths to repair carriages and wagons and to reshoe horses on the trip. The Benge Detachment may have traveled through this area on their way from Fayetteville to Mrs. Webber's farm in the Indian Territory at present-day Stilwell, Oklahoma, in January 1839.

▷ The Benge Detachment of 1,100 Cherokees reached the Eleven Point River on December 10, 1838, after traveling nine and a half miles from Fourche Damas. They crossed the river at Blacks Ferry site, north of Imboden, Randolph County, Arkansas, and probably camped close enough to the river to use the water.

THE BENGE ROUTE

CHAPTER VI

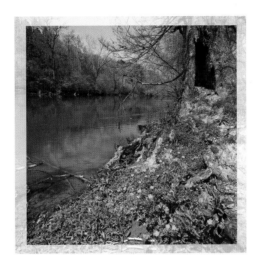

The fourth detachment, led by John Benge, started with 1,079 individuals and sixty wagons. The first group of fifteen wagons with 305 individuals departed camp on September 29, 1838. Others followed over the next week. They disbanded in the Indian Territory on January 17, 1839, with 1,132 people, despite the fact that there were thirty-three deaths and three births en route. Just prior to departure in late September, a muster roll was prepared for John Ross. It listed 1,103 individuals in camp at that time. The original muster is now in the Gilcrease Institute in Tulsa, Oklahoma, as is the paymaster's book of John Ross, which provides a record of payments to officers of the detachment.

The starting point for the fourth detachment was a camp eight miles south of Fort Payne, Alabama. From there they traveled in a generally northwest direction and crossed the Tennessee River at Gunter's Landing, and again at Reynoldsburg, Tennessee. According to Winfield Scott, they crossed the Mississippi River at the Iron Banks in

△ In late October 1838, the Benge Detachment passed the Duck River Furnace in Hickman County, Tennessee, as they traveled on the main road between Pulaski and Reynoldsburg. The furnace produced pig iron in the 1830s. The limestone stack still stands along State Route 230 near Bucksnort, Hickman County, Tennessee.

Kentucky. They traveled west and southwest through the southeastern corner of Missouri, crossing into Arkansas at the Current River. They followed the old Spanish Road into northern Arkansas, with some members traveling as far south as Batesville. From there they traveled up the White River on the old Military Road, stopping at Fayetteville long enough for one of their number to be murdered, and then disbanded in the Indian Territory on January 17, 1839. The journey of the fourth detachment is especially significant because it has been consistently misrepresented on maps depicting the routes of the Cherokee Trail of Tears developed prior to the studies by the National Park Service.

Concentration Camp in Alabama

On June 19, 1838, Brevet Brigadier General Winfield Scott, responding to a petition by Cherokee leaders, suspended the general Removal until September 1. By that time, most Cherokees had already been forced by the military into concentration camps near the primary emigrating depots in Tennessee and in Wills Valley, Alabama. The camp of the fourth detachment was located in the vicinity of what is present-day Lebanon, Alabama, eight miles south of the historic site of Fort Payne. Before it became a military establishment in 1836, the small settlement at Fort Payne was called Rawlingsville. Captain John Page wrote to C. A. Harrison on July 25, 1838, that all the Cherokee camps were in Tennessee with the exception of the one at Fort Payne, Alabama. He reported that nine hundred Cherokees were interned at Fort Payne and that A. George was the attending physician. In early September, about two hundred of the two thousand Cherokees held near Ross's Landing in Tennessee joined the Benge Detachment, according to a letter from Dr. John Young to Winfield Scott dated October 1, 1838. The number of Cherokees in the Benge Detachment continued to grow in late September and early October, and several families joined the detachment after it left camp. Also, Cherokees serving prison terms in the Georgia State penitentiary at Milledgeville were released in order to join the Benge Detachment and be removed.

On September 29, 1838, John Benge, George C. Lowry, and George Lowry wrote to John Ross from Wills Valley, Alabama.[24]

\mathcal{S}ir

We find on examination of the conditions of the detachment of Cherokees collected at this place for Emigration that many of them, say at least two thirds are in a destitute condition and in want of shoes, clothing, and blankets. We were informed on the 28th Inst. By the Commanding officer at Fort Payne, that this Detachment must move by the first day of October and that the Issuing Agent would be instructed not to issue Rations after that time unless some extraordinary circumstance should justify their continuing here after that time; in consequence of this information we

△ According to the Batesville newspaper, the Benge Detachment camped at Fourche Damas, near Pocahontas, Randolph County, Arkansas, on December 9, 1838. The Columbia Crossing, as it was known, was made easier by an excellent bridge built across Fourche Damas Creek in 1835.

△ When the Benge Detachment reached Smithville, Arkansas, on December 12, 1838, the Lawrence County Court was in session. A Batesville attorney, William Byers, who was there at the time wrote to his partner in Batesville on December 13, 1838:

"About twelve hundred Indians passed this place yesterday, many of whom appeared very respectable. The whole company appeared to be well clothed, and comfortably fixed for travelling. I am further informed they are very peaceable, and have committed no depredations upon any property where they pass. They have upwards of one hundred wagons employed in transporting them; their horses are the finest that I have seen in such a collection. The company consumes about one hundred and fifty bushels of corn a day.

"It is stated that they have the measles and whooping cough among them and there is an average of four deaths per day. They will pass through Batesville in a few days."

have this day started fifteen waggons with Three Hundred and five Persons and we will probably start Twenty more tomorrow and shall continue our best exertions until the whole detachment is underway. We would suggest the propriety and urge the necessity of your forwarding shoes, Blankets, and such other Clothing as is provided for other parties of emigrating Cherokees to meet us on the road near Huntsville or furnish us the necessary funds to purchase them at that place. The detachment consists of 1,090 persons and three families yet to come in. We have only Eighty three Tents. You will see the necessity of providing an additional supply as many families are compelled to start without a Tent. Mr. Colburn the contractor has offered to procure the Necessary supply of Tents at Huntsville if you will instruct him to do so they can be made by the same person made those we have already received and they probably be in readiness by the time the Detachment will reach that point. We wish you to forward us such written instructions as we are to be governed by in the discharge of the duties assigned us; the waggon master also wishes written instruction he also requests that he may have the privilege of Sixty waggons for this detachment as there is not the requisite number of Saddle Horses. We would also request that funds should be speedily forwarded for the use of this detachment. All of which we respectfully submit for your consideration and request as speedy an answer as the urgency of the case requires. We remain yrs Respectfully

> John Benge (X)
> George C. Lowry
> George Lowry

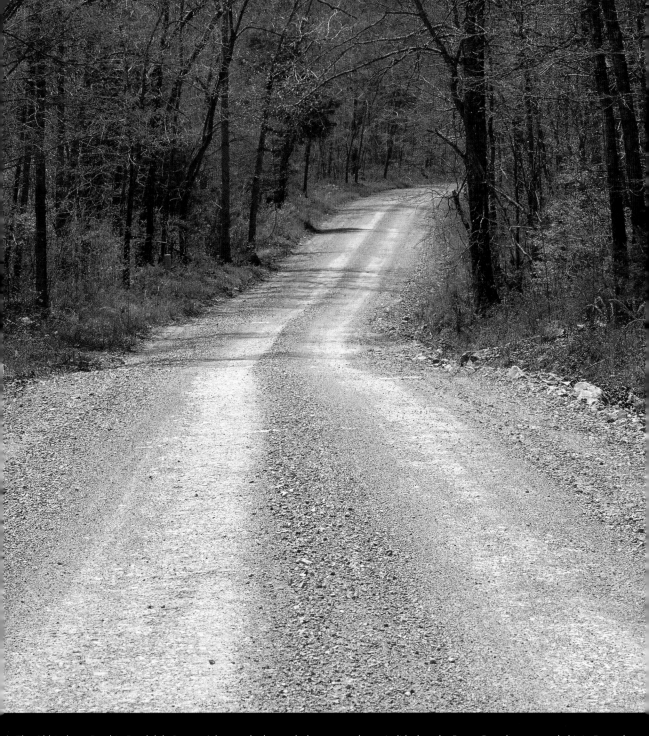

△ The Old Jackson Road in Randolph County, Arkansas, looks much the same today as it did when the Benge Detachment traveled it in December o 1838. Weldon Creek, which parallels the road for more than a mile, served as a source of water for nineteenth-century travelers.

"They left Gunter's Landing on the Tennessee, about 35 miles above Huntsville, Alabama the 10th of October; since that time owing their exposure to the inclemency of the weather and being destitute of shoes, and other necessary articles of clothing, about 50 of them have died."

Further indication of the change in the numbers for the Benge Detachment is found in a letter from Lieutenant R. Poole to Winfield Scott.

Camp near Missionary Hill, Tenn.
 October 11th 1838

*S*ir
 I have the honor to inform you that the emigrating party of Cherokees, of which Mr. John Benge is conductor, left its camp eight miles below Fort Payne, on the 4th instant; and I learned that on the 7th it was within fourteen miles of Gunter's Landing. The last of the families which Mr. Benge reported were to join his party from this vicinity passed Fort Payne on the 5th. I however ascertained on my way hither that there are three families about six miles from here in Lookout Valley, numbering about twenty persons, which are to accompany Mr. Benge. The principal man among them, named Peter Miller, informed me, that the greater part of the baggage had gone on. . . .

In Search of the Route of the Benge Detachment

The historical record for the Benge Detachment is a sparse collection of letters, newspaper accounts, eyewitness accounts, and oral tradition reported long after the event. The paucity of information is the reason the route of the detachment has been so elusive to researchers over the years. No diaries, journals, or reimbursement vouchers, which have been so critical in elucidating the routes of other detachments, exist for the Benge Detachment. However, even with only a few pages of reliable information, it is still possible to suggest with some degree of confidence a likely route through the state of Arkansas by matching contemporary reports of sightings of the Benge Detachment with the road system of the day.

A report in the *Batesville News* of December 12, 1838, and copied in the *Arkansas Gazette* on December 20, stated, "They left Gunter's Landing on the Tennessee, about 35 miles above Huntsville, Alabama the 10th of October; since that time owing their exposure to the inclemency of the weather and being destitute of shoes, and other necessary articles of clothing, about 50 of them have died." From the Ross payroll book, it is apparent that the detachment did pass through Huntsville, Alabama, since several wagoners were paid for services there.

The *Gallatin Union* of November 2, 1838, picking up a story from the *Trumpet of Liberty*, stated that twelve hundred Cherokee passed through Pulaski, Tennessee, on October 23, 1838, under Colburn and Benge, the Cherokee chief. The item reported five to six deaths in Pulaski, mostly children, from whooping cough and measles. It also said the detachment intended to pass through Reynoldsburg.

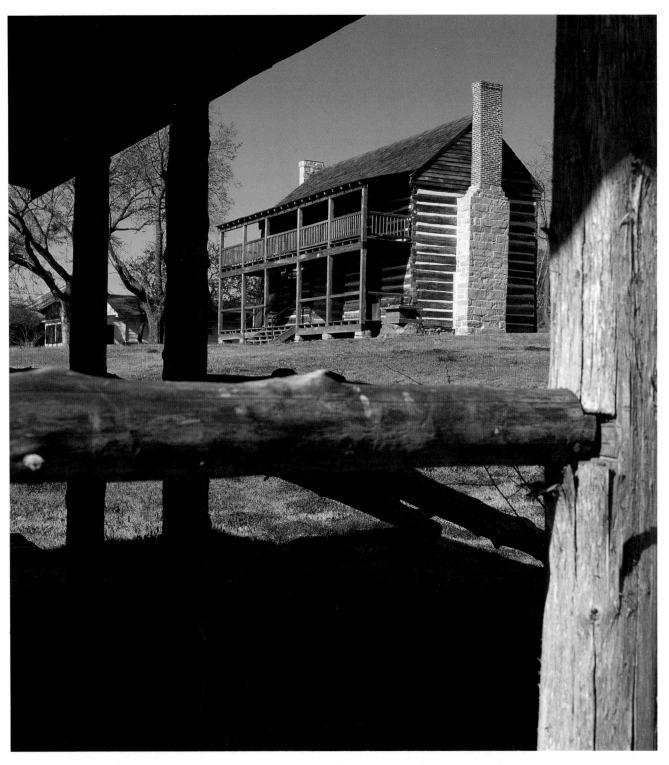

△ The Wolf House was built in 1829 and served for a number of years as the courthouse for the town of Liberty, Izard County, (now Norfolk, Baxter County), Arkansas. In 1834, the county seat moved to Athens. This building then became the Jacob Wolf home until his death in 1863. The Benge Detachment is thought to have stopped here around Christmastime, 1838. It is one of the few structures in Arkansas still standing that would have been seen by Cherokee emigrants during the forced Removal.

"About twelve hundred Indians passed this place yesterday, many of whom apeared very respectable."

The distance between Pulaski and Reynoldsburg calculated from David Burr's Postal Map of 1839 was ninety-nine miles, which the detachment traversed in eleven days, for an average of nine miles a day, if they traveled every day. If they rested on Sunday, October 28, as was customary, they would have averaged almost ten miles a day for this leg of the journey.

On November 3, 1838, they had reached the now abandoned but then thriving frontier town of Reynoldsburg, Tennessee. On November 12, 1838, John Ross wrote to Winfield Scott: "Mr. Theodore Johnson who was dispatched by Lewis Ross . . . states that he overtook (Captain Benge's) detachment near Reynoldsburg and continued with it to that town and left the Emigrants crossing the Tennessee river on the third instant—that all things were going on well, except sickness, which have prevailed to a greater extent in that detachment on the road than others." Winfield Scott wrote to Governor Cannon of Tennessee on October 8, 1838, stating, "One detachment four days in march, from Ft. Payne, DeKalb County, Alabama, will cross the Mississippi at the Iron Banks." The letter was published in the October 10, 1838, issue of the *National Intelligencer* and the October 15, 1838, issue of the *Nashville Whig*. The Iron Banks, also known as Columbia, Kentucky, was a small town in the 1830s. In January 1833, Karl Bodmer, an artist traveling with Maximilian, Prince of Wied-Neuwied, painted a landscape of the Iron Banks near Columbia, Kentucky. According to Maximilian, Columbia was the first town of any size located below the mouth of the Ohio. Maximilian reported that "Columbia has 20-24 houses."[25] The Benge Detachment undoubtedly stopped at this town sometime in mid-November 1838.

Harris Hollow and Indian Ford

In some sections of the Natchitoches Trace in Ripley County, Missouri, ribbons of wagon ruts are still clearly visible and provide a silent testament to the thousands of nineteenth-century travelers in southeastern Missouri. A local oral tradition states that the Benge Detachment camped at Harris Hollow in Ripley County, Missouri, before crossing the Current River at Indian Ford. Based on the known date of arrival at Fourche Damas, Arkansas, the date they would have camped in Harris Hollow would have been about December 7, 1838.

In 1887, Dr. John Hume of Doniphan, Missouri, interviewed Massy Harris, the widow of Washington Harris. Mrs. Harris reported that an Indian woman and baby died in the camp on the Harris property and were buried in the family cemetery, which was overgrown with trees a half century later. She also told how her husband's brother Travis Harris and a man named Jimmy Givens guided the party of emigrating Cherokees under John Ross to a ford known ever since as "Indian Ford," to avoid exorbitant costs of $.50 per person at Hix's Ferry.

Batesville News

A letter dated December 10, 1838, and published in the *Batesville News* on December, 13, 1838, reported, "Last night they [the Benge Detachment] camped on Fourche Damas. It is expected they will pass through Batesville about one week from this time. From Batesville they intend going up White River to Fort Gibson."

Another letter from Smithville dated December 13, 1838, appeared in the Batesville paper on December 20, 1838. It stated, "About twelve hundred Indians passed this place yesterday, many of whom appeared very respectable. The whole company appeared to be well clothed, and comfortably fixed for traveling. I am further informed they are very peaceable, and have committed no depredations upon any property where they pass. They have upwards of one hundred wagons employed in transporting them; their horses are the finest that I have seen in such a collection. The company consumes about one hundred and fifty bushels of corn a day. It is stated that they have the measles and whooping cough among them and there is an average of four deaths per day. They will pass through Batesville in a few days."

Both letters are signed W. B., who is not identified by the newspaper. He was, however, William Byers, a Batesville lawyer. Byers wrote to his partner in Batesville to give status reports. His partner provided the notes on the Cherokees for publication in the Batesville paper.

Hillhouse Cemetery

In the spring of 2001, Steve Saunders, an architect and resident of Catalpa Springs, Arkansas, interviewed Ivey Justus and Ed Bilbrey, who are both in their nineties. They were lifelong residents of the area and each reported that as children they had heard that Cherokees were buried in the Hillhouse (pronounced Hilhous) Cemetery two and a half miles south of Smithville. Justus stated that when he was a boy "the old-timers" talked about how "Indians came through Smithville" when they were boys and that an Indian boy showed them how to shoot a bow and arrow, using their feet to hold the bow and both hands to pull the string.

Although the oral tradition about the Hillhouse Cemetery has not been published, it does predate any research interest in the Trail of Tears. The location is on the road over which the Benge Detachment is believed to have passed, and the terrain, with its adjacency to Cooper Creek, is a logical place for a campsite.

△ On the evening of December 12, 1838, the Benge Detachment camped in the vicinity of Hillhouse (pronounced Hillous) Cemetery, two and a half miles south of Smithville, Lawrence County, Arkansas. According to a tradition passed down through the family of Ivey Justus (born about 1900), a Cherokee boy taught some local boys how to shoot a bow and arrow holding the bow with his feet, freeing both hands to pull the string. It is believed that four members of the Benge Detachment were buried in unmarked graves in a corner of the cemetery.

△ The historical marker commemorating the Trail of Tears is found at the University of Arkansas at Fayetteville. On January 13, 1839, Benge's detachment camped in this area, which was on the Cane Hill Road leading to the Indian Territory. In the short time they were in Fayetteville, Washington County, Arkansas, one member of the detachment, Nelson Orr, was murdered by a local resident. In the spring of 1839, Willis S. Wallace was tried for manslaughter in connection with Orr's death. He was found not guilty.

A Divided Detachment

On December 20, 1838, the *Batesville News* reported:

> On the 15th inst., a detachment of Cherokee Indians passed near Batesville, Independence co., Ark., on their way to their new home in the 'far west.' Many of them came through the town to get their carriages repaired, horses shod . . .
>
> The following are the principal officers among them: John Benge, Conductor; Geo. Lowery, Assistant, do.; Dr. W.P. Rawles, of Gallatin, Ten. Surgeon, and Physician; W.S. Coody, Contractor.
>
> Doctor Rawles stands high in their estimation, as a friend to the Indians, and but few men are better qualified for the station he now occupies among them. He expects to accompany them all the way, and he will not set out for home until about the first of January.

Although the newspaper article is unfortunately vague, it seems to suggest that the detachment divided into two groups before reaching Batesville. It states that the detachment passed "near Batesville" and that "many came into town" for repairs. It might be speculated from this statement that the detachment split north of Batesville, with those not needing the services found in that thriving community taking a more direct route west. Oral traditions in Izard County suggest multiple migration routes, with two routes merging at the Baxter County line.

Camp near Athens

A tantalizing reference to the Benge Detachment camping on the White River near Athens is found in a nineteenth-century family history by J. J. Sams.[26] Here it is noted that

> He [John Jeffrey, brother of Sams's maternal grandfather] killed three of the Benges family of Indians. There was some of the offspring of this family moved through Izard county in 1838, and they camped on White River as the Cherockees [sic] were moving west they were camped near Old Athens for five or six days resting up. There was said to be fifteen hundred of them.[27]

This intriguing but brief account is extremely important in that it seems to resolve the question about which road they chose, given that more than one suitable option was available. It also raises a question as to why the detachment would be stationary for nearly a week. It may have been that too many members of the detachment were too sick to travel or possibly that they were waiting for part of the detachment to catch up. If the latter was the case, the campsite near Old Athens may have been the rendezvous point for the part of the detachment that passed near Batesville and those that went into

Oral traditions in Izard County suggest multiple migration routes, with two routes merging at the Baxter County line.

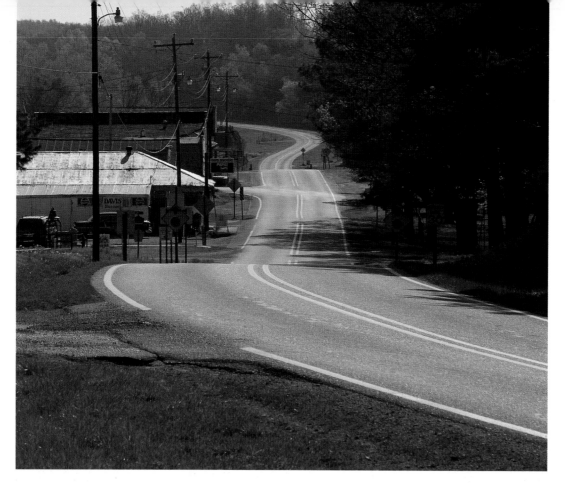

△ At the time of the Removal, the Old Military Road that passed through Smithville, Lawrence County, Arkansas, was rated as a two horse stage road, somewhat of an improvement over the one horse mail or sulky roads they had traveled on in western Tennessee, Kentucky, and Missouri. Still the condition of the roads may have been one of the reasons that many people in the detachment went into Batesville for carriage repairs at one of three blacksmith shops operating there at the time.

town for repairs. The convergence of the two trails, however, may have been elsewhere, and the abundant supply of water provided by the White River caused it to be selected as the most preferred site for extended camping. It may well have been that the time required for carriage repairs in Batesville, plus the additional distance, required five or six days longer for that part of the detachment to reach the White River.

Talbert's Ferry

Another eyewitness account of the Cherokees at the White River, only substantially farther upstream, was provided by W. B. Flippen, who, in 1899, published a series of articles in the *Mountain Echo* newspaper in Yellville. In 1838, Flippen was working as a clerk in a store owned by his uncle, Jesse Goodman, who also owned a ferry that was known as Talbert's (also spelled Talbot and Talbart).

Flippen was born in Monroe County, Kentucky, in 1817. In 1824, he moved with his father to Tennessee and from there moved to Marion County, Arkansas, in 1837, and lived on the same farm for nearly sixty years. Flippen kept a diary his entire life. Unfortunately, his house burned and his papers were destroyed. The articles may have been an attempt to reconstruct from memory his earlier writings. The passage of time may account for the historical inaccuracies. Almost six decades later, Flippen recalled the events.

About the year 1839 or 40, a large detachment of Indians came through this county. Said to be about three thousand men, women, and children moving west. They were Cherokees and Creeks. I am not certain as to the time, as there has been at least two moves, for some refused to go with the first migration. Many of the Cherokees were well dressed and riding good horses; fine looking men. From their appearance I judged them to be half breeds. While the majority, many of them poorly clad. Some of the women having only blankets wrapped around them, several carrying papooses wrapped in a blanket or some kind of cloth and fastened to the back of their mothers. Seeing so many, I wondered that I did not hear a scream from a single papoose . . .

It was winter when they came to White River, ice was frozen over along the banks of the river. I was to assist the ferryman in setting the host across the river on a ferry boat, with two oars to row with. Instead of their stopping to make terms to cross on the ferryboat, they never pretended to halt but waded across the river, women and men, all except the few who had horses and carriages. They did not pretend to let the women who had papooses ride. It reminded me of a drove of cattle crossing a stream. The river was unusually low at the time, but it was over 200 yards wide. I had stepped it once when it was frozen over.

They camped after crossing the river, built up fires and remained all night. The agent whose name I have forgotten had come on before them and bought provisions for man and beast, at least what was lacking . . .

There came to the camp that evening, a large fine looking man, whom I had seen a few times before, who had recently came to the county. He had a brother who had preceded him several years before. They both came from Kentucky. The eldest one was named Erving Hogan, the other Micajah Hogan. He was a gambler, and had come for the purpose of gambling with the Indians, which he did that night, and won a considerable amount of money. Next day early the host moved on; but two Indians crossed back over the river. Hogan had returned and put up at the house of the ferryman. I learned the name of the Indians: Benge, a sub chief, the other, a tall active looking Indian, whose name was Young. He immediately told Hogan his business was to play a game of cards with him. Hogan readily consented. They sat down on a large log and commenced playing what is called "seven-up." Hogan kept talking. Presently a crowd had gathered to see the game. Young hardly ever spoke, but seemed to watch the game closely. I noticed Hogan was losing almost every game. They were betting freely, playing out a hand. Hogan came in one of being out, as they called the end of the game. Hogan threw down his cards and cried out in a loud voice "out!"

Yes, said the Indian "out of H__l and a pity for that." Young got up pretty soon after that and said "I am satisfied I have won back all the money you won from me last night. Benge, during the game, kept talking in Indian to Young. Hogan told him to speak in English, and cursed Benge, whose eyes fairly blazed fire, returning the compliment and drew out a fine silvered handled pistol.

Hogan told him he had no arms. Benge said, "You shall not have that for an excuse, and pulled out a mate to the pistol he had and offered it to Hogan but he refused to take it. I expected to see Benge to shoot him, but he let fly a volley of oaths, cursing Hogan all the while, saying they had taken their homes from them, and compelled them to go from the home of their fathers to a land they knew nothing of in the west. Hogan told him he had nothing to do with it. Benge replied, "But your people did, and I hate them all alike."

△ The Denton's Ferry, also known as Talbert's (or Talbot's) Ferry, was a primary crossing site of the White River in Baxter County, Arkansas. The fourth detachment conducted by John Benge reached here in late December 1838. In 1839, W. B. Flippen, who at the time of the Removal was a twenty-one-year-old clerk in his uncle's store at the ferry landing on the east side of the river, wrote his recollections of the Benge Detachment. He said that the detachment waded the river without waiting to be ferried across. He also described an encounter between the conductor John Benge and a local gambler. His vivid accounts reflecting sixty-year-old memories were published in a series of articles in a Yellville newspaper called the *Mountain Echo*.

Benge was a large, square built man and appeared as vicious as an enraged lion. Benge and Young mounted their horses and rode off. I don't mean to say Hogan was not a brave man. I have seen him in several fierce contests, and he never seemed to fear the face of any man, but the Indian seemed to have the drop on him.

Young was undoubtedly John Young, a teamster, who like most heads of households was paid for providing his own team of horses for the journey west. Benge is assumed to be the conductor, John Benge, but it could have been his son Martin or his brother Robert, the wagon master, or Richard Benge, all of whom were paid for supplying teams of horses for the detachment. The fact that in his eighties W. B. Flippen could recall the surnames of two people he met only once sixty years earlier is amazing and reflects the indelible impression this encounter made on him.

The Carroll County Historical Quarterly (Volume 5, March, 1960) published an article by Coy Logan titled the "Trail of Tears." Mr. Logan wrote primarily about the attempt of Sam Leath to retrace the route of the Cherokee exodus.

> Mr. Leath reported that the trail was by the way of Carrollton, Osage, Huntsville, and Johnson's Switch near Fayetteville. The trailblazers were instructed to demand that the whisky stores be closed. They did not want the Indians to get whiskey on the march. Near Fayetteville at Johnson's Switch a man did not obey instructions. He rolled out a barrel of Whisky and provided tin cups for all. A drunken brawl followed and several men were cut with knives. One Indian was killed and a white man was missing. This brawl created ill feelings between the Indians and white people. Mr. Leath erroneously gave the date as 1837.
>
> Old timers point out a place near Osage where one of the Indians died on the March and was buried.
>
> Mr. Leath says the Indians made one request of his father. They urged him to tell the white men not to disturb the Indian graves. Even in that day there were treasure hunters and souvenir hunters.

The Indian that was killed, to whom Mr. Leath referred, was Nelson Orr, a mixed-blood Cherokee married to George Lowrey's[28] daughter Rachel. According to one account, the Cherokee encampment at that time was two miles west of Fayetteville. As soon as word of the assault reached the Cherokee camp, William S. Coody, a quarter-blood Cherokee, led twenty men back to town to prevent further bloodshed. They dashed up the principal street into the public square to address the whites. The local newspaper reported that "Orr lingered for several days in excruciating torture, and expired as he had lived, a fearless desperado."

In the May 1839 term of the Benton County Court, Willis S. Wallace was tried for manslaughter in Orr's death. The jury returned a verdict of not guilty.

△ Remnants of the Old Military Road are still visible in Baxter County, Arkansas, near the Talbert, or Denton, Ferry Landing. The road was traveled by the Benge Detachment as they approached the White River. Without waiting for the operator, the detachment immediately waded across the river on a cold day in December 1838.

According to the John Ross payroll book at the Gilcrease Institute, payment for use of Nelson Orr's team of horses for the journey with the Benge Detachment was made to his wife, Rachel, and received by his father-in-law, George Lowrey.

The Washington County Historical Society conducted research on Orr's death and discovered that Stone's Farm, where the incident reportedly occurred, is now on the University of Arkansas campus in Fayetteville. In 1998, a park was created and an historical marker erected. The marker reads:

Trail of Tears

On Jan. 13, 1839, A group of Cherokees led by John Benge passed through the frontier village of Fayetteville. They were traveling on the Trail of Tears from the Cherokee Homelands in Georgia, Alabama, and Tennessee to the "Indian Territory" (Oklahoma), as part of the forced removal of nearly 13,000 Cherokees ordered by President Andrew Jackson and the U.S. Congress. The Benge Party camped on the hillside north and east of this marker, near a creek and pond, secured supplies and repaired their wagons. They headed west of the Cane Hill Road the next day, arrived in Indian Territory on Jan. 17, 1839.

According to Jane Noble of Farmington, Arkansas, the detachment, which passed through Batesville and Fayetteville, camped on her family's farm in Farmington, by the creek that runs near the present school on present-day Highway 62. From there, the detachment continued toward the Indian Territory on the Cane Hill Road. They disbanded at Mrs. Webber's in present-day Stilwell, Oklahoma, on January 17, 1839.

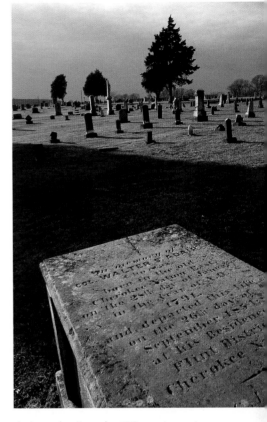

△ In early 1839, the U.S. government established no less than five issuing depots for Cherokees arriving in the Indian Territory. The largest of these was at Mrs. Webber's plantation. It is located at present-day Stilwell, Adair County, Oklahoma. It was also known as the Flint District or General Depot. The detachments conducted by Whiteley, Drane, Daniel, and Benge all disbanded at or near this location. Mrs. Webber subsequently sold the property to Colonel Walter Adair, an assistant conductor for one of the Ross Detachments. In 1854, Colonel Adair was buried on family land, later donated to the city of Stilwell; it became the Stilwell Cemetery.

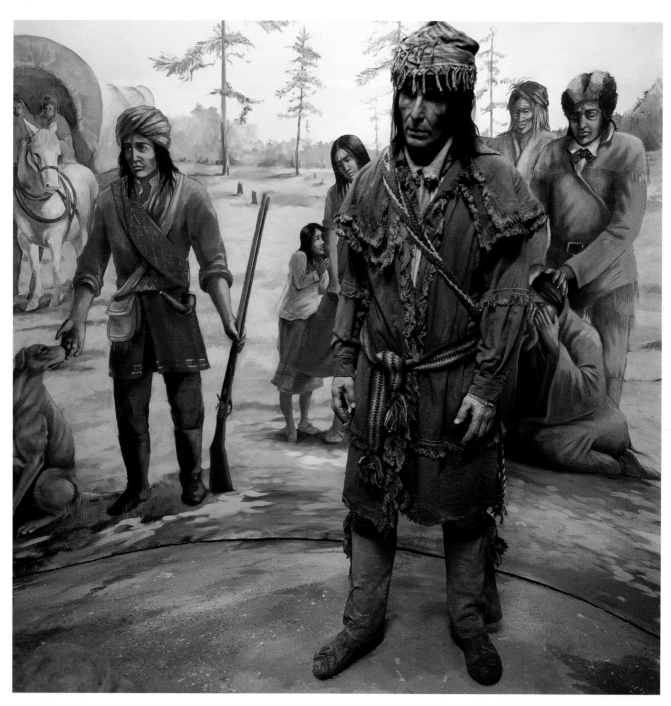

△ "Trails End: The Cherokees Reach the West" is part of an interpretive display at the Museum of the Cherokee Indian, Cherokee, Swain County, North Carolina. It is one of a number of exhibits in the museum that interpret various aspects of Cherokee culture and history.

▷ The Whiteley Detachment disbanded in this vicinity at the head of Lee's Creek on August 2, 1838, near Stilwell, Adair County, Oklahoma. The detachment departed from Ross's Landing on June 12, and suffered seventy-four deaths en route. Stilwell is uniquely situated at the headwaters of three creeks flowing in different directions.

THE DREW DETACHMENT AND LIFE IN THE INDIAN TERRITORY

CHAPTER VII

The last detachment to leave the east also entered the Indian Territory by water but was not disbanded until after a forty-mile trek overland. This smallest of the Ross Detachments was one conducted by Captain John Drew, which left the east on December 5, 1838, and disbanded in the Indian Territory on March 18, 1839. Only 231 individuals started the journey. Other than the fact that the primary means of conveyance of the detachment was the steamboat *Victoria*, owned by John Ross, little was known about the actual journey until the discovery of a previously unreported document written by John Ross on September 8, 1841.

The document, addressed to Major William B. Lewis, Second Auditor, is Ross's estimate of the cost of the trip and a narrative explanation as to why this detachment, like all the others he supervised, exceeded all financial projections. The document answers questions that have puzzled researchers for years, such as:

△ Reverend Daniel Butrick is buried beside his wife, his "beloved Elizabeth" at Dwight Mission Cemetery in Sequoyah County, Oklahoma. His valued journal of the Cherokee Removal gives one of the most important eyewitness accounts of the event. He died June 8, 1851, at age sixty-two. The inscription in syllabary proclaims that he was a friend of the Cherokees.

Did the detachment start at the Cherokee Agency at Calhoun or at Ross's Landing where the other detachments that traveled by water began?

Did the detachment take the railroad from Decatur to Tuscumbia as did the Whiteley and Deas detachments in June?

Did the detachment make it all the way to Fort Gibson by water, or did they end the travel by boat at Fort Coffee as did the Deas Detachment in June, or at Lewisburg as was the case with the detachments conducted by Whiteley and Drane?

The answers to all of these questions are found in the list of expenses. First is the purchase of four flat-bottom boats for $600 for transporting the emigrants down the Hiwassee and Tennessee rivers. Secondly, there is no mention of cost for rail travel. There is, however, an expense for $410 for services of boat hands and pilotage through the Suck and the Muscle shoals, including tollage through the Canal (forty or forty-five days). Although the *Victoria* is not mentioned by name, Ross does list an expense for one steamboat bought at Tuscumbia for $10,000, and the purchase of a keelboat at Paduca for $600. The date that the steamboat was purchased is roughly suggested by Ross's listing of the steamboat captain's pay from about January 15 or 18 until March 18.

River pilots were also employed from Tuscumbia to Paduca ($100), Paduca to Montgomery's Point ($100), and Montgomery's Point to Fort Gibson ($150). The boat, however, did not reach Fort Gibson. Low water forced the steamboat to stop at the mouth of the Illinois River. John Ross paid $422 to transport the detachment the last forty miles by wagon to the Illinois campground near present-day Tahlequah, Oklahoma. The detachment disbanded on March 18 and was supplied by the U.S. contractor with provisions throughout the summer of 1839. The cost for transporting this detachment to the Indian Territory was $21,664.35.

To justify the expenses, Ross explained:

> Besides these there are many other items of expense necessarily incurred in the removal of this detachment, which cannot now be remembered, as the vouchers of disbursement are on file, at home in the Cherokee Nation, among my other papers, not deeming it expedient or proper to encumber myself with them; nor to run the risk of their conveyance to Washington without reason for doing so, they were left . . . In furnishing this estimate for the satisfaction of the War Department, it is done in haste from memory . . .

△ With no homes in the Indian Territory many recently arrived Cherokees spent the summer of 1839 at the Illinois campground in Tahlequah, Cherokee County, Oklahoma. Captain Drew's detachment of sick and elderly Cherokees, traveling by water, was the only detachment to disband here on March 18, 1839, the same time of year that this photograph was taken. The detachment left the Cherokee Agency on the Hiwassee River on December 5, 1838. They were stranded by low water at the mouth of the Illinois River near present-day Gore, Oklahoma. From there, they traveled the last forty miles overland to reach the Illinois campground before disbanding. The trees in the background align with the Ross Branch Creek of the Illinois River, also known as Town Branch and Bear Creek.

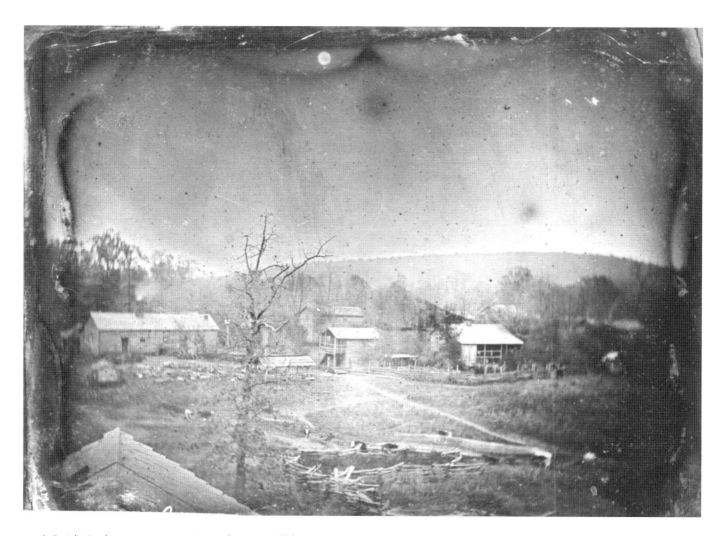

△ Dwight Presbyterian Mission in Sequoyah County, Oklahoma, is shown in this daguerreotype from 1844. This mission was established in 1821 in Arkansas and then moved to its present location in 1829 when the Cherokees relinquished their claim to lands in Arkansas. It was reopened in 1830 as one of the first schools in the Indian Territory. None of the original buildings remain but many logs from the Blue House, the last original school building to be destroyed, were incorporated into this museum cabin on the grounds. (Courtesy of the Oklahoma Historical Society)

Trail's End

On January 15, 1839, Captain R. D. C. Collins of the U.S. Army entered into a contract with the firm of Glasgow and Harrison to supply the Cherokee people with subsistence rations at up to five issuing depots that were already in existence or would soon be designated. The contract period was from March 1, 1839, to March 1, 1840, in compliance with the terms of the Treaty of New Echota. Many of the detachments were disbanded at or near the issuing depots. The general depot was located in the Flint District at Mrs. Webber's (later the home of Colonel Walter Adair), now Stilwell, Oklahoma. One of the Ross conductors, Mose Daniel, was met by a contracting agent as his detachment approached Mrs. Webber's. He was ordered to take his detachment to either Lee's Creek, twenty-five miles distant, or to Woodall's (later known as Bushyhead's) near Westville to avoid the congestion at Webber's. Daniel, obeying the wishes of his detachment, proceeded instead to Mrs. Webber's. The Whiteley Detachment disbanded at the head of Lee's Creek on August 2, 1838, near Mrs. Webber's. The Drane Detachment disbanded at Mrs. Webber's on September 5, 1838. The Bell Detachment disbanded at Vinyard Post Office just inside the state of Arkansas on the road to Mrs. Webber's on January 7, 1839. Ten days later, the John Benge Detachment reached Mrs. Webber's and was mustered out on January 17.

Four detachments disbanded at (new) Fort Wayne about fifty miles north of Mrs. Webber's. The conductors of those detachments were Situwakee, Jesse Bushyhead, George Hicks, and James D. Wofford. Bushyhead soon moved to another depot, originally known as Woodall's, where Richard Taylor's eleventh detachment arrived on March 23 and disbanded on March 24, 1839. Hildebrand's detachment, which was following closely behind Taylor's, may

◁ Daniel Ross Hicks (1827–1883) was the first son of Elijah and Margaret Ross Hicks. Elijah Hicks conducted a wagon detachment during the 1838 Trail of Tears, and Daniel was present in his father's group. Daniel served as 1st Sgt. of Co. E of the Cherokee Home Guards during the Civil War. He is buried at Tahlequah City Cemetery in Cherokee County, Oklahoma. The rifle is inscribed, "From L. Ross to Daniel R. Hicks" and is believed to have been a gift from Lewis Ross to his young nephew, Daniel. It is thought that Daniel, at about eleven years of age, carried the rifle over the Trail of Tears.

△ Quatie Ross, wife of Principal Chief John Ross, was with the last detachment to leave the Cherokee Nation in the east. She died February 1, 1839, in Little Rock, Arkansas. Her death brought the national tragedy to a personal tragedy for the Ross family. The broken sandstone grave marker was found under a building in the Mt. Holly Cemetery in Little Rock where graves from an earlier nineteenth-century cemetery had been moved. For preservation, this stone has been given to the Historic Arkansas Museum, Little Rock, Pulaski County, Arkansas. Accession Number: 2004.012.

have also reached Woodall's. Less than a month later the depot was called Bushyhead. On April 16, 1839, a letter written at Bushyhead complained about scant rations. Written "On behalf of the people of several detachments," the letter was signed by Hair Conrad, Stephen Foreman, Jesse Bushyhead, and four others. Another depot was located near Beattie's Prairie. A letter complaining about rations issued from there written on April 19, 1839, was signed by several dozen people including three of the Ross conductors: Captain Old Field, Chu-wa-lookoe, and J. D. Wofford. Formal complaints to the U.S. Army were also written by Cherokee leaders at Widow Webber's on April 19, and at the Illinois depot (near Park Hill) on April 23. The detachment led by Captain John Drew, which was the last detachment to leave the original homeland, disbanded at the Illinois campground after a forty-mile trek from the mouth of the Illinois River on March 18, 1839. Another depot at Skin Bayou was reported to be some ten to fifteen miles from Fort Smith and may be the same as the Lee's Creek depot. Still another depot at Ridge's, ten miles north of Fort Wayne, was abandoned after Ridge's murder on June 22, 1839, and afterward the issuing agents restricted their activity in the area to Fort Wayne. N. B. Daningburgh, an issuing commissary for the U.S. government, in his defense against charges of fraud in 1842, reported that more rations were issued at the Flint or Webber's depot than any other in the Cherokee Nation.[29]

△ John Ross (1790–1866) served as Principal Chief of the Cherokee Nation for thirty-eight years, longer than any other person in history. He died in Washington, D.C., on August 1, 1866, and was buried in Wilmington, Delaware. Later his remains were returned to the Ross Family Cemetery near the site of his home, Rose Cottage. His home site and the Ross Cemetery are located in Park Hill, Cherokee County, Oklahoma.

▷ After his first wife Elizabeth (Quatie) Henley Ross died on the Trail of Tears on February 1, 1839, John Ross established a new home for his motherless children at Park Hill, Oklahoma. In 1844, he married seventeen-year-old Mary Stapler of Wilmington, Delaware. She died in 1865 leaving the Principal Chief a widower for the second time. The framed photograph of Chief John Ross with his second wife dates to about 1850 and is in the collection of the Cherokee National Museum, the Cherokee Heritage Center, Tahlequah, Oklahoma.

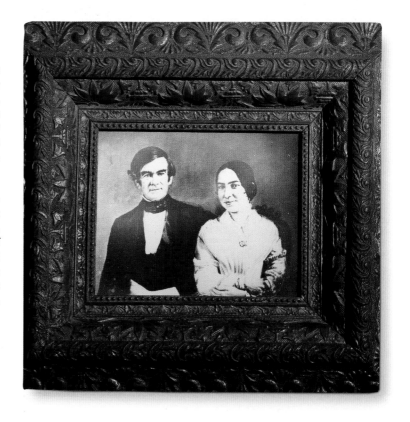

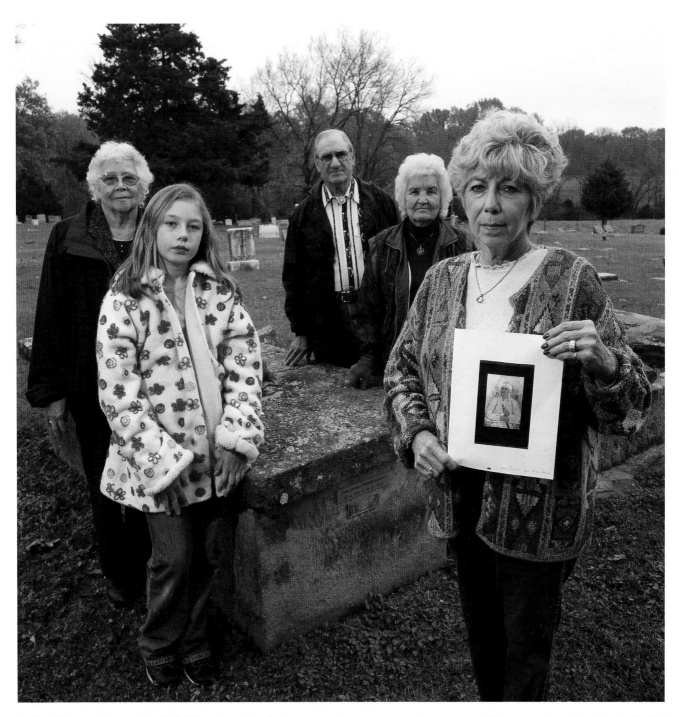

△ The Oklahoma Chapter of the Trail of Tears Association has implemented a program to mark the graves of all known survivors of the Cherokee Trail of Tears. Here at the official grave-marking ceremony for Trail of Tears survivor Jennie Pritchett Sanders at Caney Cemetery, Cherokee County, Oklahoma, are five family members (clockwise from center): Curtis Rohr, fourth great grandson, Maxine Reese Hamilton, fourth great granddaughter; Michelle Chambers A'Neal, fourth great granddaughter, Jordan A'Neal, sixth great granddaughter, and Mildred Mig Hamilton, fourth great granddaughter. Jennie Pritchett Sanders was born in the Cherokee Nation East in 1781, forced to remove to the Indian Territory in 1838, and died in 1845.

Conclusion

The controversy over the Removal lasted throughout the early nineteenth century and resulted in much public attention directed toward the Cherokees. During the 1820s, the Cherokees made numerous changes in their culture and politics to blend better with the whites. They even made an attempt to establish a national museum at New Echota. However, the repressive laws passed by the State of Georgia in 1828–29 greatly restricted public activities in the Cherokee Nation. Many Cherokees felt that their strongest fight against Removal was public opinion. The *Cherokee Phoenix*, which provided the main means of disseminating information, was short-lived. Six years after its debut in 1828, the State of Georgia confiscated the printing press, declaring the *Phoenix* a subversive newspaper.

During the paper's existence, the Cherokees mounted a legal battle to counter the extension of authority by the State of Georgia. They hired the best lawyers money could buy—including William Wirt, former attorney general of the United States—to represent them on the federal level, and the firm of Underwood and Harris to represent them in the State of Georgia. The U.S. Supreme Court eventually heard two cases: the *Cherokee Nation v. Georgia* and *Worcester v. Georgia*. The State of Georgia resented the intrusion by the Supreme Court into local affairs, and with the tacit support of President Andrew Jackson defiantly refused to honor the decisions of the court. The Cherokees, forbidden by Georgia law from assembly in groups of three or more, moved their capital to Red Clay, Tennessee, in 1832. Georgia in the meantime proceeded with the general survey of Cherokee lands, the land lottery, and the general dispossession of the Cherokees from their own homes.

Although fewer than five hundred deaths on the Trail are listed in the military records of the thirteen detachments under John Ross, the actual death toll was much higher. In early 1839, Elizur Butler, a prominent physician and missionary to the Cherokees was quoted by a Chattanooga newspaper, the *Hamilton Gazette*, as suggesting that approximately four thousand Cherokees had died as a result of the forced Removal. Butler based his estimate, in part, on the belief that half of the members of three detachments of Georgia Cherokees that departed Ross's Landing in June 1838 under military escort had died en route. Butler, who made the trip west with the first of the overland detachments under John Ross, calculated the total number of deaths based on the information from various sources at forty-six hundred individuals. He believed the estimate of four thousand deaths attributed to him in the newspaper to be conservative.

Although subsequent writers have challenged Butler's calculation as being too high or too low, the four thousand figure first given by Butler in March 1839, before the last detachments had reached their destination in the West, is still the most frequently cited estimate in the literature on the subject.[30] It is apparent from the verifiable reports that Butler's guess of a 50 percent death rate among those Cherokees hiding in the mountains and those members of the first three detachments of the forced Removal was based more on rumor and innuendo than collaborative data. It is clear from the 1840 census of Eastern Cherokees, which included deaths since the 1835 census, that the number of people who died during the time the refugees were eluding Federal troops was substantially lower than Butler had been told.[30] The same is true for the three detachments that left Ross's Landing in June 1838. Information about these detachments is found in the firsthand reports of Cherokee prisoners, which are related in contemporary correspondence of Cherokee leaders and missionaries, and in the daily journals kept by two of the military conductors and a detailed final report written by the third.

Comparing census data from the early to mid-nineteenth century, Russell Thornton, a Cherokee scholar, has concluded that the total loss to the Cherokee population was about ten thousand, including births which did not occur. Jerry Clark, a member of the Cherokee Nation and an employee of the National Archives for more than thirty years, has documented more than sixteen hundred deaths directly attributable to the forced Removal.

For America, the forced Removal of the Cherokees and other Eastern Indians was a classic example of ethnic cleansing sanctioned by governmental policy and legislative mandate. For the Cherokees, the collective suffering amounted to nothing less than a holocaust for a nation of proud and independent people. From the volumes of material documenting the diplomatic negotiations and the propaganda of the proponents and opponents of Indian Removal can be gleaned a story of farcical governmental policy and misguided legislative action. The story of man's inhumanity to man is revealed in the diaries of the travelers, the letters of the soldiers, and reports of contemporary newspapers. It is a saga of hardship and desperation, and yet through it all is a true triumph of the human spirit.

▽ An abandoned schoolhouse with wild daffodils, along the northern border of Beattie's Prairie, now Delaware County, Oklahoma, marks the location of a terminating point on the Trail of Tears. In early 1839, the detachments led by Situwakee, Jesse Bushyhead, George Hicks, and James D. Wofford disbanded here. The rations depot originally established at the home of Major Ridge was moved here after he was killed on June 22, 1839.

Appendix A
Departures and Arrivals of the Seventeen Detachments during the Cherokee Forced Removal

Detachment	Assistant Conductor
Lt. Edward Deas	David Walker and two others
Captain R. H. K. Whiteley	Col John Hooks and four others
Captain Gus Drane	Daniel R. Coody
Hair Conrad	Daniel Colston (replaced Conrad as conductor about 8/28/38)
Elijah Hicks	White Path/William Arnold
Jesse Bushyhead	Roman Nose
John Benge	George Lowery
Situwakee	Peter/ Evan Jones
Old Field	Stephen Foreman
Moses Daniel	George Still
Choowalooka/replaced by Thomas N. Clark 1/22/39	J. D. Wofford
James Brown	Lewis Hildebrand
George Hicks	Collins McDonald
Richard Taylor	Red Watt Adair
Peter Hildebrand	James Hildebrand
John Drew	John Golden Ross
John Bell	William Boling

Departure	Starting Point	Arrival	Ending Point
Jun 6, 1838	Ross's Landing	Jun 23, 1838	Fort Coffee
Jun 12, 1838	Ross's Landing	Aug 5, 1838	Head of Lees Creek
Jun 17, 1838	Ross's Landing	Sep 7, 1838	Mrs. Webber's
Aug 23, 1838	Agency Area	Jan 17, 1839	Woodhall's?
Sep 1, 1838	Gunstocker Branch/Camp Ross	Jan 4, 1839	Mrs. Webber's?
Sep 3, 1838	Chatata Creek	Feb 27, 1839	New Fort Wayne
Sep 28, 1838	8 miles south of Ft. Payne, Alabama	Jan 17, 1839	Mrs. Webber's
Sep 7, 1838	Savannah Branch	Feb 2, 1839	New Fort Wayne, Beatties Prairie
Sep 24, 1838	Candies Creek	Feb 23, 1839	New Fort Wayne, Beatties Prairie?
Sep 30, 1838	Agency Area	Mar 2, 1839	Mrs. Webber's (although ordered to Lee's Creek)
Sep 14, 1838	Taquah Camps/ Mouse Creek	Mar , 1839	New Fort Wayne
Sep 10, 1838	Vann's Plantation, Ooltewah Creek	Mar 5, 1839	Key's at Park Hill?
Sep 7, 1838	Mouse Creek	Mar 14, 1839	New Fort Wayne
Sep 20, 1838	Near Vann's Plantation, Ooltewah Creek	Mar 24, 1839	Woodhall's
Oct 23, 1838	Ocod Camp	Mar 24, 1839	Woodhall's?
Dec 5, 1838	Agency Area, Hiwassee River	Mar 18, 1839	Illinois Campground, Tahlequah
Oct 11, 1838	Agency Area, Hiwassee River	Jan 7, 1839	Vinyard Post Office, Arkansas

Appendix B
Numerical Statistics
of the Ross Detachments

Detachment	Depart	Arrive	Births	Deaths	Desertions	Accessions
Hair Conrad	729	654	9	57	24	14
Elijah Hicks	858	744	5	54		
Jesse Bushyhead	950	898	6	38	148	171
John Benge	1,200	1,132	3	33		
Situwakee	1,250	1,033	5	71		
Old Field	983	921	19	57	10	6
Moses Daniel	1,035	924	6	48		
Choowalooka	1,150	970		NA		
James Brown	850	717	3	34		
George Hicks	1,118	1,039		NA		
Richard Taylor	1,029	942	15	55		
Peter Hildebrand	1,766	1,311		NA		
John Drew	231	219		NA		
TOTAL	**13,149**	**11,504**	**71**	**447**	**182**	**191**

Appendix C
Comparison of Detachments
Under the Direction of John Ross

<table>
<tr><td colspan="5" align="center">Chart Number 1
Number of People per Wagon</td></tr>
<tr><td>Number</td><td>Conductor</td><td>Number of People</td><td>Number of Wagons</td><td>People per Wagon</td></tr>
<tr><td>1.</td><td>Hair Conrad
Daniel Colston</td><td>729</td><td>36</td><td>20.25</td></tr>
<tr><td>2.</td><td>Elijah Hicks
Whitepath
Wm. Arnold</td><td>858</td><td>43</td><td>19.95</td></tr>
<tr><td>3.</td><td>Jesse Bushyhead
Roman Nose</td><td>950</td><td>48</td><td>19.79</td></tr>
<tr><td>4.</td><td>John Benge
George C. Lowrey</td><td>1,200</td><td>60</td><td>20.00</td></tr>
<tr><td>5.</td><td>Situwakee
Evan Jones</td><td>1,250</td><td>62</td><td>20.16</td></tr>
<tr><td>6.</td><td>Old Field
Stephen Foreman</td><td>983</td><td>49</td><td>20.06</td></tr>
<tr><td>7.</td><td>Moses Daniel
George Still</td><td>1,035</td><td>52</td><td>19.90</td></tr>
<tr><td>8.</td><td>Choowalooka
J. D. Wafford
Thomas N. Clark</td><td>1,150</td><td>58</td><td>19.82</td></tr>
<tr><td>9.</td><td>James Brown
Lewis Hildebrand</td><td>850</td><td>42</td><td>20.23</td></tr>
<tr><td>10.</td><td>George Hicks
Collins McDonald</td><td>1,118</td><td>56</td><td>19.96</td></tr>
<tr><td>11.</td><td>Richard Taylor
Red Watt Adair</td><td>1,029</td><td>51</td><td>20.17</td></tr>
<tr><td>12.</td><td>Peter Hildebrand
James Hildebrand</td><td>1,766</td><td>88</td><td>20.06</td></tr>
</table>

Appendix C
Comparison of Detachments
Under the Direction of John Ross

Chart Number 2
People and Horses

Number	Conductor	Number of People	Number of Horses	People per Horse
1.	Hair Conrad Daniel Colston	729	360	2.025
2.	Elijah Hicks Whitepath Wm. Arnold	858	430	1.99
3.	Jesse Bushyhead Roman Nose	950	430	2.20
4.	John Benge George C. Lowrey	1,200	600	2.0
5.	Situwakee Evan Jones	1,250	560	2.23
6.	Old Field Stephen Foreman	983	490	2.006
7.	Moses Daniel George Still	1,035	519	1.99
8.	Choowalooka J. D. Wafford Thomas N. Clark	1,150	578	1.98
9.	James Brown Lewis Hildebrand	850	422	2.01
10.	George Hicks Collins McDonald	1,118	560	1.99
11.	Richard Taylor Red Watt Adair	1,029	460	2.23
12.	Peter Hildebrand James Hildebrand	1,766	881	2.00

Appendix C
Comparison of Detachments
Under the Direction of John Ross

Chart Number 3
Cost per Person

Number	Conductor	Number of People	Total Expenses of Detachment	Average Cost per Person
1.	Hair Conrad Daniel Colston	729	$67,884.13	93.11
2.	Elijah Hicks Whitepath Wm. Arnold	858	$72,317.10	84.28
3.	Jesse Bushyhead Roman Nose	950	$105,923.12	111.49
4.	John Benge George C. Lowrey	1,200	$97,529.20	81.27
5.	Situwakee Evan Jones	1,250	$102,226.87	81.78
6.	Old Field Stephen Foreman	983	$95,359.85	76.28
7.	Moses Daniel George Still	1,035	$103,759.66	100.25
8.	Choowalooka J. D. Wafford Thomas N. Clark	1,150	$111,745.45	97.16
9.	James Brown Lewis Hildebrand	850	$84,558.45	99.48
10.	George Hicks Collins McDonald	1,118	$112,504.80	100.63
11.	Richard Taylor Red Watt Adair	1,029	$106,730.61	103.72
12.	Peter Hildebrand James Hildebrand	1,766	$182,407.84	103.28

Appendix C
Comparison of Detachments
Under the Direction of John Ross

	Chart Number 4 Rations per Person			
Number	**Conductor**	**Number of People**	**Number of Rations**	**Number of Rations per Person**
1.	Hair Conrad Daniel Colston	729	76,745	105.27
2.	Elijah Hicks Whitepath Wm. Arnold	858	79,794	93
3.	Jesse Bushyhead Roman Nose	950	128,250	135
4.	John Benge George C. Lowrey	1,200	123,600	103
5.	Situwakee Evan Jones	1,250	133,750	107
6.	Old Field Stephen Foreman	983	124,421	126.57
7.	Moses Daniel George Still	1,035	135,585	131
8.	Choowalooka J. D. Wafford Thomas N. Clark	1,150	144,900	126
9.	James Brown Lewis Hildebrand	850	107,100	126
10.	George Hicks Collins McDonald	1,118	146,458	131
11.	Richard Taylor Red Watt Adair	1,029	143,041	139
12.	Peter Hildebrand James Hildebrand	1,766	245,474	139

Appendix C
Comparison of Detachments
Under the Direction of John Ross

Chart Number 5
Number of Rations per Day per Person

Number	Conductor	Number of People	Number of Days / Travel	Rations	Rations per Person per Day
1.	Hair Conrad Daniel Colston	729	143	105.27	.736
2.	Elijah Hicks Whitepath Wm. Arnold	858	126	93	.738
3.	Jesse Bushyhead Roman Nose	950	178	135	.702
4.	John Benge George C. Lowrey	1,200	106	103	.971
5.	Situwakee Evan Jones	1,250	149	107	.718
6.	Old Field Stephen Foreman	983	153	126.57	.827
7.	Moses Daniel George Still	1,035	164	131	.784
8.	Choowalooka J. D. Wafford Thomas N. Clark	1,150	162	126	.777
9.	James Brown Lewis Hildebrand	850	138	126	.913
10.	George Hicks Collins McDonald	1,118	134	131	.977
11.	Richard Taylor Red Watt Adair	1,029	141	139	.985
12.	Peter Hildebrand James Hildebrand	1766	141	139	.985

Appendix C
Comparison of Detachments
Under the Direction of John Ross

Chart Number 6
Cost of Hiring Wagons and Horses

Number	Conductor	Number of People	Number of Wagons	Number of Horses	Total Costs
1.	Hair Conrad Daniel Colston	729	36	360	$25,740.00
2.	Elijah Hicks Whitepath Wm. Arnold	858	43	430	$27,090.00
3.	Jesse Bushyhead Roman Nose	950	48	430	$42,720.00
4.	John Benge George C. Lowrey	1,200	60	600	$31,800.00
5.	Situwakee Evan Jones	1,250	62	560	$34,100.00
6.	Old Field Stephen Foreman	983	49	490	$31,360.00
7.	Moses Daniel George Still	1,035	52	519	$34,320.00
8.	Choowalooka J. D. Wafford Thomas N. Clark	1,150	58	578	$37,120.00
9.	James Brown Lewis Hildebrand	850	42	422	$27,930.00
10.	George Hicks Collins McDonald	1,118	56	560	$37,520.00
11.	Richard Taylor Red Watt Adair	1,029	51	460	$37,520.00
12.	Peter Hildebrand James Hildebrand	1,766	88	881	$62,040.00

Endnotes

1. James Mooney, "Myths of the Cherokee," Bureau of American Ethnology, 19th Annual Report (Washington, D.C.: U.S. Government Printing Office, 1900), 14.

2. Alexander Hewatt, An Historical Account of the Rise and Progress of the Colonies of South Carolina and Georgia, 2 vols. (London: Donaldson, 1779), I, 258.

3. Charles Royce, "The Cherokee Nation of Indians," Bureau of Ethnology, 5th Annual Report (Washington, D.C.: Government Printing Office, 1887), 2–3.

4. J. G. M. Ramsey, Annals of Tennessee . . . (Charleston, South Carolina: Walker and James, 1853), 117–18.

5. Jack Weatherford, Indian Givers: How the Indians of the Americas Transformed the World (New York: Ballantine Books, 1988), 70–71.

6. Ibid., 66–73.

7. Ibid., 42–45.

8. Ulrich B. Phillips, Georgia and State Rights (Antioch, Ohio, 1968), 29–35.

9. Ratification of the Agreement Between the United States and Georgia, by the Legislature of the Latter (Washington City, 1802), 5–8.

10. Carl J. Vipperman, "Forcibly If We Must: The Georgia Case for Cherokee Removal," Journal of Cherokee Studies (Cherokee, North Carolina: Museum of the Cherokee Indian, Spring 1978), 103–10.

11. Richard Peters, The Case of the Cherokee Nation against the State of Georgia (Philadelphia, 1831), 265–66.

12. Wilson Lumpkin, The Removal of the Cherokee Indians from Georgia, 1827–1841, 2 volumes in one (New York: Arno Press and the New York Times, 1969), 39.

13. Ibid., 40.

14. For Georgia's response to this decision, see Lumpkin, 1969: 197–209.

15. A. E. Blunt, to David Greene, Secretary to the American Board of Commissioners for Foreign Missions, Boston, written from the Candy's Creek Station on May 28, 1838 (ABCFM Papers, Houghton Library, Cambridge, Massachusetts).

16. Stephen Foreman to David Greene, May 31, 1838 (ABCFM Papers, Houghton Library, Cambridge, Massachusetts).

17. National Archives, Papers of Winfield Scott, RG 75: Brigadier General Charles Floyd commander of the Georgia Militia reported the following on June 9:

Numbers of Indians sent to Ross' Landing and the Cherokee Agency from the different parts in the Mid[dle] Mil[itar]y Dis[tric]t.

May 30th - Sent to Ross' Landing from Head Qrs. under and escort commanded by Capt. Boggess.——————— 198

May 31st - Sent to Ross' Landing reported by Major Venable, under escorts from Fort Gilmore.——————— 109

June 1st - Came to Hd. Qrs. voluntarily & thence sent to Cherokee Agency (without escort) under care of Wm. Thompson (a white Man) with subsistence for 4 days——————— 133

June 2nd - Sent to Ross' Landing under escort commanded by Capt. Patton.——————— 152

June 4th - To Ross' Landing From Fort Cumming (reported by Capt. Farris, under escort——————— 469

June 5th - To Ross' Landing from Spring Place, (reported by Capt. Jones) under escort——————— 122

June 5th - To Ross' Landing from Fort Gilmore (reported by Maj. Venable under escort——————— 225

June 6th - To Ross' Landing (via Hd. Qrs) from this (illegible) under escort comm. (sic) by Capt. Stell——————— 950

June 6th - To the Agency with Harris (a half breed) without escort, as they had voluntarily entered at Hd. Qrs.———————129

June 7th - To Ross' Landing from Fort Means (via Hd. Qrs:) under escort commd. (sic) by Capt. Means.

June 9th - To Ross' Landing from Fort Campbell (via Hd. Qrs.) under escort comd. (sic) by Lt. Rogers——————— 223

June 9th - To Ross' Landing from Fort Buffington (via Hd. Qrs.) under escort commanded by Capt. Cox——————— 479

June 9th - To Ross' Landing from Fort Buffington (via Hd. Qrs.) under escort commanded by Capt. Cox——————— 479

Total - 3636

Hd. Qrs. Mid. Mily. Dist-New Echota

Besides the above, Indians have been sent from Rome and other posts, and about 400 are now in possession of the Georgia troops, but have not been officially reported to the Brig. Genl. Chs. Floyd, Brig. Genl. G.M., Com. of Mid. Mily Dist.

18. The Cherokee camps during the summer of 1838 extended from Gardenhire Creek to Chickamauga Creek with the military headquarters about 3 miles upstream from Ross's Landing at present-day Chattanooga, Tennessee.

19. The Niles Register, August 18, 1838.

20. Robert Hodsden, a contact physician with the Whiteley Detachment, reported a higher number. He stated that either 73 or 74 of the 875 who departed Ross Landing died during the trip. His journal "Medical Report of Dr. Robert Hodsden," is at the Five Civilized Tribes Museum, Muskogee, Oklahoma.

21. The highest estimate given by John Ross on the cost of Removal was $13,000,000. See "Memorandum of Estimates Regarding the Removal of the Cherokee Nation." Samuel L. Southard Papers, Library, Princeton University, Princeton, New Jersey. For a detailed accounting of additional claims submitted by John Ross, see United States House of Representatives Report 288. "Removal of the Cherokees," 27th Congress, 3rd sess., Washington: No Imprint, 1843.

22. In a letter dated August 8, 1840, and included in Report 288 United States House of Representatives ("Removal of the Cherokees," 27th Congress, 3rd sess., Washington: No Imprint, 1843, from pages 12–24, on page 22).

23. This letter was called to my attention by Jess Bushyhead IV who found it framed and hanging on the wall of a small museum in Dahlonega, Georgia.

24. Gary Moulton, The Papers of Chief John Ross (Norman: The University of Oklahoma Press, 1985), 673.

25. David C. Hunt, Marsha Gallagher, et al. Karl Bodmer's America (Lincoln: Joslyn Art Museum and the University of Nebraska Press, 1984), 101.

26. In May 2001, Rosemary Gilihan Kenney of Mountain Home, Arkansas, called my attention to a curious manuscript in the Newberry Library: History of the J. J. Sams Family and Incidentally A History of the White River Valley Country in Northern Arkansas from 1816 to 1896, by J. J. Sams. The copy was furnished by Miss Clara Davis of Checotah, Oklahoma, the great granddaughter of J. J. Sams.

27. Ibid., Chapter 5.

28. The family name is spelled "Lowrey" but the 1838 letter in the John Ross papers (see note 24 on previous page) spells it without the "e" for both individual signers of the letter.

29. The information in this section is from Report Number 271, House of Representatives, 27th Congress, 3rd sess., "Frauds Upon Indians—Right of the President to Withhold Papers. February 25, 1843."

30. For a detailed discussion on various estimates of the number of deaths, see Russell Thornton, The Cherokees: A Population History (Lincoln: University of Nebraska Press, 1990), 73–76.

31. Microfilm copy of the 1840 consus of Eastern Cherokees compiled by Will Thomas is on file at the Museum of the Cherokee Indian Archives, Cherokee, North Carolina.

Index

Notes to Readers:
Boldface page numbers indicate illustrations and captions.

Adair, Colonel Walter, 87, **103**, 109
Adair County, Oklahoma, 36, **54–55**, 59, **86**, **87**, 103, **103**, **104–5**, 109
Adams, John Quincy, 20
agricultural economy and the pressure to cede land, 14–16
Alabama militia, participation in the Removal, 30
Alexander, Adam, 47
allegiance, oath of, 24, **27**
American Board of Commissioners for Foreign Missions, 30, 63
A'Neal, Jordan, **111**
A'Neal, Michelle Chambers, **111**
anti-Indian legislation, 21, 112
Arcadia Valley, Missouri, 85
Arkansas Advocate, 59
Arkansas Atlas and Gazetteer, 53
Arkansas Gazette, 49, 50, 56, 94
Arkansas River, 20
Army of the Cherokee Nation, 30–31
Articles of Agreement and Cession, 1802, 19
Ashopper, 76
assimilation, Cherokee, 17, 112
Athens (Izard County), Arkansas, **95**
Athens, Tennessee, 30

Bainbridge, Missouri, 82
Baker, Jack, 30
Baldwin, Justice Henry, 24
Baptist Mission Cemetery, Oklahoma, 87
Baptist Mission Church, Oklahoma, 86
Barry County, Missouri, **81**
Barrys Ferry. *See* Berry's Ferry, Kentucky
basket, 70
Batesville (Independence County), Arkansas, 91, 99
Batesville News, 94, 97, 99
Battle Creek, 47
Battle of Fallen Timbers, 20
Battle of Horseshoe Bend, 1814, 17
Baxter County, Arkansas, 20, 49, 55, 91, **95**, 97, 99–100, 101, **101**, **102**
Bear Creek, **107**
Beattie's Prairie issuing depot, 87, 110, **113**
Bedwell Springs internment fort, 32
Belk Corner, Arkansas, 56
Bell, Oklahoma, 59
Bell Detachment (4th)
　departure/disbanding information, 35, 41, 49, **58**, 59, 61, 109
　Graham, James, provisioner, **49**
　Illinois Bayou, Arkansas, crossing, **48**
　Levi Joy House, **52**
　Military Road, Arkansas, **50–51**
　Natural Dam (Crawford County), Arkansas, **54–55**

Point Remove Bridge, Arkansas, 59
Point Remove Creek crossing, **56**
route information, 33, **39**, 44
Benge, John, 35, 89, 91–92, 99
Benge, John (presumed), 101–2
Benge, Martin, 102
Benge, Richard, 102
Benge, Robert (wagon master), 102
Benge Detachment (4th Ross)
　disbanded, 87, **103**, 103, 109
　divided near Batesville, Arkansas, 99
　fatalities, **28–29**
　growth before departure, 91
　overview, 35, 89
　route information, 69
　route misrepresented, 91, 94–96
Benton County, Arkansas, **60–61**, **82**, 102
Benton Sand Bar, Arkansas River, 59
Berry's Ferry, Kentucky, **66–67**, 77–79
Big Piney River, 85
Big Spring, Kentucky, **63**
Bilbrey, Ed, 97
births, 76, 89
Black. *See* Mrs. Black's Public House
Black Fish Lake, Arkansas, 49, 50–52
Blacks Ferry (Randolph County), Arkansas, **88–89**
blacksmith shop, **88**
Blue House, **108**
Blunt, A. E., 30–31
Blythe's Ferry, 62
Bodmer, Karl, **38**, 96
Bolivar (Hardeman County), Tennessee, **46**, 47, **52**, **53**
Boudinot, Elias, 23, 26
Boudinot House, **28**
Bradley County, Tennessee, **14**, **18**, 29, 41, **45**, 62
Brainerd Mission, **28**, 63–65
Brainerd Mission Cemetery, Tennessee, 33
Breadtown issuing depot, **86**
Brevard, R., 82
Brinker. *See* Snelson-Brinker House
Brinker family cemetery, **76**
Brinker-Houston Cemetery, Missouri, **79**
Brown, John, 39
Brown Detachment (9th Ross)
　deaths in Kentucky, 80
　departure information, 62
　disbanded, 87
　Mississippi River crossing, 81
　route information, 69
Buck (Elias Boudinot), 28
Bucksnort (Hickman County), Tennessee, **90**
Buel, Alexander, **71**
Buel House, **71**, 79
Burnett's farm, Missouri, 85
Burr Postal Map, 1839, 96
Bushyhead, Isaac, 77
Bushyhead, Nancy (Otahki), **74–75**
Bushyhead, Rev. Jesse
　burial, **86**, **87**

detachment supervision, 77, **86**, 109
family information, **74–75**
in Kentucky, 74
on scant rations, 110
at the Woodall issuing depot, 86
Bushyhead Detachment (3rd Ross), 69, 77, 87, **87**, 109, **113**
Bushyhead issuing depot, **86**, 109
Butler, Elizur
　oath of allegiance trial, 24, **27**
　on casualties, 112
　on the Conrad Detachment, 87
　on the water shortage, 65
Butrick, Elizabeth, **106**
Butrick, Rev. Daniel
　conditions on the Train, 73, 80–82
　departure/disbanding information, 86
　headstone, **106**
　illness, 79–82
　on the Kentucky campsites, 76–77
　minister to the Cherokee, 63
　on the Taylor Detachment, 65–66, **76**, 87
Butrick family in Illinois, 80
Byers, William, **92**, 97

Cache Creek, Arkansas, 49
Cadron (Faulkner County), Arkansas, **57**
Caldwell County, Kentucky, **63**, 76
Calhoun (Gordon County), Georgia, **27**, **28**, 35, 41, 62
Camp Ross, 62
Candy's Creek Station, 30
Cane Hill Road, Arkansas, **98**, 103
Caney Cemetery (Cherokee County), Oklahoma, **111**
Cannon, B. B., 62
Cannon, Governor (Tennessee), 96
Cannon Detachment (Ross)
　at the Cunningham house, **85**
　at the Danforth House, **84**
　log entries, **82**
　route information, 62, 66, 85
Cantonment Wool, Tennessee, 29
Cape Girardeau County, Missouri, **68**, **74–75**, 78
card game with the Benge Detachment, 101
Carns, John B., 59
The Carroll County Historical Quarterly, 102
casualties. *See* sickness and fatalities
Catalpa Springs, Arkansas, 97
Charleston (Bradley County), Tennessee, **45**, 62
Chatsworth, Georgia, 26
Chattanooga (Hamilton County), Tennessee, 21, **33**, **39**, 42
Cherokee (Swain County), North Carolina, **10**, **12**, **20**, **31**, **60**, **104**
Cherokee Agency, 35, 62
Cherokee County, Oklahoma, **44**, **64**, 106, **107**, **110**, **111**
Cherokee Heritage Center, 64

Cherokee Home Guards, **109**
Cherokee homeland, 11, **16–17**
Cherokee Indians, 21, **50**, 70, 112
Cherokee Nation v. Georgia, 23–24, 112
Cherokee National Museum, 64
Cherokee Phoenix, 23, **28**, 112
Cherokee syllabary. *See* Sequoyan syllabary
Cherry, William, **42–43**
Cherry Mansion, Tennessee, **40**, **42–43**
Chestooee internment fort, 32
Chicamauga-Chattanooga National Military Park (Hamilton County), Tennessee, **42**
Chickamauga Creek, Tennessee, **33**, 62
Chickasaw Indians, 14, **50**, 50–52, 55
Chimney Tops, Tennessee, **13**
Choctaw Indians, 14, **50**, 52, 55
Choowalooka. *See* Chu-wa-lookoe Detachment (8th Ross)
Christian County, Kentucky, **66**, 73, 76
Chu-wa-lookoe, 110
Chu-wa-lookoe Detachment (8th Ross), 87, 110
Citico Creek, 62
Clark, Jerry, 113
classism in reallocation of arable land, 17
Clay, Henry, 20
Clayton, Judge Augustine Smith, 23
Cleveland (Bradley County), Tennessee, **18**
Clingman's Dome, Tennessee, **25**
Colburn, with the Benge Detachment, 94
Collection of the Cherokee Indian, North Carolina, **16–17**
Collins, Captain R. D. C., 109
Collins River, 69
Colston, Daniel, 18, 69
Colston Detachment (1st Ross), 69
Columbia, Kentucky, 96
Columbia Crossing, Arkansas, **91**
Commissioners of Indian Affairs, **44**
Compact of 1803, 18
concentration camps, 91–94. *See also* internment forts
Conrad, Hair, 110
Conrad Detachment (1st Ross), 87
Conrad Home, **18**, **30**
Conway, Arkansas, 53
Conway County, Arkansas, **56**
Coody, William S., 99, 102
corn farming, effect on European livestock, 14
Corn Tassel trial, 23
Cornwall Mission School, **28**
Cotton, John, 49
cotton cultivation, affect on soil, 14
Council House in Red Clay, **14**
Crawford, T. Hartley, 44
Crawford, William H., 20
Crawford County, Arkansas, **54–55**
Crawford County, Missouri, **76**, **79**, 83

Creek Indians
in the Benge Detachment, 101
in the Kentucky campsites, 74
at Mrs. Black's Public House, 55
pressure to cede land, 14
removal, 17, **50**
resisted removal, 70
Cross County, Arkansas, **40–41**, **50**, 52, 53
Crowley's Ridge, Arkansas, 52
Cumberland College, Kentucky, 77
Cumberland Presbyterian Church, Illinois, **65**
Cumberland River, 66
Cunningham, W. D., **85**
Current River, Missouri, 91, 96

Dahlonega, Georgia, 21
Danforth, Josiah, **84**
Danforth House, Missouri, **84**, 85
Daniel, Mose, 87, 109
Daniel Detachment (7th Ross), 69, 77–79, 87, **103**
Daningburgh, N. B., **110**
Daughters of the American Revolution (DAR), 52
Davis, Daniel, 77–79
Deas, Lieutenant Edward
on the Bell Detachment, 44–48
death, 44
detachment supervision, 36
role in the Bell Detachment, 41–44
Deas Detachment (1st), 36, **36**, **37**, 87
Decatur, Alabama, **37**
Deep Creek, North Carolina, **25**
DeKalb County, Alabama, 89, 91, 96
Delaware County, Oklahoma, **113**
Denton's Ferry (Baxter County), Arkansas, **101**, **102**
desertion, in the Whiteley Detachment, **54–55**
disbursing agent duties, 42–44
Dollywood's Valley Carriage Works, Tennessee, 60
Doniphan, Missouri, 96
Drane, Captain Gus, 55, 56
Drane Detachment (3rd)
disbanded, 87, **103**, 109
Illinois Bayou crossing, **48**
Natural Dam, Arkansas, **54–55**
overview, 36
route information, **34–35**, 39
west of Lewisburg, Arkansas, 56–57
Drew, Captain John, 105, **107**, 110
Drew Detachment (13th Ross), 61, 105, **107**, 110
Drowning Bear, 82
drunkenness along the Trail, 71
Duck River Furnace (Hickman County), Tennessee, **90**
Dwight Mission Cemetery (Sequoyah County), Oklahoma, **106**
Dwight Presbyterian Mission (Sequoyah County), Oklahoma, **108**

Eastern Band of Cherokees, 32
Edington, Alfred, 53–55

Edisto River, South Carolina, 13
education, Cherokee history of, 20
education in Indian Territory, **108**
1824 U.S. presidential election, 20–21
Eleven Point River, Arkansas, **88–89**
Elkhorn Tavern, Arkansas, **60–61**, **82**, 86
Ellis, John, 56
Ellis, William, 59
Euchella's collaboration, **25**
European population and New World agriculture, 14
Evansville, Arkansas, 41
Evansville Creek (Washington County), Arkansas, **58**
Evarts, Jeremiah, 23

Family separation in the water detachments, 36
Farmington, Arkansas, 103
Farmington, Missouri, **80**, 82
fatalities. *See* sickness and fatalities
Fayetteville (Washington County), Arkansas, 47, 91, **98**
ferry crossings, 45–47
Ferry Tavern, **39**
Field Trovillion Cemetery, Illinois, **77**
Fields, Archibald, **76**, **79**, 82
Fields, Mary, **76**, **79**, 82
Flint issuing depot, **103**, 110
Flippen, W. B., 100–102, **101**
Floyd, Brigadier General Charles B., 32
Fly Smith, Chief, **66**, 76
food crops, New World, effect on European population, 14
Foreman, Stephen, 110
Fort Armistead, Tennessee, **16–17**
Fort Cass (Bradley County), Tennessee
Bell Detachment, 41
concentration camps, **18**
departure area, 62
Henegar House, **45**
preparation for the Removal, 29
Fort Coffee, **36**, 36
Fort Gibson, 36, 87, 97, 106
Fort Payne (DeKalb County), Alabama, 89, 91, 96
Fort Smith, 110
Fort Wayne, Oklahoma, **87**, 110
Foster's Mill, 71
Fourche Damas, Arkansas, **88–89**, **91**, 96, 97
Foxfire Museum, **60**
Franklin, Arkansas, 52
Frog Bayou, Arkansas, 49, 59
Fulton, Hamilton, 21
Furlow, Arkansas, 53

Galagina (Elias Boudinot), **28**
Gallatin Union, 94
gambling with the Benge Detachment, 101
Gasconade River, Missouri, 85
General Depot, **103**
George, A., 91
Georgia Guard, 26, 27

Georgia militia, participation in the Removal, 30, 32
Gilcrease Institute, Oklahoma, 89
Gilmer, Governor George (Georgia), 23
Givens, Jimmy, 96
Goddard family, **82**
Golconda (Pope County), Illinois, **66–67**, **71**, **77**, 77–79
Goodman, Jesse, 100
Gordon County, Georgia, **27**, **28**, 35, 41, 62
Gore, Oklahoma, **107**
government, Cherokee, 17, 20
Graham, James, 47, **49**
Gray, Major John, **72**
Gray's Inn, Kentucky, **72**, **73**, **73**
greed, 8
Greene, Rev. David, 65, 73
Greene County, Missouri, **84**
Green's Ferry, **68**, **78**
Green's Ferry Road, Missouri, **78**
Grigsby's farm, Missouri, 85
Gunstocker Spring internment fort, 32
Gunter's Landing, 89, 94
Guthrie (Todd County), Kentucky, **72**

Hamill, Samuel, 45
Hamilton, Maxine Reese, **111**
Hamilton, Mildred Mig, **111**
Hamilton County, Tennessee, 21, **33**, **39**, **42**
Hamilton Gazette, 112
Hardeman County, Tennessee, **46**, **47**, **52**, **53**
Hardin County, Tennessee, **42–43**, 49
Harris, C. A., 44, 47–48, 91
Harris, Lieutenant John Whipple, 56
Harris, Massy, 96
Harris, Travis, 96
Harris, Washington, 96
Harris Detachment (pre-Removal), 56–57, **57**
Harris Hollow (Ripley County), Missouri, 96
Hartman, Jud, **34**
Hatchee River, 47
Henard Cemetery Road (Monroe County), Arkansas, **50–51**
Henegar, Captain H. B., 45, 62
Henegar House (Bradley County), Tennessee, 45
Henley, Elizabeth. *See* Ross, Quatie (Elizabeth Henley)
Hickman County, Tennessee, **90**
Hicks, Daniel Ross, **109**
Hicks, Elijah, **109**
Hicks (Elijah) Detachment (2nd Ross)
departure information, 62
disbanded, 87
fatalities, **66**
water shortage, 65
Hicks (George) Detachment (10th Ross)
disbanded, 87, 109, **113**
at Gray's Inn, Kentucky, 73

route information, 69
sickness and fatalities, 81
Hicks, Margaret Ross, **109**
Higginbotham Trace, 62
Hildebrand, Nancy (Otahki) Bushyhead, **74–75**
Hildebrand, Peter, 73
Hildebrand Detachment (12th Ross)
delayed at the Ohio River, 80
disbanded, **86**, 86–87, 109
at Gray's Inn, Kentucky, 73
at Mantle Rock campsite, **66–67**
in Missouri, 85
route information, 63, 69, 81–82
Hillhouse Cemetery (Lawrence County), Arkansas, **97**, 97
Hill's Turnpike, 62
historical markers
Fayetteville, Arkansas, **98**
Field Trovillion Cemetery, Illinois, **77**
Military Road, Arkansas, 52
Stone's Farm, Arkansas, 103
Hiwassee River, 62, 106, **107**
Hiwassee River Cherokee, 19
Hix's Ferry, Missouri, 96
Hogan, Erving, 101
Hogan, Micajah, 101
home, typical, **12**
Hopkinsville (Christian County), Kentucky, **66**, **73**, 76
Hornsby (Hardeman County), Tennessee, **46**
Horsehead Creek, Arkansas, 49
humanitarian conditions of the (3) Ross's Landing detachments, 36–38
Hume, Dr. John, 96

Illinois Bayou, Arkansas, **48**
Illinois Campground (Cherokee County), Oklahoma, **107**
Illinois issuing depot, 110
Illinois River (Cherokee County), Oklahoma, 44, 106
Imboden (Randolph County), Arkansas, **88–89**
Independence County, Arkansas, 91, 99
Indian Ford (Ripley County), Missouri, 96
Indian territory boundary, **56**
internment forts, 32, 91–92. *See also* concentration camps
interpreters, **79**
Iron Banks, Kentucky, 89–91, 96
issuing depots, **103**, 109
Izard County, Arkansas, 30, **95**, 99, 100–103, **101**

Jackson, Andrew, 20–24, **27**, 76, 112
Jackson, General, 74
Jackson, James, 19
Jackson, Missouri, **78**
Jacksonville, Arkansas, 53
James Foundation, **83**
James Graham House, **49**
Jasper, Tennessee, 47

Jefferson, Tennessee, 68
Jefferson, Thomas, 19
Jeffrey, John, 99
Johnson, Theodore, 68–69, 96
Johnson's Switch, Arkansas, 102
Jones, Rev. Evan, 61–62, 66, **86, 87**
judiciary, Cherokee, 17
Justus, Ivey, 97, **97**

Keeses, Oklahoma, 87
Kelley, John, 45
Kelly's Ferry, 62
Keys map, **31**
King, George, 56
Knox, Henry, 20

Lake Dardanelle, Arkansas, **48**
land cessions, early, 13
land lottery (Georgia), 24–25
land speculation, 18th-century
 Georgia, 19
land titles extinguished, 19
Langee Creek, Arkansas, 49.
 See also L'Anguille River, Arkansas
L'Anguille River, Arkansas, 53–55.
 See also Langee Creek, Arkansas
Latta, John, **58**
Latta House, **58**
Lawrence County, Alabama, **37**
Lawrence County, Arkansas, **28–29,
 92**, 97, **97, 100**
Leath, Sam, 102
Lebanon, Alabama, 91
Lee's Creek (Adair County),
 Oklahoma, **54–55, 104–5**
Lee's Creek issuing depot, 109
LeFlore County, Oklahoma, **36**
Levi Joy House, **52**
Lewis, Major William B., 105–6
Lewisburg, Arkansas, **34–35**, 36
Liberty (Izard County), Arkansas, **95**
Light Horse, Cherokee police force,
 20
Likens, Thomas, 53–55
Lindsay, Colonel William, 29
Line Road (Crawford County),
 Arkansas, **54–55**
literacy, Cherokee, 17
Little Court House, **53**
Little Rock (Pulaski County),
 Arkansas, 56, **109**
Livingston County, Kentucky,
 66–67
Logan, Coy, 102
London, Arkansas, **48**
Long House, Missouri, **80**
Lowry, George, 91–92
Lowry, George C., 91–92, 99
Lumpkin, William, 21–24

Mantle Rock, Kentucky, **66–67**, 77
map, Tennessee, 68
Maramec. *See* Massey Ironworks,
 Missouri
Marietta, Arkansas, 50–52
Marion, Arkansas, 52
Marion County, Arkansas, 100
Marshall, Justice John, 23, 24
Masons, Missouri, **81**
Massey Ironworks, Missouri, **83**

Maximilian, Prince of
 Wied-Neuwied, 96
Maysville, Indian Territory, 87
McCall, Captain George A., 55
McMinnville, Tennessee, 65, 66, 69
McMurtee's, **82**
McMurty Spring, Missouri, **81**
Meeks, 86
Military Road, Arkansas
 Baxter County, Arkansas, **102**
 Bell Detachment route, 49
 Benge Detachment, 91
 connection with William
 Strong, 52
 in Cross County, Arkansas,
 40–41, 50
 described, 52–53
 Indian removal route, 50
 Lawrence County, Arkansas, **100**
 in Monroe County, Arkansas,
 50–51
 Mrs. Black's Public House, 55
Milledgeville, Tennessee, 21
Mills family, **76, 79**
Missionary Ridge, Tennessee, 29
Mississippi River, 48, 89–91, 96
Mississippi Swamp, 48
Moccasin Bend National Park, **42**
Moccasin Springs Road, Missouri, **78**
Monroe County, Arkansas, 49,
 50–51, 55
Monroe County, Kentucky, 100
Montgomery's Point, 106
Morrilton (Conway County),
 Arkansas, **56**
Morrow, Dr. W. I. I., **76, 81, 83**, 85, 87
Mountain City, Georgia, **60**
Mountain Echo, 100, **101**
Mouse Creek internment fort, 32
Mrs. Black's Public House, 55
Mt. Comfort Presbyterian
 Church, Arkansas, **85**
Mt. Fork River, Arkansas, **54–55**
Mt. Holly Cemetery, Arkansas, **109**
Mt. Pleasant (Union County),
 Illinois, **65**
Murfreesborough Turnpike, 63, 65–69
Muscle Shoals, **37**, 106
Museum of the Cherokee Indian,
 10, 31, 60, 104
Myers, Robert A., 52

Nantahala River, North Carolina, **25**
Nashville, Tennessee, 65, 66
Nashville Whig, 70–71, 96
Natchitoches Trace (Ripley
 County), Missouri, 96
National Intelligencer, 96
Natural Dam (Crawford County),
 Arkansas, **54–55**
Neavis farm, 84
New Echota, Georgia, 23, **27, 28**
New Fort Wayne, Indian Territory, 87
New World agriculture, effect on
 European population, 14
New York Gazette, 70
New York Observer, 73–76
Niles Register, 36
Noble, Jane, 103
Norfolk (Baxter County), Arkansas, **95**

North Carolina militia,
 participation in the Removal, 30
northern route variations, 62–69

Oak Creek, Arkansas, 55
oath of allegiance trial, 24, **27**
Obannon, Judge, 82
Ochs Observatory (Hamilton
 County), Tennessee, **42**
Oconaluftee Citizen Indians, 20, 32
Oconaluftee Indian Village,
 North Carolina, **12**
Oconaluftee River, North Carolina,
 20
Oconastota, Chief, 13
Old Bird, **76, 79**
Old Field, Captain, 110
Old Field Detachment (6th Ross),
 69, 87, 110
Old Jackson Road (Randolph
 County), Arkansas, **93**
Old Jefferson, Tennessee, 63
Old Military Road. *See*
 Military Road, Arkansas
Old Stage Road (Hardeman
 County), Tennessee, **46**
Ooltewah Creek, 62
Ooskooni, 76
Orr, Nelson, **98**, 102
Orr, Rachel Lowry, 102
Orr Expedition, 1794, 20
Osage branch, Missouri, 85
Otahki, **74–75**
Overall's Creek, 66

Paduca, Kentucky, 106
Page, Captain John, 91
Palarm, Arkansas, 56
Palarm Bayou bridge, Arkansas, 49
Park Hill, Oklahoma, 64, 87, **110**
Park West, Alabama, **37**
Payne, John Howard, 26
Payne, Rev., 76
Pea Ridge Battlefield, Arkansas, **82**
Pea Ridge National Military Park,
 Arkansas, **60–61**
Pease, Theodore, 63
Penn, William (Jeremiah Evarts), 23
Pigeon Forge, Tennessee, **60**
Pocahontas (Randolph County),
 Arkansas, **91**
Poe's Road, 62
Poinsett, Joel R., 63
Point Park (Hamilton County),
 Tennessee, **42**
Point Remove Creek, Arkansas,
 49, **56**, 59
Poole, Lieutenant R., 94
Pope County, Illinois, **71, 77**
Port Royal, Missouri, 85
potato farming, effect on
 European population, 14
Powell, Colonel, 77
Powell Chapel Road, Tennessee, **46**
power lust, 8
Prairie Grove Battlefield State Park
 (Washington County), Arkansas,
 58, 88
Pratt Cemetery, 86
presidential election of 1824, 20–21

Princeton (Caldwell County),
 Kentucky, **63**, 76
prisoners in the Benge Detachment,
 91
property evaluations, **30**
Pulaski, Tennessee, 47, **90, 94**
Pulaski County, Arkansas, 56, **109**
Pyburn, Richard, 55

Racism in the reallocation of arable
 land, 17
Ragsdale, Benjamin, 55
railroad as a force for removal, 21–23
Rainfrog, **82**
Raleigh, Tennessee, 47
Randolph County, Arkansas, **88–89,
 91, 93**
Rattlesnake Springs, Tennessee, **18**, 32
Rawles, Dr. W. P., 99
Rawlingsville, Alabama, 91
Readyville, Tennessee, 68
Red Clay State Historic Park,
 Tennessee, **14**
Red Stick War, 17
Reddick family, **82**
Redsticks, Lucy, **82**
Removal
 arguments for and against, 17–23
 beginning, 30–33
 1824 U.S. presidential election, 20
 overview of 17 detachments, 35
 postponed, 69
 preparation for, 29–33
 resistance to, 112
removal, voluntary, 20, 32
Report Number 271, U.S. House
 of Representatives, 87
Reynoldsburg, Tennessee, 69, 89,
 90, 94–96
Rhea, Matthew, 68
Riddicks. *See* Reddick family
Ridge, John, 23, 26
Ridge, Major, **15**, 26, 110, **113**
Ripley County, Missouri, 96
road conditions. *See also* under
 Trail of Tears
 in Arkansas, 50–52, 59, **100**
 Bell Detachment, 48
 described, 42
Robinson, Alex F., **42–43**
Robinson, David, **42–43**
Robinson Ferry landing, Tennessee, **40**
Rock Roe, Arkansas, 55
Rohr, Curtis, **111**
Rose Cottage, **32, 110**
Ross, John, Principal Chief *See also*
 Ross Detachments
 on the Benge Detachment,
 91–92, 96
 death, **110**
 detachment supervision,
 18, 35, 61, 112
 on the Drew Detachment, 105–6
 Payne's history of, 26
 personal effects, **32**
 property appropriated, 24
 provisioning for the trail, 71, 77
 resisted removal, 32
 on routes, 63, 68–69
Victoria, 105

wedding, **39**
wife's death, **109**
Ross, Lewis, 68, 96
Ross, Mary Stapler, **110**
Ross, Quatie (Elizabeth Henley), **39**, **109**, **110**
Ross Branch Creek, **107**
Ross Cemetery (Cherokee County), Oklahoma, **110**
Ross Detachments. *See also* specific detachments
 avoided by the Bell Detachment, 42, 59
 disbanded, 87
 northern route variations, 62–69
 organization, 69–70
 overview, 35, 61
 winter camp, **65**
Ross's Landing, Tennessee
 current view, **34**
 departure of water detachments, 36–38
 emigrating depot, 32, 61
 internment camps, **33**, 62
 Whiteley Detachment departed, 104–5
routes. *See also* under individual detachments
Rubedoo Creek, Missouri, 85
Runner, Robert, 63
Russellville, Arkansas, **48**
Rutherford County, Tennessee, 62

Salem, Missouri, 63
Saluda River, South Carolina, 13
Sams, J. J., 99
Sanders, Jennie Pritchett, **111**
Saunders, Steve, 97
Savannah (Hardin County), Tennessee, **42–43**, 49
Savannah Road, Tennessee, **40**
Scott, General Winfield
 on the Bell Detachment, 44–46
 on the Benge Detachment, 89–91, 94, 96
 on conditions on the Trail, 69–73
 leader of the Removal Army, 29–30
 removal postponed, 65, 91
 Ross's Landing detachments, 36–38
 on routes, 68–69
Sea Island cotton, 14
Seminole Indians, 14, 74
Sequatchie River, 47
Sequatchie Valley, 69
Sequoyah County, Oklahoma, **36**, **106**, 108
Sequoyan **syllabary**, 17, **48**, **87**
Sevier County, Tennessee, **25**
Sheffield (Lawrence County), Alabama, 37
sickness and fatalities
 in the Bell Detachment, 42, 55, 59
 in the Benge Detachment, 28–29, 89, 92, 94, 99
 Butler's estimate, 112
 Butrick correspondence, 73
 census reviews, 112–13
 in the Harris Detachment, **57**

in the Hildebrand Detachment, 85
 in the internment forts, 32
 in the Kentucky campsites, 73–76
 in the Taylor Detachment, 77–83
 in the water detachments, **34–35**, 36, **36**
 in the Whiteley Detachment, **104–5**
Situwakee Detachment (5th Ross)
 disbanded, 87, 109, **113**
 Jones as assistant, 61
 route information, 66–68, 69
Skin Bayou issuing depot, 110
Smelter, **36**, **37**, 87
Smith, Fly. *See* Fly Smith, Chief
Smith, General Nathanial, 36
Smithville (Lawrence County), Arkansas, **28–29**, **92**, **97**, **100**
Snelson-Brinker House, Missouri, **76**, **79**
southern route, described, 41–42
Spanish Road, Arkansas, 91
spoliation claims, **30**
St. Francis County, Arkansas, 49, 52, 55
St. Francis River, Arkansas, 19, 49
St. James, Missouri, **83**
Stage Coach Inn, Kentucky, **72**, **73**
Stapler, Mary, **110**
steamboats, **38**, **57**
Steelville, Missouri, 83
Still, George, 81
Still Detachment (Ross), 81
Stilwell (Adair County), Oklahoma
 Bell Detachment settlers, 59
 Benge Detachment disbanded, 103
 headwaters, **104–5**
 Webber's Plantation, **103**, 109
Stone's Farm, Arkansas, 103
Stones River Road, 63, 65–69
Strafford (Greene County), Missouri, **84**
Strong, William A., 49, 52–53
Strong's Place, 52–53
Suck Shoals, 106
Sugar Creek, Missouri, 85
Swain County, North Carolina, **10**, **12**, **16–17**, **20**, **31**, **60**, **104**

Tahlequah (Cherokee County), Oklahoma, **44**, **64**, 106, **107**, **109**
Talbart. *See* Talbert's Ferry
Talbert's Ferry (Izard County), Arkansas, **100–103**, **101**
Talbot. *See* Talbert's Ferry
Taylor, Captain Richard, **33**, **45**
Taylor Detachment (11th Ross)
 arrival at Woodall issuing depot, 86
 in Barry County, Missouri, **81**
 Butrick on staff, 63
 at the Cunningham house, 85
 at the Danforth House, **84**
 deaths at the Mississippi River, 82
 deaths in Kentucky, 77, 80
 deaths in Missouri, **79**
 departure information, 62
 disbanded, **86**, 87, 109
 at Gray's Inn, Kentucky, 73
 Henegar on staff, **45**, 62

at the Mississippi River, 80–82
 in Missouri, 85–86
 Ohio River crossing, 77
 at Red River, Kentucky, 76
 at the Snelson-Brinker House, **76**
 at the Tennessee River, 69
Telegraph Road, Arkansas, **60–61**
Tennessee map, 68
Tennessee militia, participation in the Removal, 30
Tennessee River, 62, 89, 106
Thornton, Russell, 113
Todd County, Kentucky, **72**, **73**
Tollville, Arkansas, 55
Tolunteeskee (chief), 19
Town Branch, **107**
Trail of Tears
 conditions along the way, 69–73, 73–76, 80, 110. *See also* sickness and fatalities
 information sources, 11
 trail's end, 87, 107–8
Trail of Tears Association, **111**
Trail of Tears Commemorative Park, **66**
Trail of Tears National Historic Trail, 11
Trail of Tears State Park, Missouri, **68**, **74–75**, **78**
Trail of Tears Study Act, 42
Treaty of New Echota, **28**, 87, 109
Treaty of Sycamore Shoals, 1775, 13
Treaty Party Detachment. *See* Bell Detachment (4th)
Treaty Party leadership, 26
Trumpet of Liberty, 94
Tsali's family, resistance of, **25**
Tuscumbia Landing, **37**, 106
Tuttle, S., **85**

Uktena legend, **13**
Underwood and Harris, 112
Union County, Illinois, **65**
University of Arkansas at Fayetteville, **98**
Upper Chatate, 32
U.S. Supreme Court cases, 23, 24

Van Buren, Arkansas, 59, 87
Vann, Joseph, **26**, 62
Vann House, **26**, 62
Victoria, 105
Village Creek, Arkansas, 53–55
Village Creek State Park (Cross County), Arkansas, **40–41**, **50**, **52**, 53
Vinyard Post Office (Washington County), Arkansas, 41, 49, **58**, 59
voluntary removal, 20, 32

Wachacha's collaboration, **25**
Walden's Ridge, 62, 69
Walerns Ridge. *See* Walden's Ridge
Walker Jr., John, **74–75**
Wallace, William S., **98**, 102
Wamp, Zach, **42**
Washington, George, 19–20
Washington County, Arkansas, 41, 47, 49, **58**, 59, **85**, **88**, 91, **98**

Washington County Historical Society, Arkansas, 103
water route detachments, 35–39
Watie, Stand, 26
Waynesville, Missouri, 85
Webbers Falls, Oklahoma, **26**
Webber's Plantation (Adair County), Oklahoma, 36, 87, 103, **103**, 109
Weldon Creek (Randolph County), Arkansas, **93**
Well of Sweet Water, **73**
Westville, Oklahoma, **86**, 87, **87**, 109
whiskey, 102
White Path, Chief, **66**, **73**, 76
White River (Baxter County), Arkansas
 Bell Detachment crossing, 49, 55
 Benge Detachment, 91, 97, 99–100
 Benge Detachment crossing, **101**, 101, **102**
 voluntary removal, 1809, 20
Whiteley, Captain R. H. K., 56
Whiteley Detachment (2nd)
 Benton Sand Bar, Arkansas River, 59
 disbanded, 87, **103**, 109
 Illinois Bayou, Arkansas, crossing, **48**
 Natural Dam (Crawford County), Arkansas, **54–55**
 overview, 36
 Point Remove Creek crossing, **56**
 route information, **34–35**, **39**
 Tuscumbia Landing, **37**
 west of Lewisburg, Arkansas, 56–57
Willard's Landing, **68**
Wills Valley, Alabama, concentration camps, 91
Winchester, Tennessee, 47
Winton Spring, Arkansas, 86
Wirt, William, 23–24, 112
Wofford, James D., 109, 110
Wofford Detachment (Ross), 69, 81, 109, **113**
Wolf, Jacob, **95**
Wolf House, **95**
Woodall, Eleanor, 86
Woodall farm, **86**
Woodall issuing depot, 86, **87**, 109
Woodson, William, 47
Worcester, Samuel A., 24, **27**
Worcester House, **27**
Worcester v. Georgia, 24, **27**, 112

Yazoo Land Act, 1795, 19
Yeatman, **57**
Yellville, Arkansas, **101**
Young, Dr. John, 91
Young, John (teamster), 101–2

Zuraw Wagon, **60**